FRED ELWELL, R.A.
A LIFE IN ART

by

Wendy Loncaster

Edited by

Ann Bukantas

This book has been published on the occasion of the exhibition
'Fred Elwell, R.A. — A Life in Art'
Ferens Art Gallery, Hull, 14 August – 7 November, 1993
Laing Art Gallery, Newcastle, 15 November, 1993 – 23 January, 1994

Highgate Publications (Beverley) Limited, 1993
in conjunction with Hull City Museums and Art Galleries

For John and Juli

British Library Cataloguing in Publication Data

Loncaster, Wendy Ann
 Fred Elwell, R.A.: Life in Art
 I. Title
 759.2

ISBN 0-948929-67-7

Published by
Highgate Publications (Beverley) Ltd., 24 Wylies Road, Beverley, HU17 7AP
Telephone (0482) 866826

First Printed July 1993

Re-printed September 1993
by
B.A.Print, 4 Newbegin, Lairgate, Beverley, HU17 8EG
Telephone (0482) 886071

ISBN 0 948929 67 7

Cover credits
(On the front cover) *The Window Seat* (detail), 1932, private Collection
(On the back cover) Elwell with *The Model-Ship Builder* (373) on the easel.

Contents

Ferens Foreword ... iii

Sponsors' Forewords ... iv

Preface ... v

Editor's Acknowlegements ... viii

Photographic Credits ... viii

Editor's Note .. viii

'Master of the Forgotten Art of Living' 1

A Collection of Still Life ... 10

Portraits: Public and Personal ... 15

Every Picture Tells a Story .. 43

All the World's a Stage .. 65

Town, Country and Sea .. 75

A Sense of Place ... 91

A Window on Work ... 98

Portrait-Interiors: a Formal Audience 113

List of Titles ... 121

Ferens Foreword

One of the most enduring popular images in the Ferens Art Gallery is undoubtedly Fred Elwell's *The First Born*. The reputation of an artist cannot, however, be judged upon one painting alone and it is timely that, 40 years after the last exhibition of Elwell's work in Hull and Beverley, this project should bring together a large group of paintings that demonstrate Elwell's skill and craftsmanship across a wide variety of themes and subjects.

There has been a tendency to dismiss Elwell as a regional painter whose work does not merit national acclaim. The enthusiasm evident throughout the development of this project has indicated that there is a genuine wish to raise Elwell's reputation to match that of his fellow Royal Academicians, and we are convinced that Wendy Loncaster's authoritative publication, the exhibition and video will bring to Elwell the widespread recognition he truly deserves.

A project of this scale would not have been possible without the support of its sponsors, and we are delighted that the City, commerce and industry have worked closely together to the combined benefit of Hull's Museums and Art Galleries, the public and the companies themselves.

This is the first major exhibition to be organised by the Ferens Art Gallery since its refurbishment and extension in 1991, and it is fitting that Elwell's cosmopolitan training and influence should reflect the Gallery's importance in a national and international context, in keeping with Hull's establishment as the natural European gateway.

We would like to extend our particular thanks to Wendy Loncaster and Ann Bukantas and the other staff involved for their work on this project, and to the many private individuals and public collections whose generosity has made this project possible.

Trevor P. Larsen
Chairman, Hull City Cultural Services
Committee

Louise Karlsen
Principal Keeper of Art, Hull City Museums
and Art Galleries

Sponsors' Forewords

It gives us great pleasure to be the main sponsors of this major new work on Fred Elwell and we are honoured to be asked to write this foreword. The author, Wendy Loncaster, is the wife of one of our consultants, John Loncaster. Therefore, as a happy coincidence, we have been very aware of the birth pangs of producing a book of the breadth and quality of this. It gives us delight to see that all the hard work in preparing the narrative, and no doubt the equally complex tack of choosing the appropriate illustrations from the prolific work of Elwell, have come together to provide a harmonious whole. The book will be at once an invaluable guide and companion to the visitor to the exhibition of Elwell's works which opens in Hull this summer. It will surely also provide enduring testimony to a famous Yorkshire artist whose active painting life spanned a significant part of the end of the nineteenth and the first half of the twentieth century.

We are very pleased to be associated with the Elwell project and to further our sponsorship of the arts by supporting Hull City Council in its cultural activities. We firmly believe that Wendy Loncaster's book will play a major part in bringing knowledge and appreciation of Elwell's work to a much wider audience. We wish this book and the exhibition the success they deserve.

Peter Bowes
Managing Partner
Rollit Farrell & Bladon

Dee, Atkinson and Harrison are delighted to have the opportunity to share in the sponsorship of this publication and the exhibition, and are pleased to have attracted a BSIS award which is enabling the inclusion of extra colour illustrations of the artists's work. As auctioneers we have been privileged to sell a large number of Frederick William Elwell's works over the years, and he is to us our most eminent local artist whose works have long deserved a truly comprehensive exhibition such as this.

The variety of his subjects and his extraordinary use of interior light have endeared him to his followers.

Now, for the first time, together with Wendy Loncaster's authoritative publication, the works of Elwell should command the recognition they so richly deserve.

Christopher Dee
Partner
Dee, Atkinson and Harrison

Dee, Atkinson and Harrison is an award winner under the Business Sponsorship Incentive Scheme for its support of *Fred Elwell, R.A. — A Life in Art*. The BSIS is a Government Scheme administered by the Association for Business Sponsorship of the Arts.

My personal pleasure in once more being able to support Hull City Museums and Art Galleries in the publication of a superb book is matched by my delight in having been able to assist Wendy Loncaster with her research into the life and work of this most deserving of our local artists.

Malcolm Shields

Preface

The constructive idea of researching the works of Fred Elwell emerged from a conversation with a friend, Richard Wilson, when I was nearing the completion of my Open University Honours Degree course, in the history of art. I have every reason to be grateful for being encouraged in a quest which has fascinated and absorbed me for nearly four years.

The journey through Elwell country has produced endless visual pleasure. I wanted to chart its territory and its well-loved landmarks, and also features far less well known. This book is the result of my quest. Inherent in its purpose is an invitation to share my exploration of Elwell's art.

The research has been greatly aided by my own proximity to Elwell's native town of Beverley. I am grateful to Beverley Decorative and Fine Arts Society whose members contacted me at an early stage. Probably they were unaware of the train of further helpful communications that ensued, each from another, with the search for information becoming increasingly more fascinating. Others too heard of my efforts and took the trouble to contact me. Kindly and supportive people everywhere have shared my satisfaction in bringing useful cohesion to the many fragments of information about the artist's life and work.

Personal contacts have been more than usually essential in researching the subject of Elwell. He preferred the brush to the pen; never writing anything until the pressure upon him was irresistible. No diaries or letters existed which reveal his character. He was, however, a supremely likeable man who readily made friendships. The art of conversation was precious among those with whom he frequently associated. The people who can still remember their encounters with Elwell have been the best contributors to my understanding of his personality.

I am particularly indebted to Elwell's own family, his great-nieces and great-nephews: Ray and Jean Elwell, Jean Foster, Abner Blyth and Nora Blyth. Without their special memories, so generously shared, there would have been serious gaps in the Elwell story.

I would like to express my gratitude to the many private owners of his works. It is a sad fact of modern life that for reasons of security they must remain anonymous. All have been unstinting in their help, understanding and hospitality. I am particularly indebted to the many who have so willingly and generously allowed me to reproduce illustrations of their paintings in this book, and consented to part with them for the six months or so required to enable them to be included in the exhibition at Hull and Newcastle. I know that this will leave a gap on many a wall - and in one case it has even prompted plans to redecorate a room !

I also thank the staff of numerous museums, galleries and historic houses, as well as the officers of the Royal Collection for their often considerable contributions to the sum of knowledge of the Elwell paintings in their collections, which are widely situated across the United Kingdom. There is a central core of Elwell's work in the hands of the Beverley Borough Council, mostly bequeathed by him to the town he loved. The Council's full co-operation has been essential, and is greatly appreciated. I gratefully acknowledge the interest and support of Roy Gregory, a former officer of the Council, which was invaluable to my own sense of purpose in the Elwell investigation.

I am particularly grateful to the Ferens Art

Gallery, Hull, and to its Keeper of Fine Art, Ann Bukantas, friend and colleague, with whom was generated the attractive prospect of an exhibition entitled, as the book, 'Fred Elwell, R.A. — A Life in Art', and the emergence of the 'Elwell Project' which combined the two elements as well as the prospect of producing a video film. Our collaboration has been enriched by Ann's organizational ability, energy and enthusiasm. It is to her that I owe the responsibility of editing the script of this book, and I appreciate her considerable effort and good advice. Again it is Ann who has managed the photographic images, so important in a book of this kind. I gratefully acknowledge all the encouragement and support of Hull City Council and their important funding of the photography for this venture.

The establishment of the 'Elwell Project' has also relied on the contributions of my husband, John, whose commitment, experience, and ability to make full use of the computer, I have appreciated almost as much as the pleasure of working together.

The range of paintings and drawings presented in this book should dispel the myth that Elwell can adequately be described as a 'painter of domesticity'. It is but a fraction of the whole truth.

In order to project his works coherently, they are arranged in the book, as in the exhibition, according to subject themes, each ordered chronologically. The paintings examined in the text are closely paralleled by the selection for the exhibition, and the book is intended as its official catalogue. It is expected also to stand alone in its life beyond the exhibition period, at which time the added inclusion of paintings not available for the exhibition will be more than justified. This is consistent with the aim to present the full range and development of works by this artist.

Despite all efforts to trace certain paintings some have not come to light, and it has been necessary to resort in a few cases to reproducing the only surviving photographs of them, and to accept a reduction in quality. This seems very worthwhile, as it preserves images that might otherwise be lost. It has therefore been our policy to pursue this, even though it has meant omitting a few images of actual paintings, particularly if the originals are readily accessible to the viewer anyway.

In order to present an overview as completely as possible of Elwell's works, a full list of the titles known to me is included at the end of the book. The titles appear in chronological order, using a framework of dated works. For the placing of the rest it has been necessary to surmise from the available evidence. Those added separately at the bottom of the list have resisted all attempts to place them in a chronology. I can by no means claim the entire list is definitive. It is in fact constantly growing, leading to the necessity to use some decimal numbers. My publishers have generously allowed for additions to be made until the point of going to press.

The titles of paintings show many variations, not only through time, but also through the artist's own inconsistency. Wherever possible, the earliest known title, particularly when marked on the reverse in Elwell's own hand, is the one I have employed. But exceptions have to be made where one title is inconsistent with another, or in the case of the very familiar usage of a name. Descriptive titles are adopted for those works which never seemed to aspire to a name at all.

This publication could never have happened without the generosity and support of its sponsors. I am delighted that the major contribution has been made by the firm of Yorkshire and Humberside Solicitors, Rollit Farrell & Bladon, in which my husband is a consultant. There are many links of legal narrative subjects, and of portraiture, between this firm and Elwell's work. The front cover painting, *The Window Seat*, features charmingly the mother and sister of one of the consultants. It is also most appropriate that the firm of Auctioneers and Valuers, Dee Atkinson & Harrison of Beverley and Driffield, should have so kindly pledged sponsorship for the book. They are the leading forum for buying and selling Elwell paintings, and have often assisted me in my investigations. The art connoisseur, Malcolm Shields, has encouraged my work from an early stage by taking a keen and helpful interest. I am thus very grateful for his present sponsorship. My heartfelt thanks are due to all of them, and to John Markham, Barry Sage and their colleagues at Highgate Publications Ltd., for breathing life into the book's publication and for having confidence in me

Finally, the research entailed in the preparation of this book has involved far more people than it is possible for me to thank individually. These are gratefully acknowledged, and many of them are listed below.

Wendy Loncaster
July 1993

R. F. Ashwin
Joan Baker
Sheila Barton
Kenneth Beaulah
Evelyn Bentley
Brian and Pat Bland
Jim Bloom
Jean Bloomfield
Stephen Blyth
Joan Boston-Smith
R. A. Brewer
Gillian M. Brooke
Xanthe Brooke
Ann, Lady Brooksbank
Julie Bubbers
David Buchanan
Clive Bullock
Robin and Pam Burton
Fred Bush
S. R. Caley
Tim Carter
Peter Carver
John Chichester-Constable
James Chorlton
Honor Clerk
Sir James Cleminson
Christine Clubley
Thomas Collins
James Arthur Constable
Doris Cooper
Avril Crosbie
Frank Dawson
Pat Deans
L.W. Dickerson
Phyllis Downham
Leslie and Joy Downs
Charles Elwell
Ann Ferens
Harry P. Flynn
William Foster
Mollie Garwood
Fred Good
Priscilla Goodger
Walter Goodin
Pat Gray
Roy Greenwood
Ivan and Elizabeth Hall
Florence Hall
Sue Heard
Charles Hewson
Christopher and Lucia Hobson
Margaret Hobson
Charles Hodgson
Dickie Hofflund

Dora Holder
M. Holmes
Muriel Holtby
Elizabeth Horley
Cyril Huddleston
Sydney C. Hutchison
Pat Hutson
Barry Ireland
Peter and Sheila Jefferson
David Jefferson
Terence Jenkins
Hilda Jenkinson
Joan Johnson
Emily Jones
Sarah Kirby
Ron Lang
Mavis Latus
Terry Lazenby
John Lightowler
John Lord
Sir Ian Macdonald of Sleat
Rodney Mackay
Peter Macnamara
Thetis Malcolmson
Pam Martin
Rixon Matthews
Eileen Millest
Joan Moody
Berna Moody
Christopher Myers
Owen Nisbet
Charles Noble
R. Norfolk
Adele Nye
Dick Odey
D.D. Osborne
Ann Payne
Albert Overton
Sidney Palmer
Kenneth and Jenny Pape
Jan Peters
Vera Pickering
Owen Place
D. Powell
Michael Preston
Peter Rainer
Carol Rees
Brenda Richardson
Angela Richardson
Marjorie Robson
Julia Rolfe
Vivien Rose
Gwyn Schofield
P. M. Scott

F. R. Scott
James Scott-Brown
Mary Shaw
Alan Short
Jack Skinner
Jenny Stanley
Elizabeth Stephenson
Juliet Stirrat
Graham Stroud
Saida Symmons
Clive Taylor
Peter Taylor
Margaret Thomas
John Thompson
K. Fay Thornalley
Ernest and Doris Tilling
S. Tinegate
Anne Todd
Stephen Todd
Eric Wainwright
Helen Watson
J. B. Watson
Tony Watts
Zillah Weston
Marion Wilkinson
Bob Williams
George Wilson
Roy Wilson
Suzanne Wilson
Val Wise
Mildred Wray
Hugh M. Wybrew

Editor's Acknowledgements

Special thanks to my colleagues: David Briers, Tom Bucknall, John Devaney, Graham Edwards, Judith Fox, Ian Goodison, Pauline Greaves, Louise Karlsen, Peter Lawson, Sarah MacDonald, Maxine McKee, Lisa Pearson, Dave Ryder, Lisa Stokes, Tracy Teasdale, Catherine Train, Mark Waddell and to Bob Grantham and the Gallery's attendant staff.

Thanks also to the following for their hard work, help and support in the preparation of the book, exhibition and video:

David Adams, John Atkinson, Andrew Barber, Alison Barnard, Fred Beckett, Clare Bennett, John Bernasconi, Peter Bowes, John Bradshaw, Richard Burns, Gwyneth Campling, Lt. Col. Cardwell Moore, Joe Carr, Nigel Chatters, Jackie Clarke, Cathie Colcutt, Roger Cucksey, Alison Darnborough, Chris Dee, Victoria Ferrand, Michael Festenstein, Martin Foley, Mike Fox, Tore Gill, Anne Goodchild, Francis Greenacre, Tim Henbrey, Sarah Hibbert, Mark Humphries, Adrian Jenkins, Roger Jobson, Penny Kennedy, Shaun Kerrigan, Christopher Lloyd, Robert Lucas, Freda Matassa, Vic McCullagh, David McNeff, John Millard, Linda Murdin, Cazzy Neville, Owen Nisbet, David Nickerson, Annabel Pearson, Keith Perry, Joanna Rickards, Michael Scanlan, Nicholas Serota, Dave Shakeshaft, Michael Sheppard, Malcolm Shields, Colin Simpson, Skipper the dog, Julian Spalding, MaryAnne Stevens, Hugh Stevenson, Sheena Stoddard, Bob Taylor, Stephen Todd, Ernest Tomlinson, Julian Treuherz, Winnie Tyrrell, Helen Valentine, Paul Vinsen, Gillian Walker, Neil Walker, Stephen Whittle, Lt. Col. Donald Wickes, Christopher Wood, Mike Wood, Richard Wood.

Ann Bukantas
July 1993

Editor's Note

The catalogue numbers in the main body of this text and in the exhibition are determined by the full chronological list of Elwell's work which appears at the end of this book.

A separate bibliography has not been included but the reader may find of interest the references to other publications — and paintings — that appear in the author's footnotes.

Photographic Credits

Photographic credits are as public and private collections given in the individual text entries, other than: (122) Christopher Wood Gallery, London, (155) Phillips, Leeds, (293) The Pilgrim Press, Derby, (296) The Royal Collection © 1993 Her Majesty The Queen, (406) by courtesy of the National Portrait Gallery, London. Further credits are due to Beverley Borough Council, the Beverley Arms Hotel and private owners in respect of various biographical and contemporary photographs.

Thanks also to the following for photographic work: Geoff Beale, Winchester; Keith Dugdale, Penzance; John Gibbons, Uffington; Hull City Council Design Unit; Richard Littlewood, Huddersfield; Layland Ross, Nottingham; R. Megilly, Weymouth; Norwyn Photographics, Preston; National Maritime Museum Enterprises; Prudence Cumming Associates, London; Richmond and Rigg, Hull; Ken Shelton, York.

'Master of the Forgotten Art of Living'

Frederick William Elwell turned to his pupil, Walter Goodin, as they contemplated the view. It was Goodin's choice of subject for a painting and he was eager to start work. 'Don't rush in,' offered Elwell's voice of experience. 'Better to take a long hard look. Arrange in your mind those matters of form, and of lights and darks, which have set you wanting to paint the subject in the first place.'[1]

Elwell was a realist painter, moved to convey in his works the joy he felt from life itself. Much of his inspiration was found in the East Riding town of Beverley, to which he was devoted, and where he lived a long life. Its people and places, customs and artefacts were his subjects for over 60 years.

His paintings evoke in particular the Edwardian provincial life of the time and place of his artistic maturity. He also painted and established a successful reputation beyond that sphere, on the Continent and in London.

Fred Elwell, as he preferred to be known, was born on 29 June 1870, at St. Mary's Cottage, St. Mary's Terrace, Beverley, to Annie and James Edward Elwell. He was one of six children, of whom John, Edward, Frederick, Frances and Margaret survived to appear in a family photograph in around 1910 (Fig.1).

His father, James, was a cabinet-maker. When the family moved to No. 4 North Bar Without, Beverley, James was able to establish his own woodcarving business. Over the years this flourished and, by 1893, he was employing as many as 50 men. A lasting example of his craftsmanship can be seen in the Victorian-Gothic choir screen, designed by Sir Gilbert Scott for Beverley Minster. James was also a key figure in local

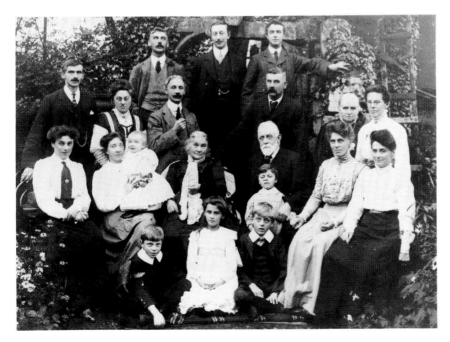

Fig 1.
The Elwell family c. 1910, in the garden at Park Villa, Beverley, with the artist (third left, third row) in front of Edward (Ted) and between Margaret (Maggie) and John. Parents, Annie and James, are central in the second row with Frances (right), Kate (Kitty) on the extreme left and Florence, holding the baby.

politics, and was Mayor of the town of Beverley in 1900 and 1902, consorted by his daughter Frances. He was fond of the theatre, attending performances in London and inviting stage-friends, including the actress Ellen Terry, to the house in Beverley.

James was too large a personality not to have left his mark on the young Fred, who subsequently set himself high standards of achievement, probably to live up to paternal expectation. He was imbued with an admiration for craftsmanship, and was to portray his father in later years amidst the ecclesiastical carvings of the workshop, or tenderly restoring china *objets d'art*.

Fred Elwell began his education at Beverley Grammar School. Later, whilst at Lincoln Grammar School, he attended evening classes at the Lincoln School of Art. There was kindled an interest in painting which was to colour the rest of his life. In 1887 he won the Gibney Scholarship which enabled him to embark upon a three-year full-time course at the School. It was a propitious start, and he decided to make a career as a painter.

Lincoln School of Art[2] was regarded then as being amongst the ten best art schools in England, and its Principal, Alfred Webster, was considered an inspiring teacher. Like many schools of art, it arose out of the Great Exhibition of Art and Manufacture of 1851, and in its earlier days its curriculum had combined fine art with the study of product design. There remained, in Fred's day, an emphasis on draughtsmanship and accuracy which reflected the School's old manufacturing links, and left its mark upon his approach to art.

Speech days at the School saw numerous prizes awarded to Elwell, including one for his copy of a plaster cast *Classical Study* (2). In 1887 he won the Queen's Bronze Medal in the National Art Schools Competition, for his first signed and dated work, *Still Life with Fish 1* (1), a reflection of the School's, and his own, strength in the field of still life.

Furthermore, as a student at Lincoln, Elwell must have been touched by his Principal's interest in the work of the French Impressionist painters, in which a flickering brushstroke alone could capture the effect of sunlight. Webster was teaching elements of Impressionism, gleaned from his travels in France. To do so at an English art school was daringly innovative in the 1880s —indeed he experienced strident opposition from the Treasurer[3] of the Royal Academy, London's leading art school.

However, at this early stage in his career, Elwell's encounter with the English prejudice against French art made him wary, and he showed no inclination then to take on the trouble it entailed.

By 1889 he was sailing to Antwerp in a Hull steamer, *Zebra*. Antwerp's Academy had attracted a former Lincoln Art School student, William Logsdail (1859-1944)[4], whom Elwell had heard exalted at Lincoln speech days. With its 2000 students, Antwerp was regarded as a fashionable training-ground for artists. Elwell was placed under the rigorous tuition of the rapier-tongued Van Havemaert, and was successful in winning, in 1891, the Silver Medal for painting. The meticulously sharp detail of Elwell's later interiors can be attributed to his Antwerp training. He would also have acquired there the versatile technique of drawing in pastel, which he later put to such striking effect in his *Portrait of George Monkman* (5).

Produced in Antwerp, *The Cello Player* (10) suggests that Elwell was by that time becoming familiar with Northern European Old Master paintings, providing the influence for such a sturdy good-humoured subject. Indeed, many of Elwell's subsequent scenes of Beverley were to owe their origins to the earthy, everyday subjects that were typical of 17th-century Dutch and Flemish artists.

From 1892 he was training once more, at the Académie Julian in Paris, under the tuition of William-Adolphe Bouguereau, a painter of allegorical nudes. Fred may have financed this project himself to benefit his career.

Paris remained at this time the artistic centre of Western Europe. A modernist revolution was challenging traditions inherited from the Italian Renaissance, to replace them with innovatory styles and subject-matter. Artists of many nationalities converged in Paris. One of many attracted from England was Augustus John (1878-1961). He and Fred Elwell are reputed to have painted each other's portrait, having met in the city. Madge Whiteing (from Beverley) encountered them together in Paris, and thereafter the portraits, now lost, passed into her hands.

Fred seems to have entered fully into the spirit of Paris. He made sketches[5] reminiscent of Degas and of the Moulin Rouge of Toulouse-Lautrec[6] (Fig. 2); he met Gauguin. The landscape, *Orchard* (16), was an experiment in Impressionism and his painting of the circus,

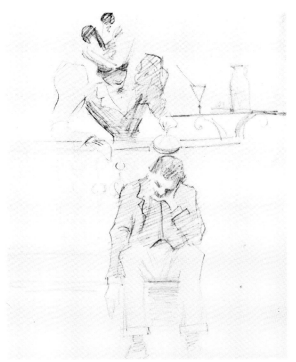

Fig. 2. — A scene in a night-club drawn by Elwell during his training in Paris, 1889-92, is included in his sketchbook. (22).

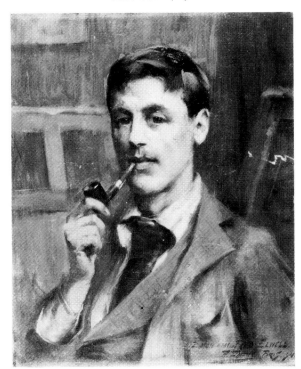

Fig. 3. — This portrait of the artist, by Richard Jack, a fellow student at the Académie Julien, is inscribed 'A mon ami Fred Elwell. R. Jack. Paris 94'.

Pierrot et Danseuses (23), hints at his Parisian activities. In fact it is likely that the more bohemian side of his personality had its roots in his experience of Paris — this was the Elwell who was subsequently to follow a circus in a gypsy caravan! He also described later to Walter Goodin a ball he had attended in the Latin Quarter, which had been a riot, attended by guests whose 'garb was very Roman indeed'.

The training itself espoused the traditional values of art, with an emphasis upon the figure, and upon qualities of tone as opposed to colour, as illustrated in his Paris painting *Léonie's Toilet* (21). There were opportunities to paint the nude from a live model, which had been denied to him at Lincoln, where it was thought to be inappropriate in a cathedral city. We learn of his father having visited him in Paris and then reporting proudly in *The Sketch*[7] that Fred had 'come head of the English and American sections and sixth of the whole 500' at the Académie Julian. The Académie Julian was a suitable training-ground for artists like Elwell, hopeful of exhibiting at the Salon in Paris or the Royal Academy in London. To exhibit there was to be given a seal of approval and the means of attracting the sale of one's work. In 1895 *Léonie's Toilet* was accepted at the Royal Academy, and achieved for Elwell the breakthrough which he desperately needed.

Elwell was, like many students, dogged by financial crises. He lived largely on omelettes and often went hungry. A friend is reputed to have offered him a drink, and Fred pleaded for a pork pie instead! It must have been a wrench to have to forfeit *Léonie's Toilet* as a means of settling the rent — this painting was only rediscovered many years later. He and his fellow students often avoided the expense of hiring models by painting one another. John Hassall[8] (1868-1948) portrayed Fred in 1892 and Richard Jack[9] (1866-1952) painted him in 1894 (Fig. 3), fortunately providing useful records of the young artist and his colleagues.

After Paris, Fred tried to make a living in London. It made sense to transfer from one capital city to another, but the project failed when his financial situation worsened, and he could no longer afford to look after his health. His normally cheerful attitude to life was overrun by a darkness with which he could not cope. Worried about his son, James visited him, and decided to bring him back home to Beverley.

Around the year 1896 found Fred Elwell fully

recovered at his parents' Victorian Gothic home, Park Villa, with its long walled garden, in a secluded, almost secret, corner of Beverley. His sisters, Frances and Maggie, and Florence (his orphaned niece who modelled for *Portrait of Florence Elwell,* 33), were also under the parental roof. Fred seemed to find the comfort and security of this new family-based phase of his life a galvanizing influence. By 1899, at least, he had acquired the Wood Lane studio of *Artist in his Studio* (38), and was exhibiting there. He had returned to his native community, in which supportive patrons such as Dr. William Stephenson admired and purchased his landscapes, including *Beverley Beck* (40).

Meeting the demand in Edwardian England for portraits, Elwell could please his sitters, like *Mrs. J. Downs* (86), with sensitive likenesses in the newly revived medium of pastel. Portraiture was to feature highly throughout his career. Had he secreted from Paris the slightest hankering for the 'demon' nude, or for modernism, he appears to have quelled it, at this point in his life, in order to make his way as a painter in Beverley.

Beverley was linked by Beverley Beck to the River Hull, and thence to the Humber, facilitating activities like shipbuilding, tanning and flour milling. Elwell painted the barge-laden waterways close to the town, as well as the more distant and peaceful networks through the East Riding flatlands, reminiscent of Holland. He took to the water in his sailing boat, *Spowder* (Fig.4) with a fellow painter, Walter Hadland, who set the scene so wittily in a poem composed for Maggie. In a parody of Longfellow's *The Song of Hiawatha*, he began:

> *'Now I sing of the great river,*
> *And the boats that come upon it.*
> *I sing also of a pair of painters*
> *Freddiwitwitt,*
> *Haddehaha*
> *How they both had indigestion*
> *How they pinched each other's baccy*
> *When they sailed up the great river'*

He spoke of getting 'their blessed feet wet' as they took *Spowder* through the lock, then of mooring up for a painting session, taking their camp stools and 'bits of wood':

> *'And they put small bits of paint on.*
> *Very pleasant were their panels*
> *Before the paint was put on'*

Fred often sailed to Wansford, near Driffield,

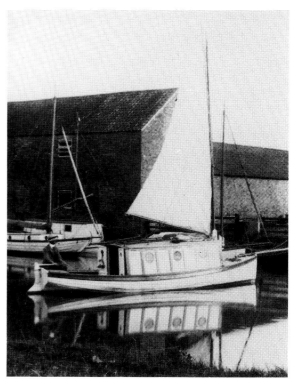

Fig. 4. — *The artist at the helm of 'Spowder', c.1907. Later he recalled to* Dalesman, *March 1958, his 'primitive, but happy, carefree life' for months on end on the River Hull, painting landscapes.*

to attend parties given by his friend, Joseph Butterell. Alternatively he would arrive in his gypsy caravan (Fig.5) which, however convenient for painting the countryside, also conveyed the image of the artist free to roam. This was the period, in the early 1900s, when Elwell produced most of his East Riding landscape paintings.

By 1909, admissions of his work at the Royal Academy were becoming regular. Curiously, exhibits at the Royal Academy that year, by Fred and by Mary Dawson Holmes, were both selected for review and illustrated together in *The English Illustrated Magazine*. It was a remarkable portent of their future marriage. His portrayals of family life, combining realism and romanticism, were of the kind that had remained popular since the Victorian era. They culminated with *The First Born* (110) in 1913, which displayed Elwell's skilful handling of the effects of light and air, as well as conveying strong emotion. He began to work more in the studio than in the countryside,

and as his confidence developed he transferred to larger premises at 22 Trinity Lane. The paintings which contributed to this increased confidence seemed to parallel his relationship with Mary (Fig.6). whose existence may have made family life seem particularly poignant to him. Mary's husband, Alfred, was suffering from a terminal illness, and together she and Fred cared for him. It was Alfred's hope that, ultimately, the two would marry.

He married Mary Dawson Holmes (née Bishop), the widow of oil broker Alfred Holmes, at Holy Trinity, Upper Tooting in Surrey, on 28 September 1914. Both were in their forties. Mary was also a painter of considerable talent, chiefly in the realm of interiors, and was to exhibit regularly at the Royal Academy for 22 years. She retained her own studio, in Beverley's Landress Lane. Mary, or 'Mamie' as Fred called her, was, for her time, a modern, independent woman. Their marriage brought Fred great happiness. They had no children, but Mary's wealth enabled them to run Bar House, Beverley, as their home, to entertain, and travel on the Continent for several months of the year. Bar House was an elegant property, much adored and painted by them both. It adjoined the medieval town gate, known as North Bar. It commanded views in all directions, which were to inspire many paintings.

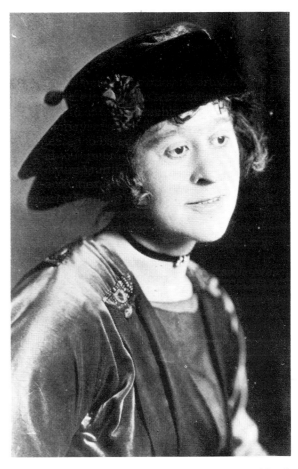

Fig. 6.
Mary Dawson Holmes, who married the artist, 28 September, 1914.

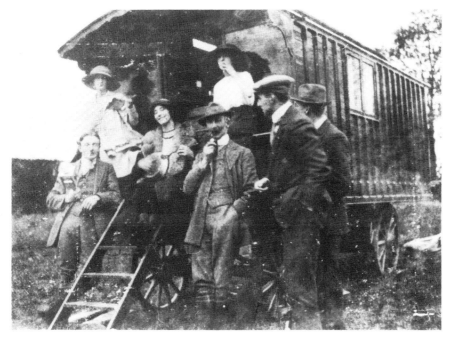

Fig. 5. — Elwell's gypsy caravan was popular at parties in the early 1900s at Joseph Butterell's home at Wansford in the East Riding. Beside the artist, smoking his pipe, Mrs. Monroe (of A Mother & Daughter, *159.1) 'plays' the banjo on a frying pan.*

So also the garden, with its huge lime trees, which were to be the source of Fred's new enthusiasm for horticulture. It was a further measure of their good fortune that they owned a car and enjoyed a private electricity supply, at a time when both were extremely rare in Beverley.

After the marriage there were indications of a change in Elwell's approach to figurative work. New freedom from financial constraint may well have enabled him to follow his own inclinations. *Maids with Pigeons* (146) was an early example of his honest, down-to-earth realism, often of the workplace, and captured from the continuous flow of life that surrounded him.

He pursued this theme in 1919 with the first of his observations of the apparently serene domestic activity at *The 'Beverley Arms' Kitchen* (150), in one of an intermittent series which has since come to be regarded as most typical of Elwell's work. By capturing the atmosphere and detail of such a specific Beverley location he was beginning to forge a special relationship between himself and the town.

The painting was purchased by the Chantrey Bequest for the Tate Gallery in accordance with its policy of acquiring British works of the highest merit. For Elwell, it was an important mark of national recognition.

In 1921 *The Last Purchase* (156) was characterised by its sharply drawn meticulous detail. The complex patterning of a collection of curios, the lifelike figure of his father, and the well defined study interior were achieved through a synthesis of technical skills. This painting was significant, as it foreshadowed the major interiors, like *'Widdall's'* (250), and portrait-interiors yet to come.

By 1923, the Elwells had left Beverley to spend six months in their gypsy caravan following Sanger's Circus. Home comforts had not entirely cured Fred of his bohemian aspirations! He was drawn to the circus, like many of his contemporaries, particularly Dame Laura Knight[10] (1877-1922), with whom he was closely associated. They discovered an extraordinary subject, full of exoticism, energy and striking form. In painting his series of circus scenes he was also keen to give reassurance, to those who doubted it, that circus animals were well treated.

The 1920s also brought to Fred and Mary the opportunity to travel extensively on the Continent. An exhibition of Elwell's works at Sunderland in 1927 included new landscape subjects of Cahors, Albi, Avignon and Les Baux, in which he introduced bolder motifs and a brighter palette. Over 60 of his paintings, many of which were Continental landscapes, were circulated by the Arts Exhibitions Bureau to the Usher Gallery, Lincoln, and the Bowes Museum, Barnard Castle, in 1928.

The introduction of the portrait-interior was made most notably, in 1928, with a painting of *Sir Alexander and Lady Macdonald of the Isles with their Family in the Gallery at Thorpe* (249). The Macdonalds, who were close friends, were quick to recognise Elwell's ability. The painting's success encouraged other stately-home commissions, including *The Earl and Countess of Strathmore and Kinghorne in their Drawing Room at Glamis* (293) in 1931. A Royal connection was established when George V admired Elwell's portrait of *Col. J.B. Stracey-Clitherow* (288) at the Academy exhibition and commissioned Elwell to execute a portrait of himself for the Palace of Holyroodhouse in Edinburgh. The years of 1931, when Elwell was awarded the Associateship of the Royal Academy, and produced the Stracey-Clitherow and Strathmore paintings, and 1932, when he completed the portrait *His Majesty King George V* (296), were surely Elwell's *anni mirabiles*. Also in 1932 appeared *A Man with a Pint* (303), a frank depiction of a Beverley character at his local. The humour of the well-lived-in face and the accustomed grasp of the beer mug were much enjoyed by the public visiting the Academy. He produced too the portrait of *Mrs. Stephen Ellis Todd at 94* (302) which, together with that of Stracey-Clitherow, he believed to be his finest.

It was also in 1932 that Elwell painted *The Window Seat* (298) with its enchanting mood of quiet intimacy and absorption, surrounding the mother and her daughters. In life, the mother was Kate Hobson, a close friend of the Elwells, and a writer of art reviews. She described the private views held in Elwell's Trinity Lane studio, when 'people streamed in and out, shook hands, admired and reluctantly departed to make room for others'.

Kate Hobson wrote about her annual visit to the Summer Exhibition at the Royal Academy, when 'naturally to a visitor from Yorkshire, the focus of interest in Gallery V was F. W. Elwell's *'The Squire'* (291) and deducing from comments overheard, it was universally appreciated'. She recognised 'something of the spirit of both artist and sitter [which] seems to have permeated this

canvas so as to be discernible even to the eyes of those who knew neither'[11]. Her reports, reflecting Elwell's popularity with the general public, are endorsed by Sydney Hutchison, Honorary Archivist to the Royal Academy, who described his works as both understandable and well executed.

On a social basis, Kate Hobson was one of those who attended the Elwells' fancy dress parties at Fred's studio in Trinity Lane. She wrote a poem, 'The Studio en fête' in appreciation of such an occasion in 1926. Clearly they had a good time:

'Shadows and glooms, half-lights and sudden gleams,
Gay wits and music, costumes quaint and bright;
The beauty of dull silver, old dark beams
And coloured plates picked out by candlelight:
Laughter and happy voices in the air —
Like children freed to play a chosen part —
Amongst the pictures glowing, everywhere,
On walls and easel and in mind and heart.'

Fred supported, and financed the training of, two pupils; his nephew Kenneth Elwell and Walter Goodin (1907-1992). Goodin was a railway porter before Fred recognised his artistic talent. The pupils shared the studio building, but were careful not to encroach upon Fred's space, as he preferred to work alone, and for his work only to be seen when finished. On one occasion he flared up in annoyance because Walter caught sight of a work in progress. From such a good-natured man, this came as a surprise. Elwell was a perfectionist, who on one occasion spent three hours getting a thumb right! He insisted that even the thinnest of plates cast a shadow of some sort, which the artist must paint.

In 1935 Elwell acquired a London studio, at 24 Holland Park. He needed more contact with the Royal Academy following his Associateship, and also with The Arts Club and fellow artists. Establishing himself in the capital, he became more available for commissions closer to London, including *The Garter Service, St. George's Chapel, Windsor, 14th June 1937* (353). He developed close friendships with Reginald Brundrit, R.A. (1883-1960)[12], Alfred Munnings, R.A. (1878-1959)[13] and John ('Lamorna') Birch, R.A. (1869-1955)[14]. From various parts of England they converged upon London and met at the Garrick Club after attending to Royal Academy affairs. If Elwell was ever part of a circle, this was it. The friendship lasted for the rest of their lives.

Elwell was honoured to be elected, in 1938, to full Membership of the Royal Academy. He served on its Council, and on the Selection and Hanging Committee, the subject of his Diploma Work (360), submitted to the Academy's keeping. The work of Elwell and his circle has since been noted for its attainment of high technical standards, an alternative to modernism when the issue was a matter for heated debate.[15] Elwell was a stalwart member of the academic camp. He exhibited 190 paintings at the Academy, and it was fitting that he should bequeath in his will to the Royal Academy Schools £1000 to endow an annual Fred Elwell

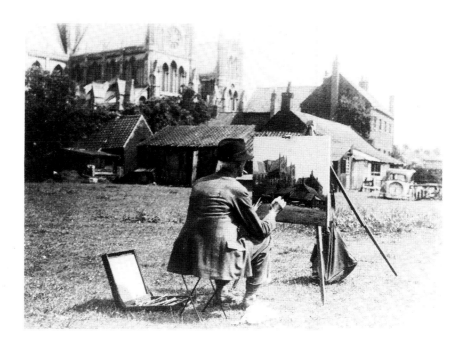

Fig 7.
Elwell at work on his painting, Beverley Minster from Hall Garth *for exhibition at the Royal Academy in 1943.*

Prize for Still-Life Painting.

His attitude to local art societies was similarly helpful and encouraging. When invited by the Huddersfield Art Society, he gave a demonstration of painting, producing a *Portrait of Edward Ackroyd* (329), their secretary, with appropriately witty features of pipe-smoke curls and one bright ear caused by a shaft of sunlight. By the 1950s he regarded local art societies as the last bastion of traditional art. When American Abstract Expressionism pervaded the art scene, he retreated even more into traditionalism, dismayed at this quickly executed art. 'There are no short cuts,' he said defiantly, adding on another occasion to Walter Goodin, 'Painting is 90 per cent perspiration and 10 per cent inspiration.'[1] He regarded such modern movements as 'misguided attempts at being different'.

Elwell recognised the importance of local art societies to their communities. He was the founder President (1943-1958) of Hull Art Society. At its functions he always courteously welcomed the guests. He instigated the Beverley and District Art Club, providing equipment and dropping in to offer kindly criticism. When called upon to select paintings for their exhibitions, they were hung from floor to ceiling, as he was too polite to reject members' works! But he was

utterly disparaging about the support he gave. When the Beverley club invited him to be their President, he retorted: 'I'm already President of the Hull Art Society. I don't do anything for them, and, if you like, I'll do the same for you.' It was in keeping with his self-effacing humour. Despite his celebrity status, which encouraged membership of the Beverley club during his presidency, when he was asked to give a talk on Greece, he at first demurred: 'You don't want to hear me. I gave a talk on Greece somewhere. Got so garrulous about the sea voyage, they never heard about Greece at all.'[16]

Yet he was the Rotarian who gave sparkling speeches. He also delighted in conversation with other men who gathered regularly at the Beverley Arms, as in *Four Friends* (153). He pursued his life in Beverley with considerable energy, serving on the Libraries Committee to keep an eye on the art gallery. He was very interested in his garden and he enjoyed taking long walks in the country. His many friends knew him as 'a man of culture, fond of books, and of music, and of all the good things of life. He was a master of the forgotten art of living' (Fig.8).[17]

Mary had suffered her first stroke around 1945, and further attacks left her in need of constant nursing until her death in 1952. Fred arranged for Elizabeth Chapman to be her companion and had her brought to the window that looked over North Bar Without. For the first time since 1911 Fred submitted no work to the Academy in 1951.

Throughout Mary's illness and following her death it was, he said, his painting that sustained him. At the age of 80 he disciplined himself, as he had done for years, to office hours. He bought

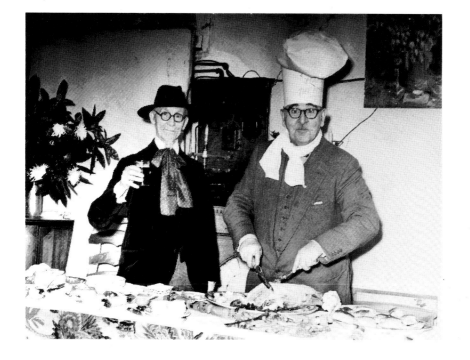

Fig. 8.
At the Christmas party in the 1950s at 'Green's' shop, members of the Beverley & District Art Club dressed to exaggerate their occupations, with Elwell, the President, in cravat and wide-brimmed velour hat.

himself a new bicycle to ride to his studio, and pedalled through Beverley with a bunch of yellow snap-dragons tied to the handlebars. Flower-pieces were becoming his most frequent subject. As he jokingly remarked: 'Old painters don't die. They simply paint away!'[18] However, even towards the end of his life he still maintained his high standards, as evidenced by the beautiful still-life with flowers, *Basket of Roses* (442), which he painted in 1955 at the age of 85.

He continued to produce his established norm of six exhibits at the Academy each year. With friends he watched television news programmes, but vigorously switched off Malcolm Muggeridge. 'Buggeridge,' he called him! In 1953 Beverley Art Gallery and the Ferens Art Gallery, Hull, showed a well-visited retrospective exhibition of the works of Fred and Mary Elwell. It included 90 of his paintings, extending up to his late work. In the same year came the rare accolade of the honorary freemanship of Beverley (awarded earlier to his father) as a tribute to his services to the arts. His speech was remembered for its wit and lack of pomposity.

Fred Elwell died on 3rd January 1958, only three weeks after being at his easel. His re-working of *A Cowshed* (177, 449), from his original output of 1922, was never finished.

There is an image of Fred's spare and sprightly figure, the habitual silk kerchief and black trilby, the meerschaum pipe, and particularly the genial and unaffected qualities of the man, that the people of Beverley fondly retain.

He devoted his life to the service of Art. He embraced the life of an era in his art. He mastered the art of living. Assuredly, a Life in Art.

1. Master-pupil quotes are recorded from a conversation with Walter Goodin shortly before his death.
2. Gray-Fow, M., *'Lincoln School of Art: from its beginnings to the close of the 19c'*, M.Ed. thesis, 1978; Lincoln Gazette (LG) 29.1.1887; and Lincolnshire Chronicle (LC) 22-29.3.1889. Archive material at Lincolnshire College of Art & Design, Lincoln.
3. Criticism by J.C. Horsley, R.A., reported in LC 29.3.1889.
4. Logsdail's early work comprised architectural and figure paintings. After Antwerp he lived in Venice. A collection of his works is at the Usher Gallery, Lincoln.
5. Vid. Paris Sketchbook (22)
6. *At the Moulin Rouge*, 1892, The Art Institute, Chicago.
7. 4.10.1893.
8. Painter, illustrator and poster designer, who probably inspired the style of Elwell's unusual *Pierrot et Danseuses* (23).
9. Visiting Bar House in 1919 resulted in his painting of the Elwells taking tea in the garden. Later Richard Jack, R.A. supported Elwell's election as Royal Academician.
10. Who produced impressionist Academy-pieces, and during the inter-war period found new subject-matter with itinerant actors, musicians and circus folk. A Royal Academician in 1936, she made a portrait drawing of Elwell.
11. *Beverley Guardian*, 1.8.1931.
12. From Masham, a painter of Yorkshire landscapes. Personal friendship messages from Brundrits to Elwells were fired onto china plates.
13. From Dedham, he was to be elected President of the Royal Academy, and knighted, in 1944. He painted the English scene, particularly gypsies and horses. Elwell went on a painting expedition with him in Suffolk for his paintings of pigs. Munnings stayed at Bar House during Beverley Races. He sent Elwell a book of his poetry lavishly illustrated with pen and ink sketches.
14. From Cornwall, a painter closely associated with landscapes of Lamorna. Elwell often stayed with him and they exchanged personally painted watercolours as tokens of friendship.
15. This view of their work was presented in 'The Edwardians and After. The Royal Academy 1900-1950', an exhibition held at the Royal Academy, after touring in the U.S.A., 1988-89.
16. Recalled by Jack Skinner, Beverley and District Art Club.
17. *Yorkshire Post & Leeds Mercury*, 4.1.1958.
18. ibid., 4.6.1956

Fig. 9. Elwell was often described as 'dapper'.

A Collection of Still Life

There is no more precise art than the traditional still life. The artist seeks to reproduce accurately on canvas the objects, whether flowers, pottery or fish, which have been assembled. Elwell found the technical challenge presented by still life much to his liking. He was an able draughtsman who also enjoyed recreating textures and the play of light. He methodically built up layers of paint to achieve the results, with an attention to detail that demanded exactitude and skill.

His training at Lincoln School of Art prepared him well in the skills of still-life painting, and he began to see himself primarily as an artist in this field. It is significant that his first signed and dated work was *Still Life with Fish* (1), with which he also won a national prize.

These remarkable abilities, gained as a still-life artist, permeated much of his work.

In his mid-career, when enthralled by painting interiors, he worked groups of still lifes into his pictures. In *A Curiosity Shop* (283), *The Fish Stall* (318) and *Girl Polishing Pans* (349), the still life was not the subject itself, but provided the convincing detail, whether they were goods for sale or the objects of the workplace.

Towards the end of his life, he returned to the still life as an independent subject. He found particular inspiration in flower-painting, and *Basket of Roses* (442) shows his ability quite undiminished, if not renewed, by age.

1. STILL LIFE WITH FISH 1 (or STILL LIFE, CODFISH, or CODFISH & HERRINGS)

Oil on canvas	63 x 76.25 cms	Dated 1897
Signed	Beverley Borough Council	

This is probably the most significant work in Elwell's early development as a painter. Not only is it his first recorded signed and dated painting, but it also gained for him the Queen's Bronze Medal in the National Art Schools Competition in 1887. The work was commended in the *Lincoln Gazette* at the time for its 'remarkable fidelity'[1].

The painting was produced whilst Elwell was studying at the Lincoln School of Art (now the Lincolnshire College of Art and Design). It illustrates the attention to good draughtsmanship and accuracy of representation which were fostered at the School. Still life as a subject featured strongly in the curriculum. Elwell, when subsequently recalling his period of study there between 1887 and 1889, commented wryly that the place 'fairly stank of dead cod'[2].

Success with this painting must have influenced Elwell strongly in his future penchant for still life, elements of which he incorporated into many of his subsequent interiors, including the Beverley Arms kitchen series [3]. Towards the end of his career, at the age of 83, he commented, 'It is sad to think that I never painted anything quite so good again.'[4]

Although the painting is dated, the date does not correspond to the period at Lincoln when it was produced. The most likely explanation[5] is that Elwell altered the date himself from the original 1887 to 1897. The appearance of the '9' in the final inscription is inconsistent with the other digits. In 1897, as an impecunious young artist in Beverley, he needed to sell work. He may have thought that an early date on this painting (and in 1887 he was only 17) could discourage a prospective buyer, by suggesting the artist's inexperience.

This still life bears the evidence of Elwell's familiarity with the French artist Jean-Baptiste Chardin (1699-1779), who took his inspiration

from the commonplace things in everyday life. Chardin's *The Rayfish*[6] is a plausible influence on this work, emphasising as it does the tangible texture of the fish, and the contrast of one surface against another. This same physical realism is brought out in Elwell's still life. He offers the contrast between the rich, red and matt surface of the lobster and that of the dark bottle beside it, which reflects the light.

Chardin had also created a convincing illusion of three-dimensional objects in a clearly defined space, using an approach that Elwell absorbed in his own work. Thus the image of the codfish is viewed from the front so that it recedes into space behind. Elwell also emphasises the depth of the shelf to assist our belief that the objects upon it are real: to clarify its front edge, he makes the mussels project over it, while the smoked herrings on the wall define its limits.

1. *[Lincoln] Gazette,* 10.3.1888.
2. *The [Hull] Daily Mail,* 15.10.1954
3. Vid. 50, 150, 172, 254, 350, 375, 401 and 402.
4. *Yorkshire Post and Leeds Mercury,* 4.1.1958.
5. Supported by another Beverley artist who was acquainted with Elwell, Stephen Blyth.
6. 1727-8, Louvre, Paris.

1. Still Life with Fish 1

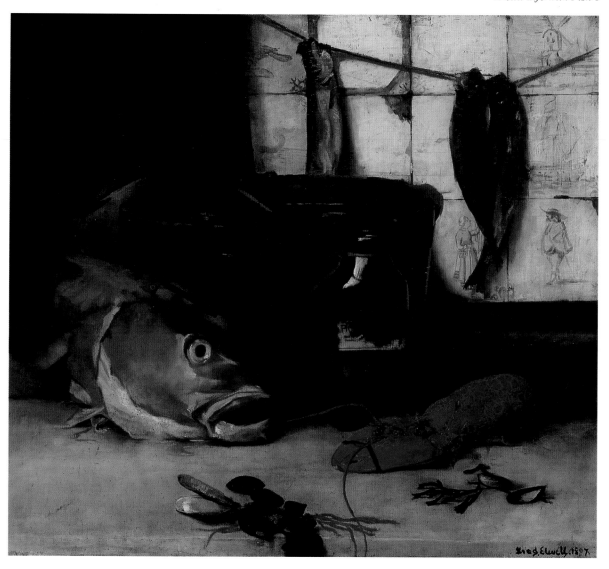

11

26. STILL LIFE, MUSHROOMS

Oil on canvas 63.50 x 76.25 cms Dated 1895
Signed Beverley Borough Council

This work pursues Elwell's preoccupation with the still life genre, begun in *Still Life with Fish 1* (1), rather than reflecting his then current training in Paris, with its emphasis upon the figure.

Netherlandish still life of the 17th century, and of later artists like Chardin in 18th-century France, had helped to shape British conceptions of this genre. In the 19th century Degas bemoaned the fact that British art students in Paris, who learnt to paint the nude, returned to their own country able to paint 'neither fish nor fowl nor good red herring'[1]. Elwell certainly countered that remark with his expertise.

Here his arrangement of objects is triangular. The partridges project outwards, to define the space behind. He selects a variety of surface textures — of feathers, copper and mushrooms — in order to emphasise their differences. Elwell achieves, from simple domestic objects, both an exercise in technical skill and a pleasing integrity and directness. By ranging objects of complementary colours, orange against blue, and yellow against green, he strengthens the effect of each. The paint is tightly handled, with great confidence, to shape with equal effect the soft round mushrooms, the veined leaves of the cabbage and the hard, shiny surface of the pan.

1. At the Exposition Universelle, 1889. Exhibition catalogue 'Post Impressionism', Royal Academy of Arts, 1979-80, p.180.

41. STILL LIFE WITH BRACE OF PHEASANTS

Oil on canvas 91.50 x 122 cms Dated 1899
Signed Private collection

The appeal of this painting is the illusion of reality which it creates. It persuades the viewer to substitute the idea of the painted canvas with the vision of the brace of pheasants. The feathers interlock and show subtle gradations of colour in a manner that is very naturalistic. The birds are life-size, and appear plausibly distanced from the wall, as if suspended on a nail.

The popularity of the shoot amongst Victorians made game a very desirable subject matter. Elwell had already produced another still life of game, *Partridges* (32), two years earlier. It is thought that he painted the pheasants as they were hanging in an outhouse at King's Mill, Driffield — he was a close friend of the Boyes family who lived there. As Elwell needed to work on the painting for some time, the original brace was replaced successively by two more, to prevent his models from becoming too high!

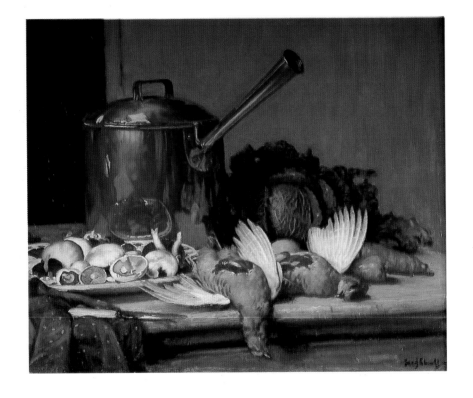

26. Still Life, Mushrooms

398. STILL LIFE: A COLD HAM AND THINGS (or A SIDEBOARD I REMEMBER, or STILL LIFE OF A HAM, STILTON, CELERY, PIE, BOTTLE AND PLATES)

114.25 x 127 cms Dated 1945
Signed Location unknown

In his seventies Elwell returned once more to the still life of his youth. This painting featured an elegant sideboard display with a joint of ham, a whole Stilton and salmon, arranged as for a buffet party.

It was recalled when the artist was in discussion with Hull solicitor, Cyril Huddleston. The sight of the good food, not for immediate consumption, was a great temptation. Elwell had to work on the painting quickly, 'to finish the damn thing and get down to eating that Stilton !'

In 1945, at the Royal Academy Summer Exhibition, Elwell exhibited both this and *Still Life: Frugal Fare* (399) — a painting of bread, boiled eggs and cheese, in a much more homely setting. The humour of the contrast was very much in evidence.

Sir Gerald Kelly, President of the Royal Academy 1949-54, was later to describe Elwell as a 'representational painter'. He added:-

'There was one thing he painted — one of those masterpieces. During the War, it was when . . . food was very difficult to get, and he sent to the Academy one of the most magnificent hams. I don't mean a real ham, I mean a painting. When I said he was a representational painter it was that ham I had in mind[1].

1. *The [Hull] Daily Mail*, 3.1.1958.

423. HARVEST FESTIVAL GIFTS

Oil on panel 71 x 91.50 cms
Signed Beverley Borough Council

Whether this work should be classified as a still life is debatable. There is a strong figurative element, yet the real focus is surely not upon the children, but upon their display of gifts, which are more richly and colourfully treated in the foreground.

An eye-witness[1] observed the painstaking care with which Elwell arranged these objects. She saw the jar of celery being moved incessantly from place to place. Then, when the painting was in progress, Elwell was seen to create the form of the orange by following a continuous curve with his brush, while sweeping into the paint the changes of tone he required.

For the children, Elwell worked from a photograph to capture their combined images.

1. Mrs. H. Jenkinson, Bridlington Art Club.

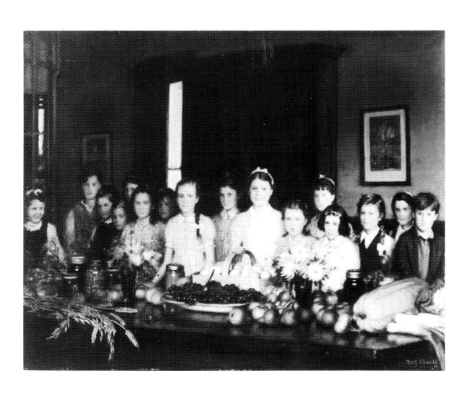

423. Harvest Festival Gifts

434. A BOWL OF ROSES

Oil on canvas 51 x 61 cms
Signed The Arts Club, London

One of many flower-pieces, this painting of Mary Elwell's favourite full-blown roses has strong qualities of realism and luminous colour. The blooms glow against a dark background and reflect in the dark-wood table beneath.

On restoring this painting for The Arts Club, of which Elwell was a member, Juliet Stirratt discovered the signature of M.D. Holmes present as well as Fred Elwell's. It was quite common for artists to re-use canvases for economy, and it is likely that Elwell had re-used one of his wife's[1].

Flower-pieces, so special to Elwell whose beloved garden was so close at hand, were to become increasingly important to him in his later years.

1. The Arts Club Newsletter, Spring 1988, p.7.

442. BASKET OF ROSES

Oil on canvas/panel 71 x 91.50 cms Dated 1955
Signed Private collection

Painted by Elwell at the age of 85, and showing no decline in ability whatsoever, this is arguably his most masterful achievement in still life.

The painting belongs to the same genus as *Still Life with Fish 1* (1). A marble shelf holds a collection of objects, but where, in the earlier painting, shellfish had projected over the edge, here gloves perform the same role. By their presence we can measure the degree of recess into which the jugs and flowers are placed.

A garden trug is massed with freely-placed roses. Jugs for displaying them catch the light, and their solid elliptical forms, with circular patterns, are set in harmonious relationship.

It is palpably real. It is also vitalized by contrasts, the roses side by side with stone and pottery. Their opacity is opposed to lustre, and their softly textured curls are set against resilience. Even the waywardness of nature is contrasted with a more geometrical order.

The painting, in the continuous ownership of one family, was originally purchased, with the paint still wet, from the artist's easel.

443. STILL LIFE WITH FISH 2

 71 x 91.50 cms
Signed Location unknown

This still life, produced near the end of his career, closely follows, in subject and style, Elwell's first recorded work, *Still Life with Fish* (1), with which he won the Queen's Bronze Medal whilst a student at Lincoln School of Art. Elwell had a particular affection for his early treatment of this subject, and here, over 60 years later, he assembles a similar collection of shellfish, herrings and a lobster, to rework a favourite theme.

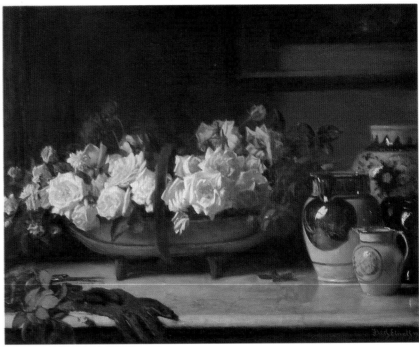

442. Basket of Roses

Portraits: Public and Personal

The theme of portraiture in Elwell's work crosses many boundaries. Paintings which might have been included in this section appear under other headings. Yet there is a significant area of his work where the focus is upon the figure itself, and this has been the criterion for the grouping that follows.

From the beginning Elwell showed a flair for portraiture and when he returned to Beverley after training, it was with works like *Mrs. J. Downs* (86) that he established himself as an artist. Although many were painted in oil, he made a name for himself (from 1890 to 1908) in the field of pastel, a medium that was unusual at that time. He was able to catch a deft likeness and convey a lively impression of the individual's personality, while evoking with equal measure his or her familiar surroundings. In the course of a prolific career as a portrait painter, it is worth noting his own stated preference for both *Col. J. B. Stracey-Clitherow* (288) and *Mrs. Stephen Ellis Todd at 94* (302).

Private portraiture was the field in which he could portray expression of feelings, or allow his sense of humour freedom to roam. He painted Florence Elwell (33) when she was about 12 years old, as she pouted, showing her reluctance to sit. *A Man with a Pint* (303) described the timeworn face of the man at his local.

Another theme to which Elwell often returned was self-portraiture. Always interesting as an indication of how an artist perceives himself, Elwell's self-portraits culminated in that of 1933 (313) which revealed him as a man of vigour, elegantly posed but allowing the energy of his movements to pull at his suit fabric.

The subject of the nude, often painted in the course of his training, was, however, neglected in Beverley. He was influenced by French modernism in Paris when he produced *Léonie's Toilet* (21), in which the sitter was observed powdering her face at the mirror. Only after a period of 40 years had elapsed, and then probably in London, did *Seated Nude in Studio* (325) emerge.

From the *Portrait of George Monkman, Mace Bearer of Beverley* (5) in 1890 to the *Posthumous Portrait of His Majesty King George VI Col.-in-Chief, The East Yorkshire Regiment 1922-1952* (430) in 1953, Elwell was producing public portraiture at an even pace. There was a demand for works that commemorated achievements, benefaction and terms of office. Many have since achieved iconic standing, like that of Monkman who 'haunts' the Mayor's Parlour in Beverley. The toast to 'The University and its Founder' at the University of Hull is traditionally addressed to that of the Rt. Hon. Thomas Ferens (287). When the portrait of His Majesty King George V (296) was commissioned for the Throne Room at Holyroodhouse, it was regarded as both an image and a symbol of the reigning monarch's presence in the Edinburgh palace. In his public portraiture, Elwell carefully linked the sitter with the symbols that denoted their status: mayoral robes, military medals or the leather-bound books of academe.

In the early years, the sitter, like Monkman, faced directly forward, a symmetric form emerging from a dark and featureless background. Attention was forced upon the features. By 1928, however, the figure of Henry Micks (247) was adopting a more relaxed pose, which emphasised to the viewer that he inhabited a 'real world' outside that of the portrait.

2. CLASSICAL STUDY

Pencil drawing 63.5 x 39 cms
Signed Beverley Borough Council

This drawing of a plaster cast of the Spearbearer[1] was produced by Elwell as a study whilst at the Lincoln School of Art. This and other studies, including 'a beautiful bust of St. Catherine, which Mr. Webster [the Principal] brought back from the Paris salon', and 'an antique head or detail', earned the young student a commendation as one of the six 'successes' of the school at the prize-giving ceremony of 1888.[2]

The practice of drawing classical statues, begun in Italy with statues excavated during the Renaissance, was one that continued in art schools throughout Europe. It was a preliminary to life drawing. At Lincoln, as at other schools, plaster casts were used as substitutes for the statues themselves.

Elwell has shown the figure standing on a plinth bearing the initials E.S.K. The significance of these letters remains a mystery. A small oval photograph of the young Fred has been inset beneath the inner frame.

1. Later Roman copy of the Greek statue of the Spearbearer or Doryphorus by Polyclitus.
2. *Lincoln Gazette*, 10.3.1888.

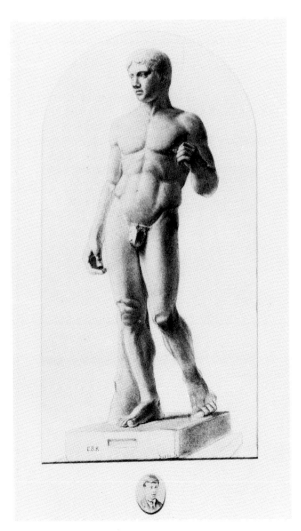

2. Classical Study

5. PORTRAIT OF GEORGE MONKMAN, MACE BEARER OF BEVERLEY

Pastel 96.5 x 68.5 cms Dated 1890
Signed Beverley Borough Council

It is remarkable that Fred Elwell, when aged only 20, should choose to draw the portrait of one so old. He was fascinated by George Monkman's features. He conveys the man's pursed lips, ashen complexion and faraway expression. The frailty of physique is bolstered by the presence of the heavy and ornate Mace which he clutches closely to his body, as if the duties of Mace Bearer (over 30 years) are as one with himself.

George Monkman[1] was 84 at the time, but Elwell played upon the aspect of the subject's age, speaking of him being about 90. 'I had,' he told a journalist later, 'to keep him alive with brandy until the sittings were finished.'[2] It was in fact three or four weeks later that Monkman suffered 'a kind of fit' and died.[3]

His long-serving role as Mace Bearer had been to carry the Mace before the Mayor of Beverley on civic occasions. Elwell would have known the duties of such civic-office holders through his father. Monkman was described as one who was 'in every way fitted for the functions he had to discharge, being of a grave countenance, somewhat reserved in manner, and rather above the average height'.[4] The Mace had recently been restored and regilded. The cost of £20 was twice its Bearer's salary, though he did receive annually a new hat and boots, in addition.[5]

Although presumably on vacation in Beverley when Monkman sat for him, Elwell was at that time a student at Antwerp. It was there that he learnt the newly revived technique of drawing in

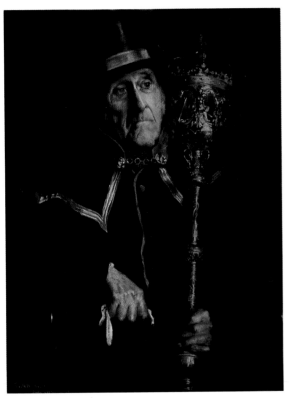

5. Portrait of George Monkman, Mace Bearer of Beverley.

pastel. Bearing in mind that this portrait was his first major pastel work, the skill with which he handled this medium was remarkable. The intensity of the light that defines the Mace emerges from the layers of pastel — yellows, whites and greys — which Elwell has applied with consummate ease.

It was bought at the time by the Treasurer of Beverley Council and became, as it is still, an icon of the Mayor's Parlour.

1. 1804-1891. Lived in Wood Lane, Beverley, and succeeded R. Arnott as Mace Bearer in 1859.
2. *The Lady*, 6.4.1961.
3. *Beverley Independent*, 28.3.1891.
4. *Beverley Recorder*, 28.3.1891.
5. Information from Monkman's great-nephew, Mr. Tinegate.

12. PORTRAIT OF CHARLES HOBSON

Oil on canvas	66 x 89 cms	Dated 1891
Signed	Rollit Farrell & Bladon, Beverley	

Even at an early stage Elwell was laying the foundations for work in public portraiture. On a visit home to Beverley (he was then a student in Antwerp) he painted the portrait of Charles Hobson, chemist and druggist. The subject had been Mayor of Beverley in 1888-89, when George Monkman was still the Mace Bearer. Elwell had painted Monkman a year before this portrait. In both, the figure looms largely and faces forward in a way that imposes its presence.

13. SELF-PORTRAIT STUDY

Watercolour on cardboard 14.5 x 12 cms
Unsigned Private Collection

The young man, clothed in a blue and rust smoking jacket over a winged collar, is probably the artist himself, as a student.

15. SMALL STUDY OF JAMES ELWELL

Watercolour on cardboard 18.50 x 25.50 cms
Unsigned Private Collection

This rare and charming watercolour combines the freshness of colour washes, that leave patches of white, with a sharp outline that emphasises the figure's profile. A sweeping curve unites his reclining body and the paper he reads.

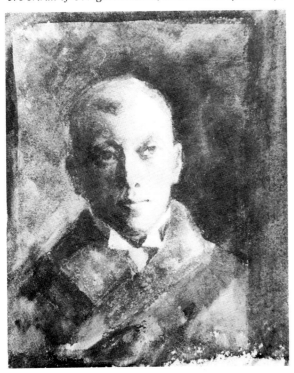

13. Self-Portrait Study

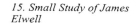

Elwell portrays his father with great sensitivity, in the profile pose that begs comparision with Whistler's (1834-1903) *Portrait of the Artist's Mother*[1], 1871.

1. The Louvre, Paris.

21. LÉONIE'S TOILET (or THE TOILET or DOLLS)

| Oil on canvas | 99 x 72.25 cms | Dated 1894 |
| Signed | Beverley Borough Council | |

This painting has an interesting history. In the early 1890s Elwell lived for a time in Paris, studying at the Académie Julian. It was a time when Paris was the inspiration for artists such as Toulouse Lautrec, Degas, and Seurat, and it is perhaps not unduly imaginative to speculate that the young student Elwell may have rubbed shoulders with them. He was then an impoverished young artist, seeking to make his mark, and submitting work to the Salon exhibitions in Paris. This was the first of his paintings to be accepted for exhibition by the Royal Academy in London in 1895. According to a note in his Paris Sketchbook (22), Elwell paid his model £5, being equivalent to the sum which

he spent on his food. It is thought that he later gave the painting to his Paris landlord in satisfaction of his rent.

Nothing is known of the painting's subsequent history until it was found by a fellow Royal Academician, James Bateman, some 50 years later at an odd-lot shop in King's Road, Chelsea. Bateman bought the painting and returned it to Elwell who was delighted to become re-acquainted with this early work, and said that it rang 'a whole peal of bells'[1] in his memory of his Paris student days. He refused offers to buy the painting from him again, and exhibited it for a second time at the Royal Academy in 1950. It surprised those who were familiar with his later Beverley productions. *The [Hull] Daily Mail* reported that 'Academicians are talking with unusual enthusiasm about one picture'[1]. Elwell ultimately bequeathed the painting to Beverley.

Léonie's Toilet is a good example of the effect of his training in Paris. He depicts the nude, taken from a life model, employing subtle gradations of tone for her flesh. The painting relies more on tonal values than colour. The whites range from pearly flesh tints to the much sharper white of the drapery.

The painting is also evidence of Elwell's awareness of the French contemporary art scene. A poster draped over the washstand refers to the novel by Alain René Lesage, *Gil Blas*. Japanese dolls, on the wall, are probably included in the painting because of an interest at the time in Japanese art and artefacts. This would explain why *'Dolls'* was the original title of this work, under which it was exhibited at the Royal Academy in 1895[2].

The choice of subject recalls Seurat's painting, *Young Woman Powdering Herself*[3]: to represent a woman at her toilet was not unusual. Degas

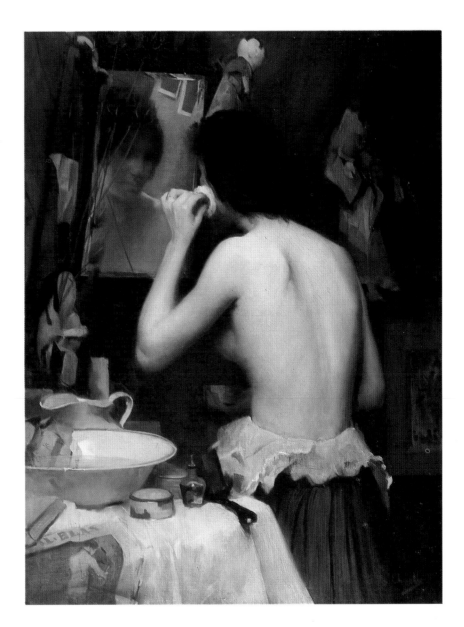

21. Léonie's Toilet

painted her in *The Tub*[4], in the natural pose of one absorbed in the task of washing. Elwell's Léonie is similarly self-absorbed as she powders her face. Alone within her own ambience, she is unaware of being observed.

In the Sketchbook which he used in Paris, Elwell drew the same model in other self-absorbed poses, like arranging the knot of her hair. Preliminary versions of *Léonie's Toilet* sketched there make it obvious that the central features of this painting are the nude figure, the reflected image in the mirror, and the dolls hanging on the wall. There are also echoes of form between these three elements, such as the parallel lines of Léonie's forearm, the mirror edge and the doll below it. These suggest Elwell was interested in more abstract formal principles than we usually attribute to him.

1. *The [Hull] Daily Mail.* 24.4.1950.
2. Elwell describes in detail the work, *Dolls*, in an interview for the *Beverley Guardian*, 12.4.1941, which removes any doubt that it is *Léonie's Toilet* of which he speaks. The second name would have surfaced when the painting did, after its long disappearance. The writer has maintained this usage because it is by now a very familiar one.
3. c.1888-90. Courtauld Institute Galleries, London. The painting was exhibited in 1892 (when Elwell arrived in Paris) at the Société des Artistes Indépendants, Paris.
4. 1886, Musée d'Orsay, Paris.

28. FEMALE NUDE

Oil on canvas 96.5 x 66 cms Dated 1896
Signed Private collection

Seated on a high stool, the woman wears the fixed expression of a long pose. She is the artist's model, and is depicted thus. At the Académie Julian, students were expected to represent the nude from life.

Elwell has followed a traditional method of gradations of tone for modelling the form, yet this is merged with a more innovatory approach.

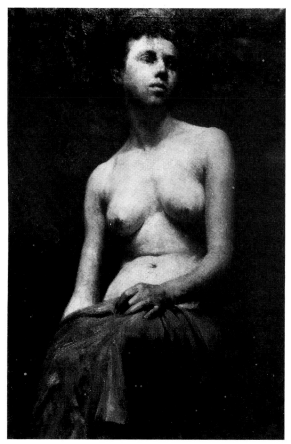

28. Female Nude

significance. The fall of her auburn hair over the cheek suggests the unposed naturalistic appearance of youth. The out-of-doors light that gently highlights the forehead is, like the expression, a transient feature which has to be rapidly transposed onto canvas. This is suggested in the hatched green strokes and the curls of shadow that represent her dress.

When Elwell returned home to Park Villa, York Road, Beverley, after living in Paris and London, he shared the same roof as Florence Elwell, his niece. The daughter of Samuel (Fred's brother) and Mary, who had both died when she was only nine years old, she was brought up from circa 1894 by Elwell's parents at Park Villa. When the artist asked her to sit for him she had planned to watch the arrival in carriages of 'grand people' at the nearby Beverley Racecourse[2]. The pout on her face was the result. He asked her just to wash her face, presumably not wishing to detract from her naturalism. The sitting lasted one hour.

1. Information regarding Florence Elwell is from her son and daughter, Abner Elwell Blyth, O.B.E., C.E., F.I.C.E., and Nora Blyth. She also modelled for *The Dressmaker* (101) and a portrait yet untraced. In the family photograph (Fig.1) in c.1910, she is holding the baby.
2. Memories of her childhood were to include those of jockeys and stable-boys standing up in their stirrups in order to reach fruit over the garden wall. It seems that racing life appealed to her. Apart from the attractions of race meetings, Beverley Westwood, where the horses were exercised, was also close to the house.

Observing the effect of outdoor sunlight, he has introduced patches of shadow, tinged with green, that draw a little from Renoir's impression of *Nude in the Sunlight*[1].

1. 1876, Musée d'Orsay, Paris. Illustrated in A. Callen, *Renoir*, Oresko Books Ltd., London, 1978, p.60.

33. PORTRAIT OF FLORENCE ELWELL

Oil on canvas 40.50 x 30.50 cms
Signed Private collection

This remarkably sensitive portrait of the twelve-year-old Florence[1] captures the petulant expression of a particular moment. She was reluctant to sit for the artist, and he fixed on canvas the temporary sadness in her large blue eyes and the pout of her lips. By applying large brushstrokes in the area that surrounds the pale oval face, he allows her expression greater

34. OLD MAN WITH A PIPE

Oil on canvas 55.75 x 45.75 cms Dated 1898
Signed Beverley Borough Council

The artist often found his subjects in the characters and life of Beverley. This portrait of a gardener depicts his sturdy integrity. He looks directly at the viewer, his pipe projecting outwards, and his fist and elbow resting squarely on the lower frame.

Although Elwell's technique is his own, it is worth noting that Cézanne painted *A Man with a Pipe*[1] some years earlier, also of a gardener, in the form of an outward-looking symmetrical portrait bust. Clearly both artists approached the subject of the gardener with similar notions of how he should be portrayed.

1. 1890-92, Courtauld Institute of Art, London. Illustrated in R. Kendall, *Cézanne by Himself*, Macdonald & Co. (Publishers) Ltd, 1988, p.181.

20

34. Old man with a Pipe

35. Girl with a Kitten 1

35. GIRL WITH A KITTEN 1

Oil on canvas	59.35 x 49.25 cms
Signed	Beverley Borough Council

In her protection of the kitten, the young woman exudes a warmth of feeling. Strong hands are made gentle. The artist's straightforward portrayal is appropriate to her nature, which totally lacks pretension.

The existence of three known versions of this portrait suggests that Elwell knew it to be successful. One at least was completed at his Wood Lane studio (appearing in *Artist in his Studio*, 38), and therefore of a date between 1896 and circa 1910.

44. F. G. HOBSON

Oil on canvas	141 x 89 cms	Dated 1900
Signed	Beverley Borough Council	

One of many public portraits by Elwell, this commemorated Frederick George Hobson's mayoralty of Beverley in 1897-99.

F.G. Hobson[1] was a solicitor, with offices at that time in Newbegin, Beverley (which Elwell used as the setting for *Visit to the Lawyer's*, 117).[2]

Ten years before the mayoralty, Hobson had fought a vigorous campaign for election to Beverley Council, partly on the bitter issue of seats at St. Mary's Church. He was opposing the Archbishop of York, who perpetrated the system of exclusive seats at the east end of the nave for the privileged. Hobson's slogan, 'Prelate and Pew the Beverley Case', hit hard. So did the caricature[3] of a fat archbishop at a church door bestowing an ambiguous welcome upon thin and timid parishioners. 'Come in my friends,' says he, wielding his staff inhospitably like a stick, 'but take the back seats.'

F.G. Hobson won the election, and free seats for all.

1. Information from his great-nephew, Christopher Neville Hobson.
2. Later at 26/28 Lairgate, Beverley, premises now of Rollit Farrell & Bladon.
3. Print displayed in the Priests' Rooms, St. Mary's Church, Beverley.

45. JAMES E. ELWELL

Pastel on paper	139.75 x 91.50 cms	Dated
1901 Signed	Beverley Borough Council	

The public portrait of James Elwell

commemorates his mayoralty of Beverley in 1900-1901, following that of F.G. Hobson, whose portrait the artist also painted (44). There emerges a pattern of portrait commissions for civic dignitaries that began with the *Portrait of George Monkman, Macebearer of Beverley* (5).

Like the latter, this is produced in pastel and, as the medium was difficult to fix, the mayoral robe has since faded to pink. The textures of velvet and of fur are most convincing.

It is a sensitive portrait by his son, revealing James as the gentle and benevolent paterfamilias, with hooded eyes and soft white hair and beard.

He was involved in many civic duties in Beverley, and was, for instance, to serve on the Public Library Committee for 17 years.

When Anthony Trollope, the novelist, tried to realise his ambition to become an M.P., and chose the Beverley constituency, it was James who was Chairman of his election committee. Trollope, however, refused to take his advice to 'go dead against the Game Laws'.[1] James knew that half the voters were poachers, so an election could never be won by supporting the Game Laws. It was the last time that Trollope would electioneer.

James wove politics into his profession of woodcarving. His craftsmen at the workshop in North Bar Without carved, in oak, caricatures[2] of Disraeli and Gladstone, which still decorate the house at No. 8.

1. *The Sketch*, 4.10.1893.
2. *ibid.*

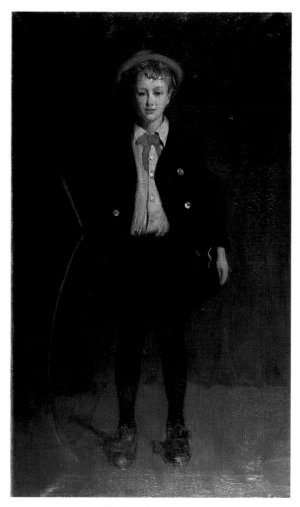

49. Boy with a Hoop

49. BOY WITH A HOOP

Oil on canvas	97.25 x 52 cms
Unsigned	Private collection

Bernard Elwell, the artist's nephew[1], cuts an engaging figure in his fine black buckled shoes, breeches, large jacket and red halo of a hat. He carries the hoop and stick at his side, and the piece of string trailing from his pocket that typify his image as a small boy at play. He was probably painted in around 1900.

With his strikingly simple and symmetrical form and bold contrasts of colour, shadow definition and flecks of highlight, he is a memorable little chap.

1. Fig. 1, back row, on the right. Bernard was son of John and Edith Elwell, of 8 York Road, Beverley, close to Park Villa where the artist lived at the time. Bernard was to become factor to the Countess of Dysart of Stabo Castle, Peebles.

54. MARY DAWSON HOLMES

Oil on canvas	134.50 x 83.75 cms	Dated 1904
Signed	Beverley Borough Council	

A portrait of Mary, the artist's future wife, depicts her looking grave in her tight waisted costume and lace cravat, in the frontal and three-quarter standing pose that befits the formality of the occasion. Elwell is influenced by the Victorian association of females with nature in painting her with a basket of flowers in her hand.

Mary was born Mary Dawson Bishop in 1874, daughter of a shipping merchant in Liverpool. When this portrait was produced, she was already married to George Alfred Holmes, a Hull oil broker. Fred visited them at Bar House, their home. Before Holmes died in 1913 he revealed

that Fred would be his choice as Mary's second husband.

Like Fred, she was a very talented painter (signing her work M.D. Holmes). The main body of her work, including 58 exhibits at the Royal Academy, was yet to emerge.

56. LADY WITH A BLACK CAP

Oil on canvas 45.50 x 35 cms
Unsigned Private collection

Elwell was drawn to paint the elderly figure when he produced his *Portrait of George Monkman, Macebearer of Beverley* (5). In this portrait of Mrs. Simpson, her face is illuminated against the deep shadow of the background, and reveals her shrewd and half-smiling expression, her pointed features and well-etched furrows.

Mrs. Simpson[1] was married to the lock-keeper of Lock House[2], Leven Canal. She was 6 feet tall and customarily wore a black cape and black bonnet decorated with jet, considered then as oddly old-fashioned.

With typical generosity, the artist gave the painting to a friend who knew Mrs. Simpson. His approach to art was often of a personal kind.

1. Information from Miss Mildred Wray.
2. Vid. *Leven Canal* (55).

82. JOHN E. CHAMPNEY

Oil on canvas 118 x 96.50 cms Dated 1906
Signed Beverley Borough Council

Elwell was often commissioned to portray public figures. He instilled this task with a spirit of rectitude, and emphasised the social function of the sitter.

John Champney is portrayed as a man of substance, with walrus moustache and a gold watch-chain across his chest. The portrait commemorates his position as benefactor, and includes the plans for Beverley's library, with which he is associated.

Champney[1] was born in Newbegin, Beverley. He established himself as a prosperous businessman in Halifax. As he was childless, he wanted to give his money to the town of his birth. By chance, while travelling in Switzerland, he met James Elwell, then an alderman. James steered Champney's thoughts towards providing Beverley with a library.

In 1906 Champney formally opened the library building (where the painting was expected to hang) with a gold key, presented by James as a memento of his generosity. It was a period favoured with benefaction of this kind. The needs of the working classes were being recognised in a new tide of social conscience. Men like Champney were offering the means of making knowledge available to all.

1. Information from *Beverley Target,* 29.3.1990.

86. MRS J. DOWNS

Pastel on felt (?) 100.25 x 72.50 cms
Signed Beverley Borough Council

One of Elwell's finest pastels is this portrayal of Ethel Downs, both for its technique, particularly in the texture of the skin and lace, and in conveying her sensitivity. She appears reflective. A book droops from her fingers as the thoughts take over from the reading.

86. Mrs. J. Downs

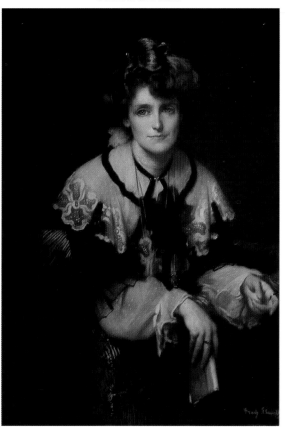

The portrait is very evocative of the Edwardian period, with its ideal of refined beauty, the hairstyle with fullness on the crown, and the eyes enhanced by shadow.

Ethel Downs was a lover of theatre and literature, and with her husband, James[1], a Hull businessman, was well-known locally. The portrait was to hang in the Vice-Chancellor's room at the University of Cambridge, when her son, Brian, was appointed to that office.

1. Vid. *Four Friends* (153).

87. PORTRAIT OF A YOUNG GIRL

Pastel on canvas 61 x 50.75 cms
Signed Private collection

The young girl looks outwards from beneath her soberly black hat, with all the gravitas of Raphael's *Baldassare Castiglione*[1]. The hat balances the wide base in the composition made by the chair.

The appeal of this portrait is enhanced by a series of contrasts: her adult solemnity and pose, set against the little-girl hands, curls and the blue

ribbon that escapes under her hat. The solid black chair is placed near the white transparency of her dress, which the artist has treated with deft strokes of the brush.

1. c.1515. Louvre, Paris.

90. PORTRAIT OF ANNIE ELWELL

Oil on canvas 59 x 49 cms
Unsigned Private collection

Charmingly sympathetic portraits of the artist's mother and father (91) were presumably produced together. They share the same format of the portrait bust, and the features are clearly lit against a dark, neutral background.

In this portrait of Annie, the light tone of the lace cravat emphasises the quiet, resourceful features of her face. Under her chin, the lace is held by a large brooch in the form of a rosette upon silver.

Before marrying James Elwell in 1860 Annie Hay is believed to have lived in Hull, but she was of Scottish descent, from Aberdeen. Her father was a Greenland whaler.

87. Portrait of a Young Girl

91. PORTRAIT OF JAMES E. ELWELL

Oil on canvas 59 x 49 cms
Unsigned Private collection

One of a pair, with that of Annie (90), this portrait features the artist's father. It conveys the 'blue eager eyes'[1] of the creative man, which are now hooded and moist. He wears his own style of necktie through a ring — a ring which Fred was later inclined to wear too.

James, whose workshop is the subject of *A Woodcarver's Shop* (155), produced a high standard of ecclesiastical carving. In his eccentric way, he once persuaded the Archbishop of York to kneel with him on the flagstones of Beverley station. He drew in chalk his design for a pulpit there and then, and they remained on their knees cheerfully discussing it until the train arrived[2].

This particular portrait appears in the painting, *Tea Time* (122) in which it is shown hanging in the dining-room at Bar House, after Fred and Mary were married.

1. *The Sketch*, 4.10.1893.
2. Idem

119. ALDERMAN THOMAS SHEMELDS TAYLOR, J.P.

Oil on canvas 203.25x152.50 cms Dated 1913
Signed The Guildhall Collection, Hull

Alderman Taylor[1] (1848-1930) was highly respected in Hull: he had completed three years of particularly strenuous service, as Sheriff in 1910 and Mayor in 1911 and 1912, dealing with 'very thorny questions'[2] on labour with tact and good judgement, when the City commissioned Elwell to paint this full-length portrait to present to him, with full civic dignity in 1913.

Sittings took place at Elwell's studio in Trinity Lane. The imagined classical column and great doorway behind Ald. Taylor convey an air of authority and tradition. The portrait is also full of vigour, the figure surrounded by space which beckons him to advance. As he does so, the lining of the mayoral robe catches the light in a swinging movement, and the cocked hat and silver sword tilt one from the other.

Ald. Taylor had inherited Taylor's Laundry, the first steam laundry in Hull, which was able to claim the privilege 'By appointment to H.M. King Edward VII'. As Mayor, he conferred upon Mr. T.R. Ferens[3] the Freedom of the City in 1911,

119. Alderman Thomas Shemelds Taylor, J.P.

and when he did so, he could regard himself as having been a close friend for 30 years. They lived near one another, Taylor in Southcoates Lane and Ferens at Holderness House. Both were devoted Methodists, and jointly superintended no fewer than 2,000 children at the Sunday School of Brunswick Methodist Church.

It was fitting that it was Ferens who presented this portrait, in the light of their long association.

1. Information from Mrs. Crosbie, his grand-daughter.
2. Letter, 19.6.1913, from T.R. Ferens to The Rt. Worshipful The Mayor of Hull.
3. The Rt. Hon. T.R. Ferens, M.P. by 1913, and later painted by Elwell (287).

134. MRS. W. R. TODD

Oil on canvas 127 x 101.50 cms
Unsigned Beverley Borough Council

After Fred's marriage, which gave him financial freedom, he began to paint subjects of everyday realism which suited his nature and ability. Even in this portrait he incorporates elements of the subject's working day. His housekeeper, Florence Todd, is portrayed in the act of arranging flowers, and within the detailed setting of a room at Bar House.

Curiously, the painting combines the realist approach with the concept of a formal portrait. Florence appears to take scissors to clip the Siberian wallflowers. An open cupboard suggests that flower jugs have recently been removed. This is plausible as a part of her everyday life. At the same time, she faces forward solemnly, as if posing for a formal portrait; and, as with the painting of *Mary Dawson Holmes* (54), she is depicted with flowers, because she is female. Seen in this light the flowers on her arm can suggest a bouquet.

Incidental, but noteworthy, are the candle-holding wall lights behind Florence. It was around 1916, and the electricity generator to supply the house with power was soon to be introduced.

142. PORTRAIT OF A SMALL BOY

Oil on canvas 124.50 x 110.25 cms Dated 1917
Signed Private collection

This four-year-old boy is no scaled down version of an adult, but is assured of his identity as a child. His context is the toybox, out of which spill many

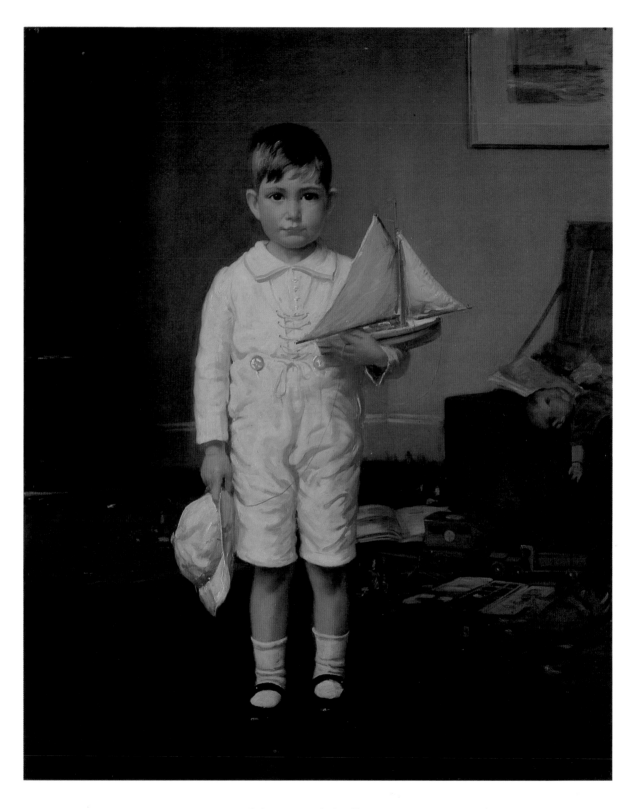

142. Portrait of a Small Boy

childhood objects. He proudly carries a sailing boat, and the damaged teddy is evidence of much play. Pristine and smart in his white suit and hat, he is an adult's image of perfection. But the small boy's mischievous nature is barely hidden in his face.

The subject of this portrait remembers the difficulty of standing still, and the urge (which he did not even resist) to pull faces. As a result, the artist took longer than expected to complete the painting, and the little white suit that had fitted at the start was beginning to get uncomfortably tight. Never again, poor Elwell swore, would he paint a child[1] ! He had intended the painting for submission to the Royal Academy, but it was not completed in time.

All this took place in a room on the first floor of Bar House, where the building arched across the pavement to adjoin North Bar. As the boy was standing on a green dais, he could see through the window Elwell's beloved view of Beverley. Apart from the boat, none of the toys were actually present, but were added later by Elwell. The period was that of the First World War, and the inclusion of a toy ambulance could be a reference to the boy's father, who was a doctor serving in the Royal Army Medical Corps, transporting the wounded.

1. From c.1898 Elwell had painted the individual child. *Motherhood* (97) exhibited in 1909 had featured a family of children, including a boy with a sailing boat in tow. Several paintings between then and this portrait in 1917 included children. After this portrait, however, ten years elapsed before the child subject very occasionally reappeared in Elwell's work.

154. PORTRAIT OF COL. RICHARD HODGSON

Oil on canvas 119.50 x 93.25 cms Dated 1919
Signed Private collection

Col. Richard Hodgson (1820-1911), of Westwood Hall, Beverley, founded the tanning business, Richard Hodgson & Sons, on Beverley Beck. At the turn of the century, when Elwell included its chimneys in the canal scene, *Beverley Beck* (40), the business was already the largest tannery in Beverley and employed 450. In founding the tannery, Hodgson established a family dynasty. Sons Richard, of Molescroft Hall, Phillip, of St. Mary's Manor, and Edward continued the business. Richard's wife,

Catherine (1862-1918) was the subject of another Elwell portrait (248).

Although a photograph[1] was necessary for the posthumous portrait of Col. Richard Hodgson, Elwell sought to capture a life-like character by using one of his sons as a model. A comparison of the photograph and painting shows Elwell's choice of a more relaxed position. Details, such as the watch-chain, were removed, presumably to give more focus to the face. The portrait succeeds in displaying more expression of personality. Elwell exaggerated the image of the book beside Hodgson, probably to invest it with the symbolism of the sitter's intellect.

1. Information from Charles Hodgson, great-grandson.

158. ALDERMAN HARRY WRAY

Oil on canvas 127 x 101.50 cms Dated 1921
Signed Beverley Borough Council

'He had an enviable diction and wit. His repartee had the sparkle without malice which often made a dialogue between him and Mr. Macdonald [Hull Stipendiary Magistrate] a delightful interlude on many a dull morning.'[1]

This was Harry Wray[2], solicitor, youngest councillor in England (when he was 24) and Mayor of Beverley eight times. When the townsmen of Beverley conferred upon him the Freedom of the town, after his long service during the First World War, they presented him with this portrait of himself in mayoral robes, by his old friend Elwell.

In 1921, the year of *The Last Purchase* (156), Elwell makes the figure appear particularly lifelike and closely detailed: this portrait follows that development. The veins of the hand, for instance, are represented with close anatomical accuracy.

1. *Beverley Guardian*, 12.12.1959.
2. Information from his daughter, Fay Thornalley.

230. SELF-PORTRAIT 1

Oil on panel 47 x 36 cms
 Private collection

In this self-portrait, where the artist is free from pressure to fulfil patrons' expectations, his style is more experimental.

The broad forehead, deeply set and hooded

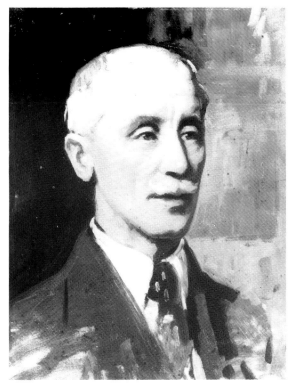

230. Self-Portrait 1

Augustus John would have expected!

The commission marked the end of Charles Gore's headship. He was, said Mrs Joan Abbott, 'a charming and cultured man, very greatly esteemed in music'. He was regarded as a born teacher who carried his own mystique — a man who was both 'distinguished and yet always happy to talk to the youngest of his boys'. Professor A. G. Dickens remembered, as a pupil, being 'happily enslaved by Gore's personality, presence and courtesy'.

During his headship the school provided a cultural space and dignity, in which boys were helped to reach their best level of attainment. He made the school popular in the city, achieved membership of the Headmasters' Conference, and introduced the best of the English public school traditions to the College.

Ten years before this portrait, Miss K. Darneley (Kate Hobson of *The Window Seat*, 298) was appointed to teach young boys at the school[3].

1. Information and quotes from F.W. Scott, A. Sutton & N.J. King, *Hymers College. The First Hundred Years*, Highgate Publications (Beverley) Ltd, 1992, p.44, 70-5; and letter F.W. Scott to the author.
2. Ref. F.W. Scott's note of information from Prof. A.G. Dickens, past pupil.
3. *Hymers College. The First Hundred Years*, op. cit., p.59.

eyes and the long lean face with receding and whitening hair and neatly curled moustache, all contribute to an appearance many described as dapper. In the painting, the features are sharply defined in strong light, against an extremely dark background. The contrast of tone is reminiscent of the work of Manet[1]. The effect of using a square brush, for the hair for instance, conveys a vigour which is unusual in Elwell portraiture.

1. e.g. *The Balcony*, Louvre, Paris.

246. PORTRAIT OF CHARLES H. GORE

Oil on board 152.50 x 122 cms Dated 1927
Signed Hymers College, Hull

Charles Gore[1] was the first headmaster of Hymers College, Hull, from 1893 to 1927. This lifelike portrait includes a very tactile sheaf of papers, a library globe, and the window of the school library where he sat. The art teacher at the school, Eileen Anderson, had urged that Augustus John should be commissioned[2] to paint him, but Elwell was chosen instead. He came to Hymers on several occasions, and for a fee less than

247. PORTRAIT OF HENRY MICKS

Oil on canvas 124.50 x 99 cms Dated 1928
Signed Hull & District Chamber of Trade

There is an arresting presence in this portrait, enhanced by the challenging gaze of the subject. Henry Micks is depicted with convincing likeness, particularly in the anatomical accuracy of the hands. The detailed depiction of the metal-framed window and the carving on the chair alludes to his existence in a real and solid world.

This setting is the boardroom of the Pacific Club, in Hull's High Street. The chair (decorated with a sheaf of corn, symbol of Hull Corn Trade Association Ltd.) is that of the Chairman of the Club. Henry Micks is portrayed comfortably at ease with his term of office.

He was a broker in the Hull grain trade[1], which was then prospering, and was centred around High Street by the River Hull. His firm, Micks Lambert & Co, was regarded as the founder of the trade in Hull, and had often provided Presidents of the Association.

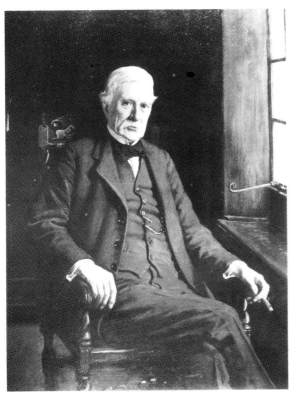

247. Portrait of Henry Micks

The Pacific Club came to be regarded as the East Coast base for corn trading, with the Atlantic Club in Liverpool as its counterpart on the West. It had a vast trading floor, with Ionic columns separating the aisles from a central hall. Traders wishing to do business wore hats as a sign understood by the fraternity. Prices were agreed in advance of the completion of shipment, and paid 'on the nail'. Such was this powerful trading group, with important codes of honour and symbols of prestige, of which Henry Micks was the representative.

1. Information from Ron Lang, Secretary of the Hull Chamber of Trade.

248. MRS. R. HODGSON

Oil on canvas 127 x 101.50 cms
Signed Beverley Borough Council

Catherine Maud Hodgson (1862-1918) is portrayed in the relaxed, yet authoritative pose familiar from the *Portrait of Henry Micks* (247). It is assumed that the setting is that of Molescroft Hall, Beverley, of which she was mistress.

Her husband, Richard Hodgson (1852-1929), continued the running of the tannery, founded by his father, Richard Hodgson & Sons[1]. It was he who commissioned the portrait, at a date between 1918 and 1928.

1. Vid. *Portrait of Col. Richard Hodgson* (154). Later, in 1920 the firm was bought by the Barrow Hepburn & Gale Group.

279. SELF-PORTRAIT 2

Oil on canvas 76.25 x 63.50 cms
Signed Private collection

In this second self-portrait, the edges are blurred and the colours softened. The artist's earlier urbane image (230) is replaced by that of the tweeded countryman. Bespectacled now, and the moustache lacking its once flamboyant curl, this is a man seriously at work, painting.

Originally he portrayed himself as bare-headed; the line of the head is still visible in the painting, as *pentimento*, despite the later addition of a hat. Mrs Morley[1], the proprietor of the Beverley Arms and a friend of the Elwells, criticised the painting for revealing the artist's bald head, so Elwell painted in the hat.

1. John Markham, *The Beverley Arms. The Story of a Hotel*, Highgate Publications (Beverley) Ltd 1986, p.17-18.

287. THE RIGHT HON. THOMAS ROBINSON FERENS, P.C., LL.D. 1

Oil on canvas c127 x 101.50 cms Dated 1930
Signed The University of Hull

Thomas Robinson Ferens (1847-1930) founded the University College[1] of Hull (later the University of Hull) and was its first President. In the year of his death in 1930, to commemorate his distinguished career, Elwell presented this portrait to the University. Ferens is shown wearing academic dress of blue and gold against a background set with the emblem, 'Lampada Ferens'.

The painting was hung in the original refectory, where it was traditionally addressed in the toast, 'The University and its Founder'. It now adorns the Jubilee Room, together with portraits of other men significant to the University's history, including A. E. Morgan (328) and James Downs (339).

1. Established through his endowment of £250,000 in 1925, it was incorporated on 7.10.1927, and the foundation stone of the buildings was laid by H.R.H. the Duke of York (later H.M. King George VI) in 1928.

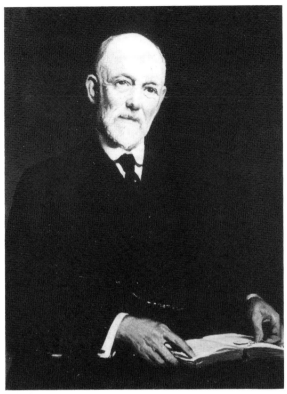

287.1. The Right Hon. Thomas Robinson Ferens, P.C., LL.D. 2

287.1 THE RIGHT HON. THOMAS ROBINSON FERENS, P.C., LL.D. 2

Oil on canvas 90 x 69.75 cms
Signed The University of Hull

Whereas the official portrait (287) portrays the public face of T. R. Ferens, this presents a more personal image.

Born at New Shildon, County Durham, he began his working life at the age of 13 with the railways in the North East of England. In 1868 he came to Hull as confidential clerk to Mr. James Reckitt. The firm of Reckitts, famous for the manufacture of 'Reckitt's Blue', was later to become Reckitt & Colman plc. Reckitt's Colours International are now a major world manufacturer of pigments.

Contemporary accounts describe Ferens' progress through the firm of Reckitts as rapid, owing to his energy, thoroughness and interest in new developments. During his lifetime Ferens accumulated considerable wealth, but owing to his Methodist upbringing he believed that this should be used, not for his own enjoyment, but for the benefit of others. His strong sense of pride in Hull and its people is reflected in gifts which totalled over £1m, a considerable amount even in today's terms[1].

In addition to the University College, amongst his many other benefactions, he financed for Hull the building in 1927 of the Ferens Art Gallery, and provided a substantial endowment that still forms the core of the Gallery's funds for the purchase of works of art. He had a strong belief in the morally and spiritually uplifting qualities of art, and had already advised the City on the purchase of paintings for its collection. It was in 1913, probably with Ferens' approval, that Hull's Picture Selection Sub-Committee purchased Elwell's sentimental picture *The First Born* (110).

In 1911 Ferens was granted the Freedom of the City and County of Kingston upon Hull. He was the Member of Parliament for East Hull for 13 years.

1. Ann Bukantas, 'Awaiting the Dawn of a Bright New Era for the Ferens', *Select Magazine*, June/July 1989 p.12.

288. COL. J.B. STRACEY-CLITHEROW

Oil on canvas 127 x 101.50 cms Dated 1930
Signed Private collection

Elwell rarely commented on his own work, but he was definitely pleased with this portrait of Col. Stracey-Clitherow. He described this, and that of *Mrs. Stephen Ellis Todd at 94* (302), as the best portraits he ever painted[1].

The subject's powerful personality is suggested in his expression, in his upright and commanding pose, and the parallel and precisely placed hands. His attentiveness is arresting. He might almost be engaged in a dialogue with the viewer.

Perhaps, too, there are elements of the composition which hold our attention; like the diagonal flow of the body, and the highlights on the chair which point this out. This would not be as effective without the horizontal line of the table and the vertical fall of the coat, both of which anchor the figure to the frame of the painting, and satisfy us, the onlookers, with a sense of order.

Col. John Bourchier Stracey-Clitherow, C.B.E., T.D., D.L., J.P. had served in the Scots Guards[2]. Amongst the objects on the table beside him is placed a silver snuff box, decorated with

the emblem of the Guards.

In the 1888 season, the young Capt. 'Jack' Stracey had participated in the revival of the London to Brighton 'Comet' coach[3]. Coaching revivalists, like himself, were restoring the coaches (used for the carriage of mail until the arrival of the railway) and driving them on the old fashionable routes[4]. They enjoyed the nostalgic pleasure of the open road and the sporting challenge of 'handling the ribbons' of four horses simultaneously. Jack also undertook the driving of the London-Devonport 'Quicksilver' Royal Mail coach[5], with four brother officers. Proud of the colourful experience of his youth, Jack continued to wear the style of long brown coachman's coat, which he wears in the portrait.

From the beginning of the century Jack took up residence at Hotham Hall, having inherited the estate. His granddaughter, Ann, Lady Brooksbank, recalls that Elwell painted the portrait there, working in the mornings and joining the family for lunch. While discussing the progress of the portrait, Jack had insisted that the hunting tie should be less voluminous than Elwell had painted it. Elwell was, she said, 'mortified' at having to alter the work already done. In such ways was Elwell the portraitist not entirely free to paint as he chose.

As a man of action, Jack found the task of sitting for the portrait irksome. On 5th August

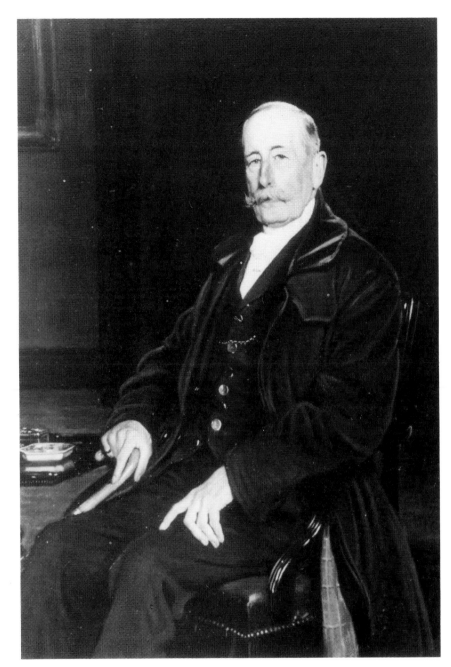

288. Col. J. B. Stracey-Clitherow

1930 he confided to his diary, 'Elwell finished my portrait today — thank goodness!'

At the Royal Academy Summer Exhibition of 1931 the portrait was hung 'on the line'. This was regarded as a privileged position, being at the eye-line height of the viewers. It was particularly commented upon by King George V, and later the

same year Elwell received a Royal commission to paint *His Majesty King George V* (296).

1. Elwell wrote the remark on the reverse of a photograph, of himself and the artist Vincent Galloway, taken with Elwell's *Self-Portrait 3* (313) of 1933. On file at Beverley Local History Library.
2. Biographical information supplied by his great-grandson, Peter Carver, J.P., D.L.
3. *Carriage Driving*, Dec/Jan 1989, article p.12 gives a full account.
4. Before the decline of coach travel, George IV's patronage of Brighton did much to ensure the popularity and fame of the coach route from London to Brighton.
5. For the history see R.C. & J.M. Anderson, *Quicksilver. A Hundred Years of Coaching 1750-1850*, David & Charles (Holdings) Ltd., Newton Abbott, 1973. The 'Quicksilver' was exhibited at the Museum of Commerce & Transport, Hull, latterly known as The Transport & Archeology Museum. Information from Steve Goodhand, Keeper of Transport, Hull City Museums and Art Galleries.

296. HIS MAJESTY KING GEORGE V

Oil on canvas	156.25 x 213.25 cms Dated 1932
Signed	Her Majesty The Queen

Surprisingly, it was not a Scottish artist, but Fred Elwell from East Yorkshire, whom the Holyrood Amenity Trust[1] invited, in 1931, to paint this

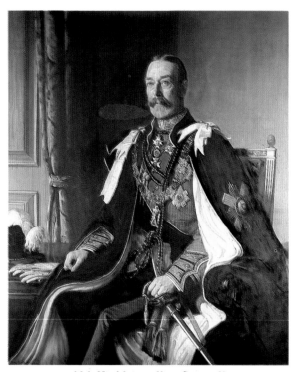

296. His Majesty King George V

portrait for the Palace of Holyroodhouse[2] in Edinburgh. The King and Queen personally chose Elwell for the commission.

The portrait was required specifically for the Throne Room, where it was to be part of the refurbishments of the State Apartments. Queen Mary was reviving an interest in Holyroodhouse at this time.

It is worth speculating upon the reason why Elwell was their Majesties' choice. He had already painted, in Scotland, *The Earl and Countess of Strathmore and Kinghorne in their Drawing Room at Glamis* (293). The fact that the Earl and Countess were the parents of the Duchess of York (now Queen Elizabeth, The Queen Mother) meant that Elwell was already established as a painter of subjects close to the Royal Family. Thus, a link between the Strathmore painting and the portrait of King George V is, at least, possible.

However, a stronger case can be made for a connection with his portrait of *Col. J.B. Stracey-Clitherow* (288), which was on display at the Royal Academy in 1931. When His Majesty King George V visited the exhibition he particularly admired the portrait, and exclaimed, 'I know that chap.' It seems that the Royal commission was granted almost immediately afterwards, for Elwell visited Holyroodhouse in June 1931. Similarities between the Stracey-Clitherow portrait and this portrait of the King suggest an influence, particularly in the pose of the figure and the diagonal movement in the composition. In the King's portrait the effect of the pose enables the gesture of the hand on the hilt of the sword to appear in the foreground. As he is seated, the mantle falls outwards, displaying the uniform and decorations which symbolize his status as Monarch.

The King's attire[3] is significant, and clearly identifiable. He wears the military uniform of Colonel-in-Chief of the Scots Guards, and the Star of the Order of the Garter. Over the uniform is the mantle of the Order of the Thistle[4], together with other items of the Order's apparel such as the Collar composed of alternate thistle heads and crossed sprigs of rue, the Pendant of St Andrew, modelled in gold and translucent enamels, and the tall hat with a plume of feathers. As the Chapel of the Most Ancient Order is St. Giles, Edinburgh, it is appropriate for the King to be dressed thus for a portrait to hang at his Edinburgh palace.

The painting was originally in a 'covered

laurel leaf gilt frame surmounted by a crown'[5], a special frame for the purpose. It was intended to hang in the Throne Room over the fireplace, where it would be flanked by large paintings at either side. The dimensions would be determined by this setting. It was the traditional site for the portrait of the reigning Monarch, and it followed therefore that the painting would be relocated[6] during subsequent reigns. It is today set in one of the smaller rooms, known as the King's Wardrobe, in the 17th-century King's Suite at Holyroodhouse.

After Elwell had viewed the Holyroodhouse site for the newly commissioned painting, he was advised by the Duke of Atholl (one of the Trustees of the Holyrood Amenity Trust) that the King would give sittings. He may have given three, in London, during which time the artist concentrated on the King's features. One account of the sittings states the the King and his portraitist both smoked like chimneys, and got on very well together. Part of the attire was lodged at Elwell's studio afterwards, so that he could continue work on the painting with the help of his nephew, Kenneth, modelling as the King.

The President of the Hull Art Circle, Mr. R. A. Brewer, recalled the existence of three paintings, including the one upon which Elwell had worked for months, and which was intended for Holyroodhouse. There was a rough preparatory study (295), now in Beverley Art Gallery, and a third painting, produced in a comparatively short time, for Elwell's own keeping. According to Mr. Brewer, the artist sought the opinion of an expert, his close friend Vincent Galloway[7], upon the three paintings. Much to Elwell's mortification, Vincent pronounced the speedier version to be the best. For some time afterwards Fred refused to speak to him !

Fred's Royal Academy friend, Alfred Munnings, who was staying with the Elwells during the Beverley Races, dared to agree with Vincent Galloway. Elwell, it seems, was thereby convinced at last, and Mr. R. A. Brewer is sure that it was this quickly executed version which King George and Queen Mary ultimately received.

It was exhibited at the Royal Academy in 1932, before finally arriving at the Palace of Holyroodhouse on 17th August of that year.

1. Set up in the 1920s to gain control of half the takings from public admissions, in order to buy furniture and furnishings for the Palace. It remained in existence up to the late 1970s, when its assets were taken over by the Lord Chamberlain's office. Now all the acquisitions are part of the Royal Collection.
2. I am indebted to Lt. Col. Donald Wilkes, Superintendent of Holyroodhouse, for information on the painting in the context of the Palace.
3. Information from the Royal Collection Inventory No. 401242, and *The Times*, 1991 Autumn report of Sotheby's London, regarding apparel of the Order of the Thistle.
4. The Most Ancient Order was founded by James II in 1687.
5. Holyrood Inventory 1958.
6. Probably in the early 1960s, and certainly in its present location in 1970 (by Holyrood Inventory).
7. Vincent Galloway (1894-1977), himself a portrait painter, became the Curator of Hull's Ferens Art Gallery, in 1928. He held the position for 31 years.

302. MRS. STEPHEN ELLIS TODD AT 94

Oil on panel	86.25 x 68.50	Dated 1932
Signed	Private collection	

The portrait conveys the vitality and personality of the old lady. She has momentarily put down the cream wool she is knitting, to rest it on her lap. She is leaning forward slightly, giving the viewer her interested attention.

Ann Elizabeth Todd was daughter of Thomas

302. Mrs. Stephen Ellis Todd at 94

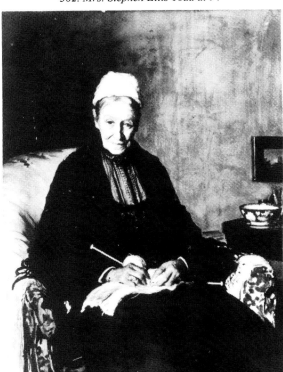

33

Cussons. He ran a tannery in Beverley (Thomas Cussons & Sons), was a senior Justice of the Peace and twice Mayor of the town.

Born in 1837, Ann married Stephen Ellis Todd, and was the mother of thirteen children. Aged 94 at the time of the portrait, she was to live five more years.

In 1933, Elwell expressed unusual pleasure in this portrait[1], claiming that this one and that of *Col. J.B. Stracey-Clitherow* (288) were the best he ever painted.

1. Vid. Catalogue entry for *Col. J.B. Stracey-Clitherow* (288).

303. A MAN WITH A PINT

Oil on canvas 91.50 x 106.75 cms Dated 1932
Signed Grundy Art Gallery, Blackpool

Although the man grasping the beer-mug, with the air of an habitué in his local, is an everyday kind of fellow, Elwell gives him the centre-stage. There is tension between our expectation of a figure more heroic and handsome, and the frank reality. The humour which this generates is entirely sympathetic. The artist would be familiar with characters at his own local, the Rose &

303. A Man with a Pint

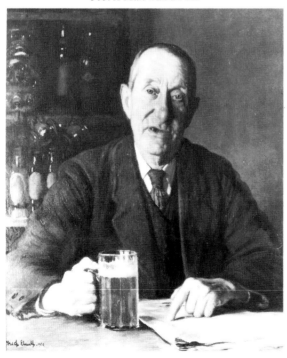

Crown in Beverley, where he was a popular customer.

The man is represented in the painting as one engaged in conversation with us, his fellow drinkers. He appears to make a point, as he stabs the newspaper with his finger. The sense of a personal encounter makes his presence even more real.

At the Royal Academy Summer Exhibition in 1933 the painting was regarded as 'one of the most popular pictures'[1].

The figure was the Beverley character, Jack West, whose loud voice fitted him well for his part-time jobs as Town Crier and auctioneer's assistant. He chose to live on his wits.

He was interviewed[2] by Wilfred Pickles in a radio programme as the 'man' in *A Man with a Pint*. Wilfred asked him if he really drank a lot, as the painting of him suggested. 'Certainly', he boasted, 'I can drink a bucketful before breakfast!'

1. *The Artist*, Vol. VI, No. 6, Feb. 1934.
2. Information from Jim Bloom.

304. ANOTHER MAN WITH A PINT

Oil on canvas 91.50 x 71 cms
Signed Private collection

Following the theme of *A Man with a Pint* (303), Elwell portrayed another Beverley character, who was its last Town Crier. William Good[1] ('the Major') always wore a buttonhole on his black jacket, and a stiff collar. He was meticulous. His hair was parted down the middle and arranged in quiffs, and his handlebar moustache was waxed to perfection. He was renowned for his eccentric habit of wearing around the town eight medals which he had earned in the First World War. Elwell shows him bemedalled, sitting in the taproom, probably of the Rose & Crown, with his tankard at the ready.

1. Information from Mavis Latus, Leslie Scott and William Good, his descendants in Hull and Beverley.

313. SELF-PORTRAIT 3

Oil on canvas 122.50 x 98.50 cms Dated 1933
Signed Beverley Borough Council

At the age of 63, Elwell depicts himself as a man of vigour: a tall wiry figure in his working suit and trilby, leaning purposefully into the act of

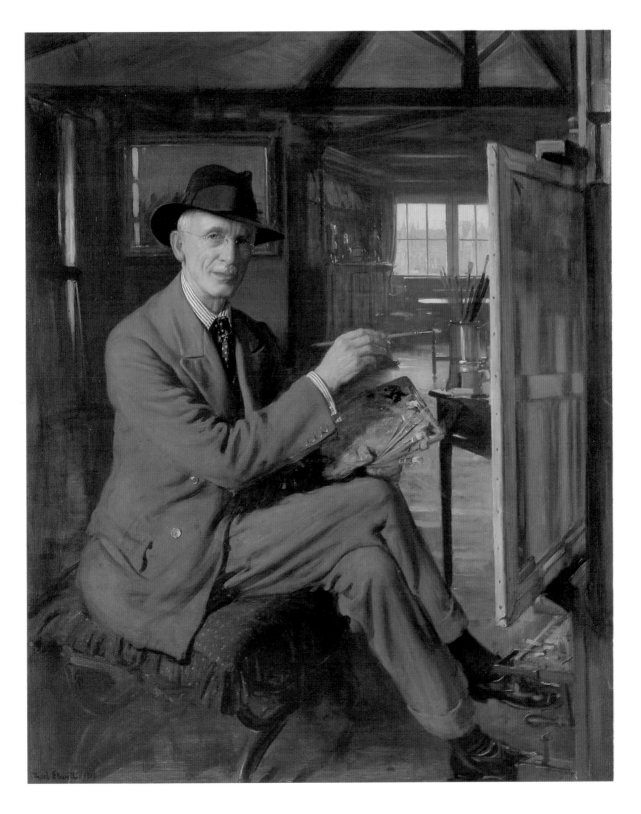

313. Self-Portrait 3

painting, the fabric of his jacket and trousers pulled into taut folds. The elegant pose and close scrutiny of the view ahead convey an air of confidence.

The artist is at his easel, with the colours for this actual painting mixed on the palette. Nearby is the pewter tankard he used for paint brushes. Behind are the timbered walls of his studio, the second floor room at 22 Trinity Lane, Beverley, next to the Telegraph Hotel. Between 1854 and 1890 the building had been used as a warehouse, and loading doors are visible beyond the dresser.

Elwell always wore a trilby hat to shield his eyes while painting.

323. A BOY WITH A PIG

Oil on canvas 114.25 x 172.75 cms
Signed Grundy Art Gallery, Blackpool

The contemporary critic, Kate Hobson, described this as 'a laughing boy clutching a

323. A Boy with a Pig

young and agile pig'. She found the painting 'refreshingly human, alive and natural'[1].

The boy, in his over-large laced boots and jaunty hat, is one of the three sons of the Elwells' gardener and chauffeur, Mr. Shaw.

1. *Beverley Guardian*, June 1935.

324. THE LANDLORD

Oil on canvas 137.25 x 83.75 cms
Signed Ferens Art Gallery, Hull City
 Museums & Art Galleries

The landlord of a public house is well assured of his role. He faces the viewer with confidence, his bearing upright. Elwell's composition clearly draws our attention to this figure. He is centrally placed and his height determines the format of the painting. The shelves, crowded with bottles and flagons, close the view beyond the figure and project him forward.

Like *The 'Beverley Arms' Kitchen* (150), the painting represents a familiar aspect of everyday life. The landlord, in knee-breeches and lime-green waistcoat, is at his work. He stands by the bar, holding a funnel over a richly embossed keg, with a copper flagon in his other hand. Authentic touches of Martini and Red Bass labels contribute to the reality of the setting, which is filled with objects of varying shapes and textures to test Elwell's abilities as an artist.

The landlord was modelled by John Booth [1] who was actually a butler. Brought up in Beverley, he acted as butler both at Tranby Croft, near Hull, and to the Duchess of Westminster. It is interesting to note that, having posed for this painting, he was later to become a publican for a short time at the Molescroft Inn, near Beverley.

Despite popular assumptions that the painting was set in Beverley, Elwell himself stated in an interview that it was at the Buck Inn, Driffield.[2]

1. Information from Mr. & Mrs. Jack Skinner, Beverley.
2. *Beverley Guardian*, 12.4.1941.

325. SEATED NUDE IN STUDIO (or THE MODEL)

Oil on canvas 75 x 62.25 cms Dated 1935
Signed Beverley Borough Council

The female nude is portrayed in elegant profile, her 'glowing flesh tints'[1] set off by the shadow of the studio interior.

324. The Landlord

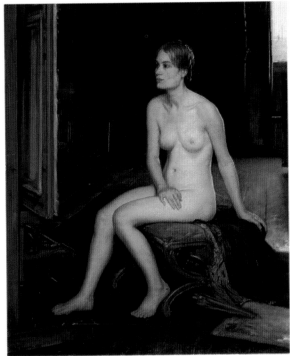

325. Seated Nude in Studio

his newly acquired London studio. He had neglected the nude subject after returning to Beverley in his post-training days, but he might have felt it was not too risqué for London. He may also have produced *Girl with a Cigarette* (372) there, featuring the same woman.

1. Kate Hobson reported in the *Beverley Guardian*, June 1935.
2. Beverley Borough Council.

Her role in the painting is ambiguous. As she has removed her clothes, in the setting of an artist's studio, we assume her to be the model. Yet she is also a modern sophisticated woman, portrayed almost as though it is she who is the artist, seated on the artist's chair and examining the painting on the easel before her.

The colouration is uncommon in Fred's work, and may well be influenced by Mary Elwell, who used the rich blue-green and the effect of colour echoes in *Minster from the Friary*[2] (exhibited in 1934, the year before). In this portrait of the nude, he uses the device of a palette to introduce the blue-green, gold and red that appear elsewhere in the composition, in the drapery and the woman's hair and lips.

It is possible that this painting was produced at

352. PORTRAIT OF WALTER GOODIN

Oil on canvas 89 x 69.25 cms Dated 1937
Signed Sewerby Hall, near Bridlington

At the time of this portrait, in 1937, the artist Walter Goodin (1907-1992) was recently returned from training at the Royal Academy Schools, London. He had acquitted himself well, including winning the Academy Gold Medal. He had vindicated Elwell's faith in his talents.

It was, said Goodin, Elwell's idea to use the pose of playing the mandolin, in order to create a triangular composition, and his idea again to add the fringed and colourful scarf, emphasising the projecting arm. During a period of about one month required to complete the portrait there were four sittings. Goodin recalled that he

became cold as he held the pose for a long time without a break. Elwell was so engrossed in his work that he forgot the time.

Goodin could remember the moment, in 1926, when he became acquainted with Elwell. Fred had seen Goodin making a drawing of Samson and Delilah, which he admired. He invited Goodin to tea at Bar House. 'It was like visiting Buckingham Palace' for the younger man. This encounter resulted in the Elwells giving Goodin the financial backing which he needed to enable him to follow art training.

Goodin practised in Beverley, using a studio on the floor below Elwell's in Trinity Lane. He and Fred's nephew, Kenneth, were friends and both benefited from Fred's encouragement and supervision.

In 1939 Walter Goodin exhibited his work at the Royal Academy and at the Carnegie Institute, Pittsburgh, U.S.A.

After the Second World War, during which Walter served overseas, and his friend Kenneth[1] was killed, he took no pleasure in resuming his old life. He moved to Bridlington, where he married Violet Williamson, and remained there for the rest of his life.

Among Goodin's works are views of seacoast and marine activity, in Bridlington and Flamborough, and landscapes of Yorkshire. *The Old Custom House*[2] (a Hull subject) highlights in meticulous detail the topography of the scene. He could commit to his memory an exact view to be painted and then transpose it, with conviction, despite having retained the image, on some occasions for ten years or more.

1. Vid. Cat. 51.
2. c.1957/8. Ferens Art Gallery, Hull City Museums & Art Galleries.

376. 'MY OLD FRIEND, MRS. LEAKE'

Oil on canvas	91.50 x 71 cms
Signed	Beverley Borough Council

The subject of this portrait study was a long-standing and well respected employee, described by the artist as 'my old friend, Mrs. Leake'. She

352. Portrait of Walter Goodin

376. 'My Old Friend, Mrs. Leake'

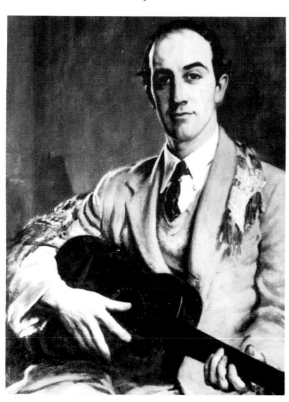

is portrayed sitting by her bureau with its personal possessions of photographs and ornaments. This is a sensitive portrait of old age: her eyes are moist and hooded, the skin taut over the cheekbones, her hands arthritic. Elwell must have wanted to portray her everyday appearance, so the apron and hairnet are retained, and she holds her knitting, as she sits austerely on a ladderbacked chair against an undecorated background.

Part of Mrs. Leake's special position in the Elwell household was due to her having worked for both Elwells before their marriage. As early as 1913, she was cleaning Fred's studio, a task he allowed none other to perform and about which he was most particular. She was also linked to the painting, *The First Born* (110), as she was the midwife for the actual mother of the baby[1], and it was she who brought the baby to the studio.

She had a smiling disposition, was reliable and wore her clothes to the floor in the old-fashioned style, even in 1939. The portrait is probably set at her house in North Bar Without, Beverley, which the Elwells provided for her.

It is thought to be her daughter, Annie Towse, who modelled for Mary Elwell's *Green Bedroom*.

1. Later Muriel Holtby, Ripon, North Yorkshire.

383. IN A BAR

Oil on panel 81.25 x 63.50 cms Dated 1943
Signed Ferens Art Gallery, Hull City
 Museums and Art Galleries

Seated at the bar, with a gin and tonic at hand, the woman nonchalantly gestures with a cigarette. Her feet are poised with casual ease on the rung of the stool beneath her. The rouged cheeks and tightly waved hairstyle are typically 1940s, and she conveys by her direct and confident gaze a female independence, often associated with being involved in war-work.

Elwell asked Muriel Fox[1], his tenant of No. 6 North Bar Without, to pose in the bar of the Beverley Arms Hotel. She was then aged 28 and worked as a cook for the Beverley Westwood Hospital. A frequenter at this bar, she customarily sat on the stool upon which she is portrayed. Shortly before this portrait was painted Muriel had given birth to a daughter, who has since speculated that she might even have been secreted in a basket behind the bar[2]!

1. Information from her brother, S. Palmer.
2. Information from her daughter, Pat Gray.

389. PORTRAIT OF A GIRL

Oil on panel 50.25 x 40 cms
Signed Private collection

The same woman as *In a Bar* (383), Muriel Fox, appears in this portrait, both serene and poised. She is seated upon a settee, with her body turned to present a classical profile and the shining ringlets of her hair, yet owing to the simplicity of the setting and her dress, the effect of her image is entirely modern — nothing detracts from its beauty.

389. Portrait of a Girl

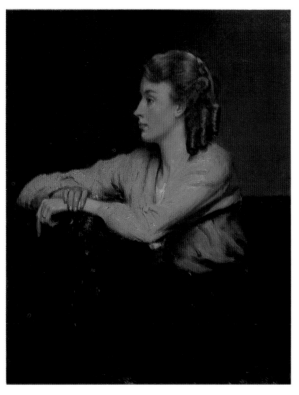

409. PERCY DALTON, ESQ.

Oil on canvas 127 x 101.50 cms Dated 1947
Signed Beverley Borough Council

Becoming more reluctant to paint portraits in his later years, Elwell was nevertheless regarded highly in this field and continued to receive commissions. This portrait, commissioned by Mr Dalton's co-directors of Stokes and Dalton Ltd., Leeds, rusk manufacturers, is both lifelike and accurate in detail. Percy Dalton (1894-1968) is appropriately depicted at his office desk (though sittings also took place at his family home in Ilkley). He was co-founder of the company in 1921 and a man of considerable business acumen: 'a keen observer of the market and sometimes rather ahead of his times'[1].

A classical column and decorative objects in the background support the notion that he is a man of culture. Particularly a devotee of architecture, he was, for instance, responsible for rescuing the Manor House in Ilkley from demolition. Elwell is skilled in drawing together the elements which convey the person.

1. Information about Percy Dalton supplied by his daughter, Mrs. Priscilla Goodger.

412. GHAR ULLIN APPLE SAMMY MARKAWAY

Oil on canvas 58.75 x 74 cms
Signed Private collection

This is a presentation double-portrait of both the racehorse, 'Ghar Ullin', and his trainer, Billy Hammett. It was unveiled and presented to Billy Hammett at a party held at the Beverley Arms, on 9 February, 1948, to celebrate the winning of 14 races.

The rendering of the bay racehorse in profile in his loose-box, has captured the physical likeness. One ear is pricked up in a familiar quizzical expression. The texture of the glossy coat is enhanced by reflected colour, some from the background wall, which is blue-green. Pale and suggested forms of the straw-strewn floor and the horse-rug, in the owner's colours of blue, red and yellow, allow the horse's image to shine out as richly dark and sure. The trainer, Hammett, is portrayed holding the lead rein.

Jim Bloom, the nephew by marriage of Billy Hammett, has supplied information regarding this work. The painting is set at Pasture House Stables (owned by the Jockey Club), in Pasture

Lane, Beverley. The mews buildings, which would have been too far to the left, are incorporated into the view, probably to convey the context of the trainer and horse. The artist worked on this painting in the horse-box itself, and was photographed thus for *The [Hull] Daily Mail* before the unveiling ceremony[1]. On one occasion, he asked Hammett just to leave his boots there to be painted, and they alone required a full day's work.

Billy Hammett[2] had a good sense of humour and 'his stocky figure' was a familiar one. Though born in Devon in 1899, he was seen as a typical Yorkshireman. He began his racing life as 'one of the tough National Hunt riders' who would ride any type of horse and accept falls as part of the job. Then for over 20 years, when he lived at Pasture House, he held a licence to train racehorses, and was regarded as a man of great experience[3]. His premises were adjacent to the long garden of Bar House, and he and Elwell had been neighbours since 1926. A further link with Elwell was his participation in the lunchtime coterie of conversationalists at the Beverley Arms[4], and also his fondness for the Rose & Crown, the nearest public house.

'Ghar Ullin' was a likeable and affectionate horse and was regarded as a bit of a character. In equine terms he was a local hero. He possessed a great turn of speed and was winning races at the advanced age, for a flat race performer, of twelve. Amongst his honours were the Milton Plate at Doncaster and the Hobmoor Plate at York. He gained a total of £4,518 in prizemoney. Latterly he carried the colours of Mr. R. L. Crowther.

In the year of this painting, 'Ghar Ullin' was narrowly beaten in a selling race at Doncaster. Billy Hammett lost a wager on this result, and had to hand over (to C. R. Harman) a grand old saddle[5] which he possessed and which had been used by the famous jockey Steve Donoghue, in 1904.

1. Painting on the site was similarly proved in Cat. 331.
2. Billy Hammett married Irene Bloom, proprietor of a Beverley dress-shop.
3. References from *Sporting Chronicle*, 18.12.1963.
4. J. Markham, *The Beverley Arms, The Story of an Hotel*, Highgate Publications (Beverley) Ltd, 1986, p.26.
5. Exhibited at York Racing Museum. The saddle had earlier been presented to Billy Hammett by the Turf historian, Major Jack Fairfax-Blakeborough, who had received it as a gift from Donoghue himself.

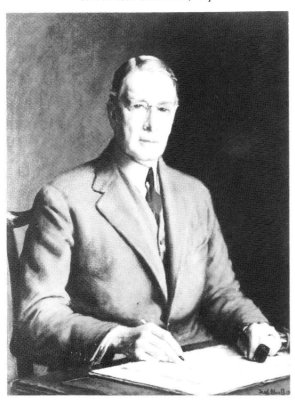

417. Arnold Cleminson, Esq.

417. ARNOLD CLEMINSON, ESQ.

Oil on canvas	91.50 x 71 cms	Dated 1948
Signed	Private collection	

This portrait of Arnold Russell Cleminson[1] (1883-1950), Chairman of Reckitt & Colman Ltd., was a gift from employees, intended to be hung in the Boardroom, and was presented at a special ceremony in February 1949 to commemorate 50 years of service with the company. The portrait conveys him as the astute businessman at his desk, an appropriate pose for such a presentation.

Cleminson had 'clarity of vision' and 'could spot the weak point in an argument with lightning rapidity'. He played a leading part in the company's overseas affairs, and the amalgamation of the Reckitt and the Colman organizations in 1938. During the 1941 blitz, which destroyed the greater part of the Hull works, he climbed through the chaos by ladder to his office and immediately made plans for the continuation of production. For three years he had been the successful Chairman of the

Company, and his sympathetic leadership had created the atmosphere of 'a very happy family'.

His son, Sir James Cleminson, has contributed an interesting anecdote:

> 'Many people said that it was rather more severe than their memory of my father, and when I tackled Elwell on this he said that the reason was that he felt that he was painting the leader of a very big business, and that it was appropriate that he should give him a fairly severe countenance !'

1. Information and quotations drawn from 'ROC' Reckitt Edition, Vol. 2, Spring 1950, No.2, p.79-84

430. POSTHUMOUS PORTRAIT OF HIS MAJESTY. KING GEORGE VI, COLONEL-IN-CHIEF, THE EAST YORKSHIRE REGIMENT 1922-1952

Oil on canvas
Signed

Officers' Mess, 1st Battalion,
The Prince of Wales' Own
Regiment of Yorkshire,
Osnabruck, Germany.

The East Yorkshire Regiment commissioned a portrait to honour the memory of His Majesty King George VI, soon after his death in 1952. He had been Colonel-in-Chief of the Regiment from 1922 to 1952. At the request of Her Majesty Queen Elizabeth The Queen Mother, the painting was viewed by her at Clarence House in 1954[1], the year of its ceremonial unveiling by the Colonel of the Regiment, Brigadier R. J. Springhall[2]. The painting was hung beneath the Regimental Colours in the Officers' Mess at Victoria Barracks, Beverley, until the depot was closed in 1961.

In the portrait[3], the King wears the service dress[4] and cap of the East Yorkshire Regiment, and the rank and insignia of its Colonel. Beverley Minster appears in the background, to link the King with the town. A photograph of George VI, dated 1937, seems likely to have been Elwell's source for the painting[5].

There had been close connections between the Elwell family and the East Yorkshire Regiment. In 1878 James Elwell designed the Regimental furniture which carried the Rose of York, and Fred was an Honorary Member of the Officers' Mess at Victoria Barracks for many years. The Regiment was to become a section of the Prince of Wales Own Regiment of Yorkshire in 1961,

and this painting is now with that Regiment's First Battalion at Belfast Barracks, Osnabruck, in Germany, together with the Regimental furniture designed by the artist's father.

1. *Manchester Guardian*, 3.1.1958.
2. *The [Hull] Daily Mail*, 3.1.1958.
3. Information about the portrait from Brig. Cubiss (Prince of Wales and Royal Dragoon Guards 4/7th Regimental Museum, York) and Maj. J.R. Caley (PWO, Belfast Barracks, Osnabruck, Germany).
4. Currently on display at the above Regimental Museum.
5. Photograph now the property of Beverley Borough Council.

22. Paris Sketchbook, Standing Nude

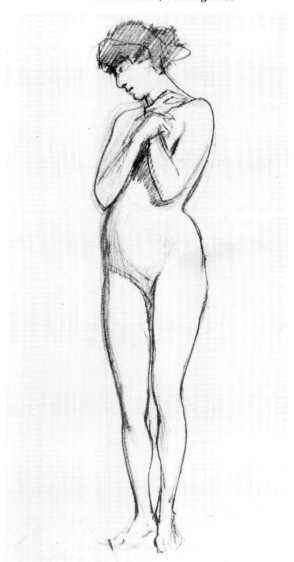

Every Picture Tells a Story

Those of Elwell's paintings which can be considered as 'narrative' tell a story or describe an event, actual or fictitious. Some, such as *The Last Cab* (292), illustrate familiar occurrences, restaged by the artist, while others, like *The Home-coming* (109), follow a 19th-century tradition of moralising and sentimental evocations of family life.

Narrative paintings also gave Elwell the opportunity to express his wry and observant sense of humour. This is particularly evident in *The Butler takes a Glass of Port* (6), *Cavalry Cartoon* (31) and, in the Paris Sketchbook (22), the fisherman as a skeleton, still holding rod and pipe, having waited so long for a bite!

In the early 1900s Elwell adopted a heightened sense of realism, particularly around the theme of the family. This he mixed with a moral or emotional content. *The First Born* (110), and the much later example, *The Window Seat* (298), were very expressive of family joy and intimacy.

He imbued his work with his own strong sense of place, and many of his narratives were set in specific and identifiable parts of his native town of Beverley and the neighbouring Ridings. In this respect, his approach could be likened to that of the Newlyn school of painters in Cornwall. Like them, he painted scenes from close observation and understanding.

Following his marriage in 1914, Elwell's focus turned to familiar scenes of life in and around Beverley: arriving home in Beverley's last cab (292), lunching at the Beverley Arms (153) or singing hymns at the Minster (226). He captured the atmosphere of the period. He included the 'conversation-piece', popular at the time: *Tea Time* (122) and *Four Friends* (153) reveal how people conducted themselves. Often the close detail of the small events of human experience, like the china collected by the artist's father in *The Last Purchase* (156) or the fish set out on *The Fish Stall* (318), made the scene more palpably real.

The irony inherent in his realism, however, was the necessity of staging it, to achieve the composition Elwell demanded. To perfect the figures, he would ask models to pose in his studio as well as in the setting, and sometimes they knew nothing of the other people or props that would appear in the complete painting. Yet in the result there was a sense of personal and historical reality that those who can still remember also recognise.

6. THE BUTLER TAKES A GLASS OF PORT (or ALL THINGS COME TO THE MAN WHO WAITS)

Oil on canvas 94 x 74 cms Dated 1890
Signed Beverley Borough Council

The butler emerges from the deep shadow of the room to seize his opportunity. He has crept up to the table, where others have enjoyed a feast, and is helping himself to a glass of port. With great empathy for the subject, Elwell captures his moment of relish, and in so doing gives the word 'takes' in the title a *double-entendre*.

As Rembrandt would use dramatic light against dark, Elwell has let the glow, issuing from the candelabra and striking the remains of the dinner, highlight the butler's furtive actions.

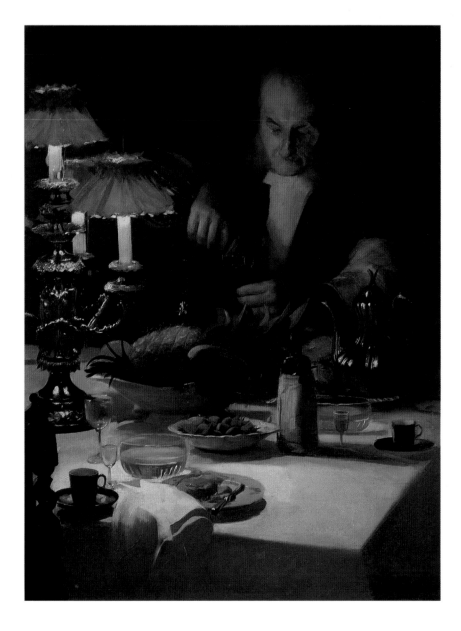

trooper, whose mount, with rustic disregard for military discipline, is munching the grass. The handwritten dialogue reads:

'Why the devil don't you dismount, man. You heard the order didn't you?' 'Why, if you get down you can't get up again,' comes the lame reply!

The uniform[2] is loosely based on that of the Yorkshire Hussar Regiment (being Waterloo style), worn in the period 1890 to 1900 at this location. Elwell has generalised it: the officer is distinguished by his cuff-lace and smart butcher boots, and his mount sports a scarlet saddle-cloth and matching throat plume.

1. Vid. *Alderman Harry Wray* (158).
2. Information on military uniform from Roy Wilson, Beverley Borough Council.

31. CAVALRY CARTOON

Oil on panel 25.50 x 30.50 cms
Signed Private collection

When Elwell witnessed the annual camps of the local yeomanry on Beverley Westwood, he was in the company of Harry Wray[1], who was himself a yeoman. This quickly executed cartoon was given to his friend, Wray, as a shared joke.

In the painting, two mounted and uniformed figures face each other. One is a cavalry officer, astride an alert looking horse. The other is a

97. MOTHERHOOD

Details and location unknown

The theme of motherhood is well expressed by a mother bathing her children. Even in his Paris Sketchbook (22), some ten years earlier, Elwell had been exploring this idea, which necessarily brings the figures into close relationship. A strong comparison can be drawn between Elwell's *Motherhood* and *Dressing the Children*, circa 1906, by Dame Laura Knight (1877-1970)[1].

Like Laura Knight, Elwell suggests the

mother's loving care by creating a continuity of figures, a maternal bond, from the seated mother, with a baby on her lap, to the small child in a bath on the floor. The older boy is different. Having demonstrated his independence by fastening his braces to the wrong button of his trousers, he stands with his back to the viewer, in a position within the composition which disrupts its continuity.

It is entirely conceivable that Elwell was familiar with this particular work by his friend Knight, and borrowed elements of the composition from her.

There prevails in *Motherhood* a continuance of the Victorian enjoyment of paintings of family life, with an emphasis on the mother's devotion. The older boy, with his braces askew, represents that small element of innocent disorder which the public adored.

The mother in the painting is the artist's sister-in-law, Kate Elwell (or Kitty), who is portrayed in the company of her children, Edward, Kenneth and Jack. With her husband, Edward, they lived at No. 4 North Bar Without, behind which was *A Woodcarver's Shop* (155). The artist would often ask his relations and friends to sit for him, and in this case the 'child' Edward was to remember how 'Uncle Fred' had given him five shillings for posing with his toy boat.[2]

1. Ferens Art Gallery, Hull City Museums & Art Galleries.
2. *Yorkshire Life Illustrated*, May 1959, p.38.

98. STUDY FOR PICTURE 'FOR THESE AND ALL HIS MERCIES'

Oil on panel 22.75 x 19 cms
Signed Private collection

The small girl is seated at the table, and in the conventional pose for prayer. In the context of the completed painting she is the well-behaved child, as grace is being performed by her father; the other children are more eager to eat their soup.

A model of perfection, her symmetrical pose forms a classical triangle, and her rich auburn hair matches in beauty her righteous intensity of purpose.

Despite the looser painting of the study (compared with the completed work), Elwell deftly captures his observations of the girl, including the effect of light which locks an area of minute shadow between the hands she presses tightly together.

Elwell invited Grace Morley, whose family owned the Beverley Arms Hotel during the period 1852 to 1920, to pose for this painting. By doing so, he gave to the alternative title of the completed work, 'Grace before Meals', a particular poignancy.

99. 'FOR THESE AND ALL HIS MERCIES' (or GRACE BEFORE MEALS, or COTTAGE SCENE)

Oil on canvas 101.50 x 127 cms Dated 1909
 Signed Location unknown

Before eating, the young family pauses to say grace. The sunlight shining on the table seems to be a light of morality. Elwell represents a contemporary view[1] of the 'home of a humble cottager' as a place 'where the best traditions of the Englishman's home . . . are

99. 'For These and All His Mercies'

preserved'. The frugal meal is 'earned by the sweat of his brow'. While elsewhere there are 'idlers' ungrateful for 'many a sumptuous feast', here, in the cottage, 'reverence goes hand in hand with toil'. This was considered to be a scene to touch the viewer's conscience.

At the time when this painting was reviewed in *The English Illustrated Magazine*, it was also clear how popular was the subject of homely human interest. The behaviour of the children of different ages would have been fully appreciated[2] and the devout and serious air of the girl compared with the boy's impatience to eat, and the smallest child's fractiousness.

As a depiction of domestic life, this work continues in the tradition of the Northern European genre painters of the 17th century, and of Chardin, who carried their influence into the 18th century. It was Chardin, in *Saying Grace*[3], who grouped a family round the table to express a mother's pure integrity as she nourishes her family.

Chardin's painting could easily have been at the back of Elwell's mind when he included the circular table, at which one figure was standing, in his composition. It was one that Elwell would often use, even much later, as in the painting *An Inn Kitchen: Elevenses* (375) of 1940.

As he often did, Elwell invited local models to pose. The mother is believed to be Mrs. Violet Prest[4], and the little girl, Grace Morley, both of Beverley.

1. *The English Illustrated Magazine*, June 1909, p.214.
2. Op. cit. p.209.
3. *Saying Grace* or *Le Bénédicité*, c.1740. Louvre, Paris.
4. She also modelled for *The Wedding Dress* (102).

102. THE WEDDING DRESS

Oil on canvas	128.25 x 102.50 cm	Dated 1911
Signed	Ferens Art Gallery, Hull City	
	Museums & Art Galleries	

As a woman mourns the man she would have married, her grief flows into her unworn gown. Its sheen is intensified in the dim light, its whiteness emphasised against the black dress she wears instead in mourning. Her bowed body, silhouetted against the open trunk, conveys the formal language of grief.

The realism of the painting is heightened, so that we are touched by her sorrow. Such emotive

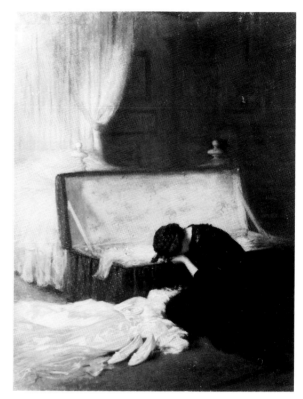

102. The Wedding Dress

subjects were popular in 19th- and early 20th-century art, typified by paintings like Sir Luke Fildes' (1843-1927) *The Doctor*[1], which appealed in its evocation of grief for a dying child. Mary Dawson Holmes, Fred's future wife, also explored the subject of widowhood in *Bereaved*, exhibited at the Royal Academy in 1909.

In view of the sorrow conveyed in *The Wedding Dress*, it is interesting to note that Elwell has used the same props to stage *The First Born* (110), with its tremendous sense of optimism. In the latter, a window lets in fresh air and sunlight onto a scene, set around the bed, which symbolises new life. In the former, a claustrophobic composition conveys a mood of dark pessimism, where the bed is in the shadowy background.

The model for this painting was Mrs. Violet Prest, a costumier of Minster Moorgate West in Beverley. Fate dealt an ironic blow, when, shortly after posing, she lost her husband in the First World War, after only a short marriage.

1. c.1891. Tate Gallery, London.

46

106. THE HOUSEKEEPER'S ROOM (or MORNING ORDERS)

Oil on panel 113 x 92 cms Dated 1911
Signed Ferens Art Gallery, Hull City
 Museums & Art Galleries

Attending 'morning orders' in the housekeeper's room is a nerve-wracking encounter for the poor housemaid. She tugs nervously at her apron. The light from the window illuminates her stooped back, and the housekeeper's stern countenance and admonishing finger.

Typically, the scene is enlivened by the effect of light. It gives a natural emphasis to the gestures and expressions which contribute to the narrative, and models the details of the room. The reflection from the fire in the grate imparts its glow upon the housekeeper's chair.

The setting is Bar House, Beverley, in the peaceful environs of Elwell's future home. The Adam-style fireplace and steel grate belong to the sitting room on the ground floor. The artist's attention to detail reveals the Meissen candelabra, bearing a lute-playing figure at its base, which was one of the treasures of the house.

106. The Housekeeper's Room

In 1911, Fred often visited the house and helped to care for Alfred, Mary's ailing husband. Mary and Fred were to marry after his death. The household continued to be run under the charge of a housekeeper: the structured domesticity portrayed in this painting was therefore maintained.

Interestingly, the figures in this painting present conflicting evidence with the date inscribed on it. Emily Rowley, who lived opposite the artist's studio in Trinity Lane, is thought to be the woman who modelled for the maid. This, however, was in around 1930. Even more confusing, the housekeeper's features have been recognised as those of Elizabeth Chapman, who was the Elwell's housekeeper in the 1950s. One can only assume, therefore, that the painting was subject to modification during the 43 years between the stated date of completion and the time it was ready for the Royal Academy Summer Exhibition in 1954.

The domestic life of the private home was, in 1911, a fashionable subject for artists. Brake Baldwin (1855-1915) pursued this theme when he produced *Cook Darning* and *Setting the Evening Table*[1]. The subject matter, so immediate and commonplace, would have been very familiar to, and popular with, an Edwardian public.

1. Both c. 1912, *Brake Baldwin 1885-1915. An Edwardian Painter*, Michael Parkin Fine Art Ltd, London, 1990.

109. THE HOMECOMING

Oil on canvas Dated 1912
Signed Location unknown

This is a tale charged with the threads of Victorian moralism. A daughter returns home, is judged by her parents to be dishonoured, and is threatened with a gesture of banishment. We see the symbolism of the open door, through which she has entered and must now leave. Her collapsed posture depicts her literally as the 'fallen woman'. She is engulfed in shadow, or moral darkness. By contrast to her lonely and humble position on the floor, the parents are united in anger, righteously upright and bathed in light from the doorway.

The Foster family[1], who lived at the corner of Trinity Lane and Railway Street, in Beverley, were well known to Elwell, who frequently visited the stable that adjoined their house — he

this painting of family life, highlighting a deeply emotional moment, remains enduringly popular. The father, still in the gaiters and working clothes of a gamekeeper, has rushed to his wife's side after the birth of their first baby. The painting is imbued with the symbolism[1] of spring and its associations with new life, to be found in the primroses which the father carries, and in the soft light and slight shadow within the room. Fresh air passes visibly through the open window, where the curtains are billowing.

At the time *The First Born* was painted, many of Elwell's contemporaries were exploring their own reactions to French art. The Newlyn school of artists, including Dame Laura Knight (1877-1970), were keen to instil into their paintings the light and airy atmosphere so characteristic of the French Impressionists . Her painting *The Beach*[2], of 1908, made outdoors, exudes the same feeling of fresh air and natural light that is also apparent, indoors, in *The First Born*.

The setting is a country cottage, simply furnished and without ornament. Elwell's careful working of the tester bed with its flower-sprigged drapery, the ottoman, and the rush-seated, ladder-backed chair contribute to the realism, and bring the viewer closer to an understanding of the scene. The magazine dropped on the floor signifies the domestic disorder that accompanies such an important family event.

Preliminary studies for the painting, on a folding screen (227), reveal a careful consideration of the relationship of the bed to the picture plane. In the final work the bed is almost parallel to it, so that the bedposts and canopy become a framing device. The family scene is thus safely and cosily enclosed, within its aura of well-being.

Elwell merges the Victorian sentimentality with more contemporary social ideas. The mother is portrayed as more self-assured than her Victorian counterpart would have been, and does

was fascinated by its oak beams, and chose the stable, normally used by Joseph Foster's carthorse, as a setting for the narrative. Being a rough workplace, strewn with agricultural implements[2], it provided a suitably inhospitable background for this traumatic domestic scene. The family was asked to act the roles of Elwell's fictitious narrative, but the daughter, unable to pose that day, was replaced by another woman. Joseph, the carter, wears corduroy breeches tied below the knee to prevent mice climbing up his legs. With gnarled hands, he clenches one fist and points vehemently to the door as his wife, Mary, clutches his arm.

The theme of 'the homecoming' was not new to Elwell. He explored it as early as 1892-96 in his Paris Sketchbook (22), where he depicted the physical gulf between a daughter and the rest of her family. In 1895 his Royal Academy exhibit *Disgraced* (24) was probably a resolved version of that sketch.

1. Information from William Foster and Marion Richardson.
2. Thought to be a chaff cutter and a cake crusher. The door is ventilated and bears the sign of an upturned horseshoe.

110. THE FIRST BORN

Oil on canvas 102.25 x 127.25 cm Dated 1913
Signed Ferens Art Gallery, Hull City
 Museums & Art Galleries

The Victorian tradition in art that has influenced

110. The First Born

not defer to the father's gaze. Furthermore, the model for the first born is a real baby, rather than a doll or older child.

The model for the baby (later Mrs. Muriel Holtby) was both newly arrived and first born. Elwell waited for her birth in March in order to complete his painting. His link with her family was through Mrs. Leake (376) who was both the cleaner of his studio and the midwife attending the birth. Muriel was held for two hours for Elwell to paint her image into the picture. Her reward of half-a-crown was considered by her real father (a young police officer earning 22/4½d. a week) as most generous. The mother was modelled by Mrs. Lil Utteridge (née Davy), the wife of a stable-lad. Her home in Norwood, Beverley, was probably the inspiration for the cottage setting of the painting, even though the actual scene was reconstructed in Elwell's studio. Arthur

Constable[3], an employee of James Elwell, was the model for the father. The identity of Elwell's models for this painting is frequently contested because other people were requested to stand in for the mother and father figures[4]. All, however, were natives of Beverley.

There were some problems amongst the 'cast'! Arthur Constable's real wife, Ruth, was told, 'There's a painting in [James or Ted] Elwell's window of your Arthur in bed with so-and-so', and she marched down to the shop in high dudgeon. She was only mollified by being told that Arthur and the girl had been painted separately and had never posed together[5].

The painting was hung 'on the line' (at eye level) at the Royal Academy Summer Exhibition in 1913. A general public accustomed to faithful realism discussed the painting in terms of its social mores. Some thought the father should

have removed his hat; others found its presence forgivable in the light of his eagerness to see the baby. However, Elwell himself explained that an originally hatless father deprived the composition of a strong central shape. The hat was therefore added as an element of form.

1. The use of symbolism, and a general background sympathetic to the human drama, was also part of the narrative style of Thomas Hardy (1840-1928) in literature.
2. Laing Art Gallery, Tyne & Wear Museums.
3. Constable was born in 1886 and was first apprenticed as a cabinet maker to James Elwell. He worked on the grandstand at Beverley Race Course in 1909. Later he was recruited for civilian government work during the First World War and was killed in 1917, at Irthlingborough, Northamptonshire, when he fell 50 ft. into a vat, which he was helping to construct. Information from his son, Arthur Constable, of Old-le-Clay, Grimsby.
4. Cis Davies, Muriel Palmer, Edward Elwell, Bernard Elwell, for instance.
5. Information from Cedric Parcell

111. SLUMBER

| | 50.75 x 68.50 cms | Dated 1913 |
| Signed | Location unknown | |

Just as in *The First Born* (110), the bed is at the centre of a composition in which a woman, peacefully sleeping, lies cosseted from the world. There are few details to distract our attention from her slumber.

The same woman, Mrs. Lil Utteridge, is lying in the original tester bed, with flower-sprigged drapery. As she lies back in sleep, her knees beneath the bedcover are raised into a hillock. This corresponds, in the centre of the composition, to the triangular form of the 'father' in *The First Born* as he leans lovingly towards the child.

117. VISIT TO THE LAWYER'S

| Oil on canvas | 127 x 170.25 cms | Dated 1913 |
| Signed | Beverley Borough Council | |

The range of emotions expressed by the group of clients in his office suggests that the solicitor, Charles William Hobson, is reading a will. In this tableau, each figure communicates by emphatic gesture, in dark silhouette against the light. The effect is to dramatise their very different responses.

In 1913, when Elwell produced this painting, Charles Hobson was still using a quill pen, and his office, containing its briefs tied with red tape, and steel deed boxes, was lit by gas. The legal practice, in which he was in partnership with his brother Frederick G. Hobson (44), had premises at the corner of Newbegin and Lairgate, Beverley. It was the antecedent of the Beverley branch of Rollit Farrell & Bladon.

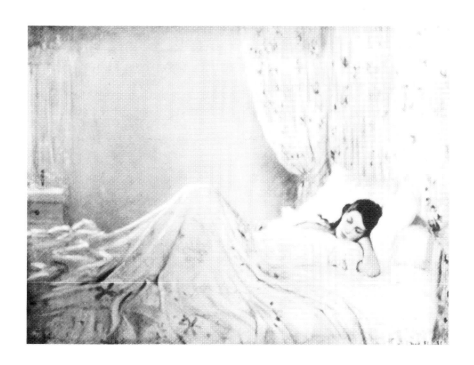

111. Slumber

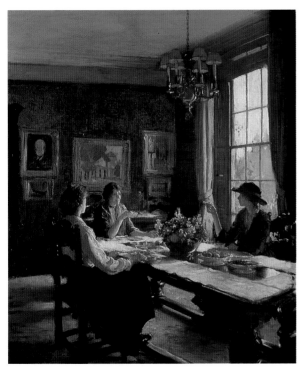

122. Tea Time

122. TEA TIME (or THE TWO VISITORS)

Oil on canvas 61 x 50.75 cms
Signed Private collection of Mr. &
Mrs. John Kilroy jnr., Malibu,
California

There can hardly be a more British approach to the representation of middle class Edwardian life than that of taking tea. James Guthrie explored the subject of ladies at a tea-table in *Midsummer*[1], conveying the relaxed elegance associated with its ritual, and Elwell achieves a similar mood.

Three women sit at a table decorated with flowers, in a room filled with light: two of them casually smoke cigarettes. A sketchy handling of paint lends itself to the immediacy of the moment, and to the sense of the scene being a slice of actual life. Its air of authenticity is enhanced by the fact that the women, deep in discussion, are unaware of the artist's watchful eye.

Such 'conversation-pieces' were popular with patrons who saw this as a true reflection of their own lives.

The setting is the dining-room of Bar House, and perhaps it is even Mary who is seated at the centre of the group. It is likely that the guest on the

right is Florence Blyth[2], the artist's niece. Also seen in the room are the Elwells' oak refectory table and Yorkshire chairs, and Fred's portrait of his father (91).

1. James Guthrie (1859-1930). *Midsummer*, 1922, Royal Scottish Academy.
2. Florence Blyth (née Elwell) was represented in *Portrait of Florence Elwell* (33). Vid. Fig.1.

147. THE NEW FROCK

Oil on canvas 126 x 100 cms Dated 1919
Signed Sheffield City Art Galleries

The woman, having donned the dress for its final fitting, examines her reflection in a wardrobe mirror. Elwell has exploited the situation to establish an inter-relationship of figures in the composition. In fact, an arc could be described through the arrangement of heads — from the crouching woman, to the seated; from the one who stands, and then to her reflected image.

The woman trying on the dance dress at Bar House was Phyllis Downham. As Mary's god-daughter, Phyllis knew the Elwell family well

147. The New Frock

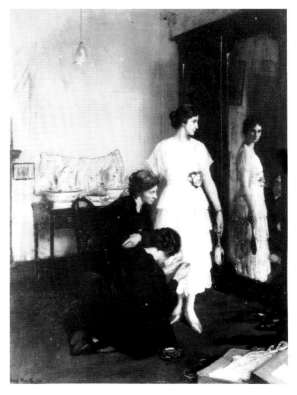

and often attended dances with Fred's younger siblings. Models were hard to come by during the First World War, and Fred persuaded Phyllis and his sister Margaret (Maggie) Elwell, to model the daughter and mother. The dressmaker was such in real life . Phyllis found herself modelling for *The War Worker* (148), too.[1] She described Elwell as 'a charmer'.

1. Information on the modelling from Phyllis Downham, Cheshire.

153. FOUR FRIENDS

Oil on canvas 127 x 101.50 cms
Signed Beverley Borough Council

At lunchtime Elwell regularly met his friends at the Beverley Arms, where he enjoyed good conversation, food and drink. This painting portrays the relaxed and convivial atmosphere of these gentlemanly gatherings.

His treatment of the four men is particularly naturalistic. A roll call identifies John Turton, manager of the Midland Bank in Beverley, who is seated in the foreground. On his left is Dr. Robert Grieve, consultant surgeon of Beverley Road, Hull. James Downs[1], chairman of Rose, Downs &

153. Four Friends

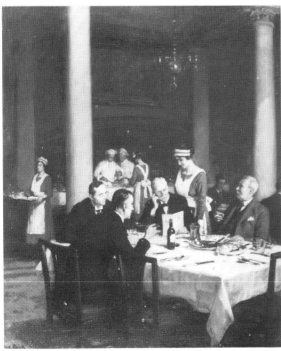

Thompson Ltd. (a Hull seed-crushing firm), consults the menu, and beside him, Ernest Mills, landlord of the Push Inn, leans back in his chair.

The silverware, set on a white tablecloth, is painted with verve, not unlike the style of Edouard Manet. The colour scheme that combines black and white with a dash of orange, echoes Manet's *A Bar at the Folies-Bergère*[2].

Although the friends were seated in the dining-room of the Beverley Arms, the painting was clearly constructed on a composite basis. The colonnade of giant Corinthian columns is from another source, perhaps the artist's imagination.

1. His wife Ethel was *Mrs. J. Downs* (86). James Downs O.B.E., J.P. (1856-1941) was later to become Treasurer of the University College of Hull. A portrait of him (339), in this capacity, was produced by Elwell in 1936.
2. 1881-82. Courtauld Institute, London.

156. THE LAST PURCHASE (or THE NEW PURCHASE)

Oil on canvas 99.60 x 125.10 cms Dated 1921
Signed Private collection

This painting is significant in Elwell's career as being the moment of synthesis, in a single composition, of all the strongest elements of his portraiture, still life and room interiors. All are handled meticulously. This was an approach he was later to develop in part for interior pieces, like *'Widdalls'* (250), but more essentially for his portrait interiors.

At the age of 85, James Elwell, the artist's father, is delightfully portrayed amongst his 'spoils', from the latest antiques auction, which he has set out for inspection. The painting captures the intensity and joy of the connoisseur as he repairs a vase with craftsmanlike dexterity, and even tenderness.

The scene is instilled with the artist's empathy for his subject. His respect for his father's skills leads him to give prominence to the tools of conservation: the paste, brushes and paints, and magnifying glass are placed in the foreground. Elwell's own fascination for curios is reflected in the almost Pre-Raphaelite sharpness of definition and the juxtaposing of complex patterns. Objects, like the 18th-century Crown Derby statuette of Falstaff, are represented with identifiable accuracy. A lot-number still attached to a punchbowl enhances the sense of authenticity.

The figure of James is astonishingly lifelike,

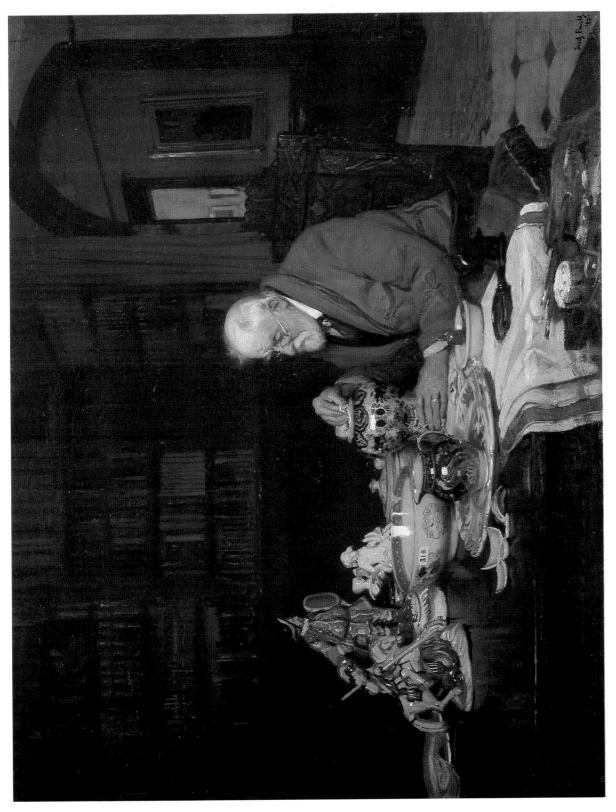

156. The Last Purchase

with finely worked hairs and wrinkles on the hand. Here, the artist may have been influenced by the increased naturalism of expression and close attention to detail of 'The New Sculpture'. An example which provides an almost familial relationship with this figure is the sculpture of *James Prescott Joule*[1], by Sir Alfred Gilbert, produced in 1895 for Manchester Town Hall.

When this painting was produced in 1921, James was living with Fred and Mary at Bar House. The setting is its book-lined study (an indication of Fred's remarkable collection of 2,000 books). One story of this period relates that James, who suffered from gout, found he could treat this by eating the watercress that grew abundantly in the stream flowing through the Elwell's garden. But sadly, it was only five years after this painting that James died, at the ripe old age of 90. Poignantly, Elwell then changed one word of the picture title, 'New', to 'Last'.

1. 1895, Manchester Town Hall, Greater Manchester. Vid. Benedict Read, *Victorian Sculpture*, Yale University, 1982, p.314.

225. IN CAMERA

Details and location unknown

This trial scene, set in Beverley Guildhall, was the first of three. It depicts 'a small timid girl in the witness box and Elwell senior as one of the

225. In Camera

magistrates in whispered colloquy on the bench'[1]. A policeman stands firmly to attention to give evidence.

In the later painting, *The Police Court, Beverley* (356), the same courtroom is viewed from the opposite end.

1. *Dalesman*, March, 1958, p.734.

226. THE FRONT PEW

Oil on canvas
Signed Location unknown

Diagonally across the canvas is the light-filled vista of the interior of Beverley Minster. The front pew runs counter to it, and the hymn-singing girls, who stand there, are touched by the light. There is surely an implied symbolism. Their poses are naturalistic and various — the youngest, finger in mouth; another attentively upright; one, from behind, indicated only by the presence of a hat, while a hymn book belongs to an unseen figure behind.

The pew, defined in the painting by a closing finial of carved wood, looks towards the south

226. The Front Pew

transept and the Chapel of the East Yorkshire Regiment beyond. Illuminating the Chapel, and striking the columns, is a flow of light from a lancet window which lies just outside the painting. In order to bring the girls closer to the light, the artist has reduced the depth of the transept.

To draw out the purple and deep rose-pink in the central stained-glass window, Elwell arranged for the colour of the girls' dresses to be similar. The window had been recently installed, in 1922.

The far window, which was later replaced by one to commemorate John Champney[1], was at the time of this painting still in situ.

Wearing a purple silk dress and black plush hat, Mrs. Florence Hall (née Thompson), of Beverley, modelled for the girl who appears second from the front. She posed on two occasions in the Minster and on two further occasions in Elwell's studio. Always alone in this, she had no concept of the group scene which Elwell envisaged. She recalled the date to be 1925-6.

1. Vid. (82). The replacement window dated 1929 (Champney's death) or thereafter.

284. THE BAILIFF MAN

Oil on canvas 61.50 x 76.25 cms
Signed Newport Museum & Art
 Gallery, Gwent

284. The Bailiff Man

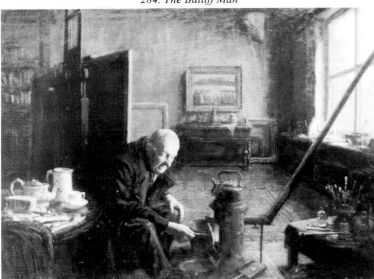

Elwell imagines himself having been evicted from his studio in Trinity Lane, and the bailiff is now in occupation. It is typical of the artist's sense of humour to picture the man enjoying creature comforts. Having prepared tea in a china pot, the bailiff uses the cast-iron stove for making his toast.

The ambience of the studio is otherwise unchanged: the table that holds the artist's brushes, his painting, *Scarborough Harbour* (257), the easel, and the frames propped up against the wall. The bailiff is indifferent to its meaning, yet he exists amongst it. The irony of such a situation clearly interested Elwell. *Refugees in my Studio* (127, 377), with its much related theme, was painted twice.

As the studio's appearance changed throughout Elwell's many years of usage, the bookcase and window represented in this painting point to its date, likely to be about 1923-1933.

291. 'THE SQUIRE' (or FAMILY PRAYERS)

Oil 114.25 x 109.25 cms Dated 1931
Signed Glasgow Museums: Art Gallery
 & Museum, Kelvingrove

Sir Ian Macdonald of Sleat has confirmed that, unerringly every day, his grandfather used to conduct 'house prayers' at Thorpe Hall in the East Riding. The domestic staff would sit on plaid covered benches against the wall.

In Elwell's painting, Sir Alexander Macdonald of the Isles is seated at the table, reading the Bible, while the staff 'sit like ramrods of respectability in one corner of the room.'[1] However, the painting is a reconstruction, not actually set at Thorpe, and Sir Alexander is represented by J. Simons Harrison[2], of Beverley, who acts his part as 'the Squire'.

He is attired in hunting pink, and sits with his back to the viewer, in a dominant position in the composition, rather like that of the butler in *An Old Inn Kitchen* (172). His daughter, tucked away in the corner of the

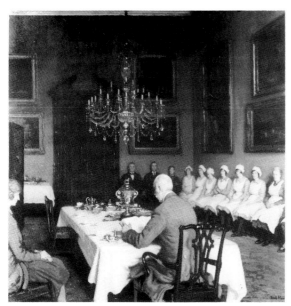

291. 'The Squire'

(née Curtis) recalls the eager sense of participation of Bar House employees in this painting and others upon which Elwell worked. Shaw customarily drove them to Elwell's studio when required.

For this painting, said Dora, the artist would sometimes, on finding there was an absentee, fill the gap with a mop, upon which he placed a maid's uniform cap!

1. *Dalesman*, March, 1958, p.734.
2. Vid. interview given by Elwell to the *Beverley Guardian*, 12.4.1941.
3. Report by Kate Hobson. *Beverley Guardian*, 6.6.1931.
4. Idem.
5. 1965, p.143.
6. Also in *An Inn Kitchen: 'Elevenses'* (375).

frame, almost goes unnoticed. Preliminary sketches on a painted screen (413), show that her inclusion was not part of the original plan. Perhaps she was added later for authenticity, as the Macdonald family customarily did attend 'house prayers'. In fact, when the painting was exhibited at the Royal Academy in 1931, there was still speculation amongst the public as to the 'whereabouts of the rest of the family'[3] — they cared about such factualness.

The painting was 'universally appreciated' at the exhibition, particularly in the 'slightly late Victorian atmosphere' of the show [4]. *The Country Life Annual* was later to see this painting as an example of Elwell's 'genius for investing a place with character'[5].

Dora Curtis[6], an Elwell housemaid, and their gardeners, Shaw and Duncan, were used as models. Dora Holder

292. THE LAST CAB (or MY NEIGHBOUR RETURNS)

Oil on canvas 63.50 x 76.25 cms Dated 1931
Signed Beverley Borough Council

Surely one of the most memorable of Elwell's images is the horse-drawn cab, pulled up to the kerb, silhouetted darkly against the sunny Beverley street.

292. The Last Cab

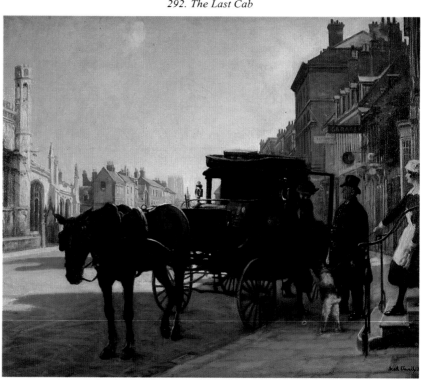

It is not his neighbour, but Mary Elwell who alights; 'old Camm', the top-hatted cabbie, stiffly opens the cab door for her. Her little dog, restrained by the parlourmaid, welcomes her ecstatically.

North Bar Within, the oft-painted street where Fred and Mary lived, is the gracious thoroughfare. St. Mary's Church appears on the left. The depth of the view has been somewhat reduced by letting the parlourmaid descend, not from Bar House (though we assume it to be), but from No 59, in the Georgian block next door[1]. Fred's pride in the Beverley landmark of St. Mary's made him determined to include it, so he brought it closer to home.

The cab, as the last of its kind in Beverley, clearly stirred Elwell's sense of nostalgia. He was attracted to record for posterity a feature of the town that was soon to be a part of its history. The cab met travellers at Beverley station, and it is likely that this painting shows Mary arriving home from a journey.

Earlier memories, including those of Muriel

Holtby who modelled in *The First Born* (110), recall the trips by Camm's cab to parties. The writer's mother remembers the jolting journeys on cobbled roads to boarding school, with old Camm as a polite but reticent travelling companion. The model for the little girls in *The Window Seat* (298) found memorable the crabbing manoeuvre of the horse as it struggled to ascend the pink mud of St. Giles Croft, after the rain. The smell, said another, was never to be forgotten: 'horse mingled with damp blanket' was a fair description.

The parlourmaid in *The Last Cab* was modelled by Mrs. Doris Cooper, a 'daily' of the Elwell household who, on other occasions, would sit for the artist when he needed a face in profile, a leg, or even a buckled shoe!

1. A reason for the alternative title, *'My Neighbour Returns'*, no doubt.

298. THE WINDOW SEAT

Oil on canvas	81.25 x 61 cms	Dated 1932
Signed	Private collection	

'This is of the Bar House garden; the setting sun parting the branches of dark trees and making patterns on the grass. One can almost hear the birds singing their evensong, and the distant voices of other children playing beyond the walls; whilst surely the story she reads is a fairy-tale.'

Kate Hobson was arts reporter to the *Beverley Guardian* when she commented on this scene in her report on a Preview of Elwell's paintings before their submission to the Royal Academy exhibition in 1932. She recognised the aura of childhood happiness that prevails.

Exceptionally, Kate is describing a painting in which she herself is represented. She is the mother who reads 'a fairy-tale', and the two little girls, absorbed in the listening, are both modelled by her daughter, Jan.

The composition of this family scene, bathed in a soft evening light, is well orchestrated to convey their shared pleasure in the book. Their close arrangement on the window seat evokes the comfort of their home, which combines with the pleasing prospect of nature beyond the glass.

Jan Peters, who modelled for both the daughters, has said that, although the painting was at first sold, Elwell 'bought it back because

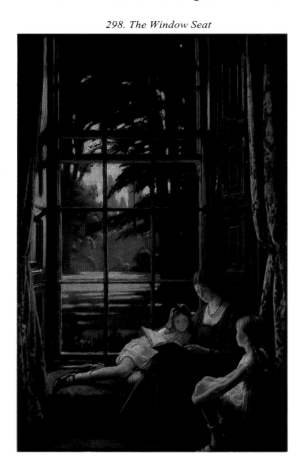

298. The Window Seat

he loved it.' She remembers with affection the 'bubble' beads worn by her mother, and her own silk dress.

The painting was set in the dining room of Bar House. On one occasion, as the light was right, Fred urged them to stay longer, to permit him to continue working on the canvas. He asked them to stay for a meal, but, unfortunately for Jan, it was the day for fish which she hated. She 'kicked up a fuss, and Mama was not best pleased'.

Later, however, when the painting was complete, Fred gave Jan her first watch, inscribed with his handwriting, as a 'thank you' gift. Her parents, Kate and Neville Hobson, were close friends of the Elwells, and Kate wrote a poem after one of their fancy dress parties[1] which recaptured the light-hearted mood of their social life.

1. Vid. 'Master of the Forgotten Art of Living'.

318. THE FISH STALL

Oil on canvas	127 x 101.50 cms	Dated 1934
Signed	Bury Art Gallery & Museum	

A contemporary critic of this work was impressed by its 'imposing sense of distance'[1].

318. The Fish Stall

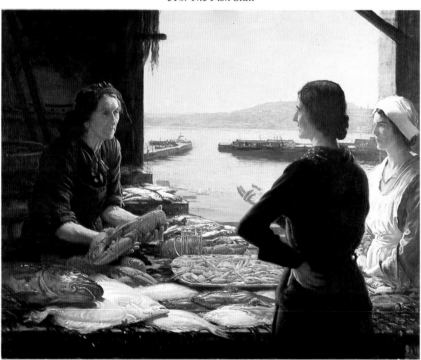

From the fish stall there is a dramatic plunge down into Scarborough harbour. There are no obvious clues to the physical connection between the main subject in the foreground, and the landscape below and beyond.

Elwell has taken a commonplace event — the purchase of a lobster — and has instilled it with a powerful sense of drama. Fisherfolk have customarily held stalls within sight of the sea at Scarborough, though not necessarily as high up on the castle headland as this painting suggests. The high viewpoint is more striking.

The fish are arranged on the stall to create a still life, and Elwell skilfully emphasises their physical presence. A writer for *The Southport Journal* in 1937 dwelt on his technique. It was, he claimed, 'well nigh perfect . . . as one expects from this artist'. The same year, a reviewer for *The Bury Times* emphasised the realism of the fish on display. He admired the 'great shining expressionless cod' and 'fresh pink bewhiskered prawns'. He admitted he felt compassion for the lobster, because of the power of its presence[2].

When Bury Art Gallery acquired the work, it was as part of a general policy in the 1930s for the gallery to make very good purchases from Royal Academy annual exhibitions[3]. This painting was regarded as 'most outstanding' and it aroused much interest among the public[4]. It occupied a central position, and 'attracted considerable attention and admiration'[5].

The view of Scarborough harbour is represented without a lighthouse, just as Elwell had painted it in an earlier picture (257). The old lighthouse was demolished after it had been severely damaged in the German naval bombardment of Scarborough in December 1914[6]. The fact that the new lighthouse had been built in 1930/31, before this painting was executed, suggests that Elwell drew upon his previous work for the distant view.

58

By using a composite structure of the old seascape and the newly observed fish stall he was able to manipulate the high viewpoint to achieve a sense of drama.

1. *The Bury Times,* 4.7.1937.
2. Idem.
3. Information from Richard Burns, Curator, Bury Art Gallery & Museum. The painting was in fact noted at the R.A. exhibition of 1934, he added, when insufficient funds were available for its purchase. By the time it appeared at the Southport exhibition three years later, the funds could be accessed.
4. *The Bury Times*, op. cit.
5. *The Southport Journal*, 1937.
6. Information from David Buchanan, Research Assistant, Scarborough Art Gallery.

354. THE COUNTY COURT, BEVERLEY

Oil on canvas 91.50 x 71 cms Dated 1937
Signed Beverley Borough Council

The scene encapsulates the ordered system of a court of law. We view the bench from the lawyers' table, where Counsel for the Defendant appears to be sharing a point of law with his

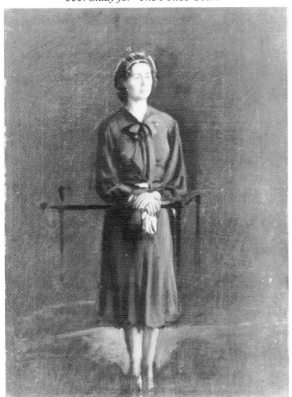

355. Study for 'The Police Court'

Instructing Solicitor. Meanwhile, Counsel for the Plaintiff addresses the Judge, who makes notes with a quill pen.

The viewpoint emphasises the tradition and authority of the court, by the prominent placing of the elaborate crest. It also reveals the allotted space of each participant, in an ordered arrangement. Even the sculpted bust of Queen Victoria occupies a particular niche.

355. STUDY FOR 'THE POLICE COURT'

Oil on panel 38 x 28.50 cms
 Private collection

The figure of the witness for *The Police Court, Beverley* (356) is thought to be Elaine Jenny, an employee of the Picture Playhouse cinema in Beverley's Saturday Market.

When she arrived for a sitting for this study at Elwell's studio, she had no idea of his intention to include her in a courtroom scene. She was smartly dressed for a portrait, and Elwell had to acquire the plain green dress he thought more appropriate for a witness.

356. THE POLICE COURT, BEVERLEY

Oil on panel 101.50 x 127 cms Dated 1938
Signed Beverley Borough Council

The Police Court is in session at Beverley. As the magistrate presides, we are able to view the scene over his shoulder. The witness is giving evidence under cross-examination and the prisoners stand in the dock.

Elwell's devilish sense of humour led him to place his nephew, Kenneth[1], and Walter Goodin[2] in that position. His two pupils were close friends and often no doubt in league with one another. 'At last', quipped Elwell, 'I've got the pair of you where I want you!'

His father, James, acts as the magistrate. As he died in 1926, it seems that this painting was begun earlier than its inscribed date of 1938, and perhaps closer to the 1926 period of the other courtroom scene, *In Camera* (225), in which he also appeared.

The extent of the view is manipulated, probably to include significant architectural features on or near the ceiling, which support the meaning of the narrative. We look up to the 18th century Cortese[3] ceiling, to see the central medallion which encloses the figure of Justice,

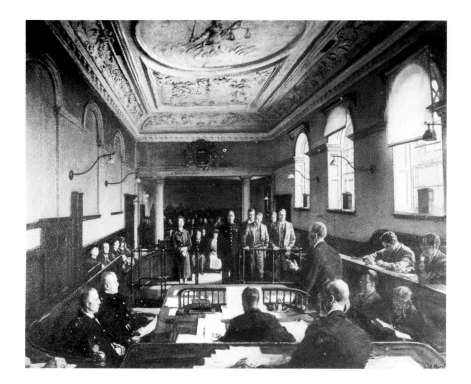

and the distant crest[4] of Beverley, over the portico. Simultaneously, the viewpoint, looking down on the back of the magistrate's clerk's head, takes in the action of the courtroom.

1. Vid Cat. 319.
2. Vid. Cat. 352.
3. Giuseppe Cortese, an Italian, was the leading stuccoist of the North of England for a decade, following the death of Thomas Perritt in 1759. He settled in Yorkshire.
4. A silver shield with three wavy bars blue. Above the bars on a blue field a gold beaver looking over its shoulder.

377. REFUGEES IN MY STUDIO 2

Oil on canvas	101.50 x 127 cms	Dated 1940
Signed	Beverley Borough Council	

Reference to wartime is only indirectly made in Elwell's paintings, such as here, where he describes the use of his studio in Trinity Lane as accommodation for evacuees. Blackout curtains hang at the windows. A cluttered and makeshift series of additions are woven into the artist's environment. The blurred and distant figures do not relate to the context of the studio, and their attitudes express their displacement. The artist, upon whose solitude the evacuees impinge, is himself displaced, and only his reflection is visible. This understandable lack of harmony between the evacuees and the unfamiliar surroundings in which they find themselves was also to be seen in Edward Halliday's *The State Apartments, Chatsworth*[1], exhibited at the Royal Academy with Elwell's painting in 1940.

Elwell had already used 'Refugees in my Studio' as a subject for an earlier painting, executed during the First World War (127). From that painting of 1915 he has retained the same viewpoint in his studio, together with some of the same features — the iron bedstead on the left, the curtain attached to his easel, and the woman by the window. The earlier painting, however, described the condition of a family and was more intimate and evocative of feeling. It was closer in spirit to *The First Born* (110), produced only four

377. Refugees in My Studio 2

years before. In the 1940 painting the mood is more detached.

The woman at the table feeding the child was modelled by Hilda Curtis, a maid at Bar House, while the older woman on the left may be Eliza Barrow, a cleaner at Beverley Library. Both appeared in *An Inn Kitchen: 'Elevenses'* (375), of the same year.

1. *Royal Academy Illustrated* 1940.

392. A FAMILY SCENE

Oil on canvas 61 x 48.25 cms
Signed Private collection

His chin barely reaching the table at the restaurant, everyone is coaxing the small boy to take just one more mouthful.

As well as being an affectionate look at family life, the painting is also a study of light. The parents, set indoors against the sunlight from the window, appear as blurred and shadowed images with glowing outlines. This is the effect known as *contre-jour*.

392. A Family Scene

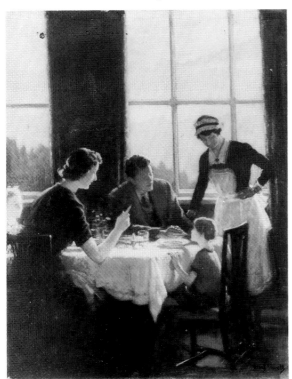

The composition of seated figures at a table, with one standing, was a favourite of Elwell's. He used it to great effect in *Four Friends* (153). The inwardly focused attention of the group is emphasised by the light that falls upon the surface of the table, and by the shape of the cloth that folds at the corner to make an arrow which directs the viewer's eye into the central scene.

Despite the impression given that the family are on holiday, Elwell would almost certainly have added the mountainous landscape later, to a figure group posed closer to home — the style of chairs and the waitress's uniform could be those of the Beverley Arms.

403. A HAYLOFT IN WARTIME

Oil on canvas 53.25 x 63.50 cms
Signed Private collection

A gabled room, overlooking a garden, is used by the couple in this painting as an elaborate summer house, where they lunch, play the piano and play snooker. However, the overall ambience remains enigmatic. The refinements of the room are curiously at odds with its exposed beams and rafters.

The interior is dark except where a white damask tablecloth, dressed with vivid red nasturtiums, is illuminated by light from the window. The eye is drawn to this.

Close inspection reveals a mahogany propeller in the rafters.

403. A Hayloft in Wartime

406. I DREAMT ST. PETER SAT FOR HIS PORTRAIT (or AN ALLEGORY OF ART AND ARTISTS)

Signed Location unknown

This painting of his dream is certainly Elwell's strangest and most surreal piece of work. The setting is a palace courtyard of immense scale and magnificence in which Elwell, in period costume, is seated at his easel, painting the portrait of St. Peter beside him. At the far end of the courtyard is a palace façade, like a triumphal arch, reached by a flight of steps. Above the balustrade is a domed city, a city of temples, and a wide prospect of mountain peaks.

It is the disconcerting effect of the portrait-painting activity, taking place in these apparently unconnected surroundings, that gives to this work its surreal quality.

Elwell's scene of Paradise is hosted by angels. St. Peter is identified by his symbol, the Key of Heaven. More particularly, this is an Artist's Paradise. It has a formal setting, like an Italian *piazza*, with many straight line patterns and edges — an ideal subject for displaying skill in perspective. The bottle and plates assembled on the small table make a still life. Central to the composition, to emphasise the act of painting, are the artist and his model. There is even a tentative connection with the Italian artist Veronese's *The House of Levi*[1] in the figures at the long table.

Seated at the table are artists of an earlier age than Elwell's, including Rubens, Reynolds and Rembrandt. Once again his sense of humour is apparent, because, of all the great artists present, it is, of course, Elwell whom St. Peter has commissioned. He is being personally fêted by angels, appearing like *'amoretti'*, who admire his work or serve him with champagne and canapés! There is an impish motive in Elwell's decision to represent St. Peter in the likeness of George Bernard Shaw, who was not popular at the time (around 1946) for having been a pacifist during the Second World War.

The painting caused much controversy and outcries of blasphemy when it was exhibited at the Royal Academy Summer Exhibition in 1947. It was later discussed by Michael Holroyd in *The Genius of Shaw*[2].

It was produced at Elwell's studio in Trinity Lane, where Mark, the son of Mary's doctor, Adele Nye, was the model for a boy-angel. The artist asked Mark's little brother for his opinion of the painting, encouraging the reluctant parents to let him speak his mind. The

406. I Dreamt St. Peter Sat for His Portrait

child's criticism of Elwell's balance of colour was accepted. 'Quite right,' came the response!

The present location of this painting is a mystery. In 1992 the National Portrait Gallery, in preparation for an exhibition 'GBS in close up: Bernard Shaw', appealed for news of it and three other portraits of Shaw, but, as regards this work, apparently to no avail[3]. It had appeared for sale at Christie's in 1966 under its alternative title, but subsequently disappeared.

1. 1573. Brera, Milan. Illustrated in John Murray, *Artist's on Art*, Pantheon, 1981, p.105.
2. Hodder & Stoughton, 1979, p.78-9.
3. *The Times*, 20.3.1992 (with illustration).

410. STUDY FOR PICTURE, VALUATION FOR PROBATE

Oil on panel 43.25 x 29.75 cms
Signed Private collection

The figure of the solicitor for *Inventory and Valuation for Probate* (411) was modelled by George Whitehead, headmaster of Minster Boys' School, and affectionately known as 'Mr. Minster'.

For this study, Elwell used broad strokes to capture his intent expression, and the light glinting on his spectacles. More vigorous in style than the completed picture, this has been produced with more spontaneity, and still holds the germ of his original inspiration.

411. INVENTORY AND VALUATION FOR PROBATE (or ARDEN'S VAULTS)

Oil on canvas 96.50 x 124.50 cms Dated 1947
Signed Russell-Cotes Art Gallery &
 Museum, Bournemouth

When the Russell-Cotes Art Gallery and Museum acquired this painting in 1950, their bulletin-writer recognised its humour. The men are gathered in a wine cellar, and in order to value it for Probate, the valuers taste it. They are seated at a table with an 'outsize ration of cheese' and glasses of wine, but 'the young clerk [who records the valuers' findings] is not allowed to be initiated' into this refined art. 'He must quench his thirst in a mug of ale.'[1] Elwell lightens the mood of their business and explores its interest as a narrative.

The painting is actually set in a 17th-century brick-lined and vaulted wine cellar in Beverley, known as Arden's Vaults[2], Hengate. They were the property of the nearby St Mary's Church. Four generations of the Arden family (1756-1935) had successively leased them. During their occupancy there were facilities for customers to drink on the premises. In an upper room, wine was bottled and crated and below, in the vaulted chamber, it was stored. There was an impressive tunnel nearly 100 feet in length. Its antechamber was the setting for this painting,

411. Inventory and Valuation for Probate

while the arched door-way behind the figures led to the vaulted chamber itself.

On the left of the painting a column has been added, probably to complement the vertical pose of the solicitor. The tilt of his head also echoes the architecture, where an arch springs above the shaft. The addition of the column also helps to define the shallow space in which this scene is set.

The Russell-Cotes writer, at the time of the painting's acquisition, also mentioned two points of particular interest in this work: a 'sextet of high colour key' included the valuer's canary waistcoat, and the 'green apron over a waistcoat of waspish stripes' worn by the cellarer. Secondly, there was appreciation of the realistic detail: 'even the cobwebs festooning the vaulted roof . . . have not been forgotten!'

1. *The Bulletin*, Ed. 1950, Russell-Cotes Art Gallery & Museum, Bournemouth.
2. Information on its history from its owner.

435. The Lumber Room

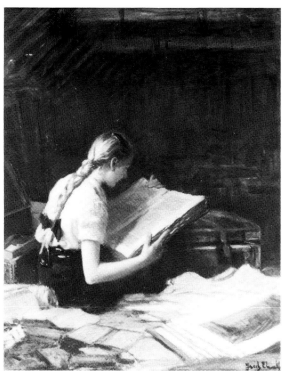

435. THE LUMBER ROOM

Oil 76.25 x 63.50 cms
Signed Private collection

Surrounded by the chaos of treasures unearthed in the lumber room, a young girl, with fair plaited hair, leans into a precious book. When Elwell painted this he was aged 85 and Pat Scoffin was only ten.

It seems he already had in mind the idea of a girl with a long plait defining the curve of her back, proportioned exactly to the book she is reading. He made enquiries at the Minster Girls' School, in Beverley, where Pat was a pupil. She was chosen, she feels sure, for the style of her hair.

She arrived twice a week at Bar House, where sittings were held, appropriately enough in the 'sitting room'. By then, in Elwell's old age (he seemed 'fragile' to his young model), this was a more convenient studio than that in Trinity Lane, at the far end of the town. Pat would be asked, as she posed with the large book, to hold her right hand very precisely. He worked quietly. Nothing existed in the room that hinted at the timbered roof or the array of objects which were finally painted in. Tea, brought by Elwell's housekeeper[1], was taken at 'the enormously long table' in the dining room. Pat Hutson (née Scoffin), says she found Elwell very polite and kindly, and she has a lasting impression of his elegant, long and slender hands.

Only at the end was Pat permitted a sight of the painting which she had so eagerly awaited. She was impressed by the colour (her own pink blouse and black skirt against the parchment colour of the old book), and loved the realism of the silky folds of her blouse. As he often rewarded his models, he presented her with the gifts of a handbag and a photograph of the complete work.

1. *Portrait of Miss Elizabeth Chapman* (429).

64

All the World's a Stage

The world of entertainment, with its players and colourful characters, was an obvious attraction to Elwell, whose love of people, keen observation and wry sense of humour could find an outlet in his paintings of musicians and circus performers.

In Antwerp, his interest in the cello-player (10) taking refreshment followed the lines of a Northern European tradition. The player was a cheerful character recalling the jovial musicians painted by Frans Hals (1580/5-1666). There is humour in the man's self-indulgence and a projection of his ordinary humanity, captured in an off-duty moment.

In Paris during the 1890s Elwell filled his Sketch Book (22) with drawings made at concerts and the circus. His sense of humour is again apparent when he depicts a man with a hangover at a nightclub. Yet the wider significance of these images is that of Elwell discovering the theme of entertainment and leisure as an entirely modern subject. Paris was at the centre of a revolution in art. A city thronging with lively pleasure-seekers was abounding with new subjects for artists. Innovatory styles were often appropriate for expressing a modern phenomenon. Henri Toulouse-Lautrec (1864-1901), for instance, was painting the gas-lit world of the nightclub. His vigorous and exaggerated style captured its mood, while striking images of performers were effective for his poster design. Elwell's energetic pierrot (23) owes much to these influences.

Long afterwards he maintained an interest in people at their leisure, and retained through this his early links with French modernism. He found reference in the scene of bathers by the Seine at Asnières[1] painted by Georges Seurat (1859-1891), when he represented day-trippers at Brick Bridge (385). In 1923 Elwell followed Sanger's Circus for six months, allowing himself to become steeped in the atmosphere of circus life. Although at that time he had just completed *A Cowshed* (177), which evoked the placidity and immutability of country life, the scenes of the circus stimulated a more energized approach to his painting.

1. *Bathers, Asnières,* 1883-4. National Gallery, London.

7. The Trumpet Player

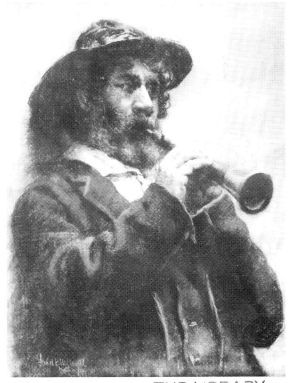

7. THE TRUMPET PLAYER

Pastel on paper? 66 x 52 cms Dated 1890
Signed Private collection

Holding the trumpet to his lips, a tousled and bewhiskered Antwerp musician is intently playing his tune. Elwell has captured this image of him in pastel, applying broad highlights down the nose and across his knuckles to emphasise the vitality of expression.

In the same year Elwell produced, also in pastel, his striking *Portrait of George Monkman, Mace Bearer of Beverley* (5), and both works proclaim his mastery of this revived medium.

10. THE CELLO PLAYER (or INTERVAL FOR REFRESHMENT, or THE SNUFF TAKER)

Oil on canvas 101.5 x 91.50 cms Dated 1891
Signed Private collection

The musician savours the moment of taking snuff during the interval of a performance. He is seen in a relaxed mood, his cello now cradled in the crook of his arm. The man portrayed is nameless — he is simply a player, cheerfully indulging in his twin passions.

Just as in *The Trumpet Player* (7), also painted in Antwerp, perhaps Elwell was inspired by such works as Frans Hals' *Fisherman Playing the Violin*[1], to paint the good-humoured musician. It was also a subject close to Elwell's own heart — as a young man, he played the violin and loved music.

Indeed, the links with 17th-century Dutch portraiture, particularly that of Frans Hals and Rembrandt, are strong. The painting is tonal, rich and warm, in colours of brown, yellow and red-brown. The figure looms, his face glowing and he appears very human. Emphasis is made of the musical instrument and the hands that take a pinch of snuff.

The composition is carefully considered. There are opposing elements in the tilt of the cello and that of the man's head, which achieve a lively, yet balanced, effect. The hand brought around the instrument is poised to take snuff and is also the focus of the composition. Elwell uses deep shadows to contrast with the illuminated face and hands of the figure to add depth and character.

The painting was originally bought by Dr. William Stephenson, of Beverley, Elwell's early patron, who helped to establish him in his career.

1. c.1630, Thyssen-Bornemisza collection. Illustrated in exhibition catalogue, *Old Master Paintings from the Thyssen-Bornemisza Collection*, Royal Academy of Arts, 1988, p.73.

10. The Cello Player

22. PARIS SKETCHBOOK

Drawings in pencil, charcoal and crayon
Signed Private collection

When Elwell was training at the Académie Julian in Paris, from 1892 to around 1896, he found himself in a city invigorated with activity. Paris was at the centre of the modernist revolution in art, and was surging with excitement and new ideas. It was also a city of entertainment, where people sought their pleasure at concerts, theatres, circuses and cafés.

Elwell carried with him a small sketchbook, drawing images of what he saw. The drawings are spontaneous and immediate, often executed in theatres or bars. They reflect the general mood of the time and place more effectively than his finished works are able to do.

Figures — clowns, dancers, or players in an orchestra — are captured in the act of performing. Sometimes, a swirling movement is conveyed by the vivacity of line, or a form is exaggerated for effect. One drawing of a theatre interior gives prominence to the powerful curve[1] of the dress circle seen from below. The curve is itself the

22. Paris Sketchbook, Theatre Interior

force behind the composition. In another drawing it is a guitar-player's arm that is the striking element. It stretches across the composition and creates a simple motif that attracts the eye. A further sketch suggests a scene in a Parisian night-club. The ostrich-plumed hat and leg-of-mutton sleeves of the woman might be found in the style of dress at the Moulin Rouge[2] (Fig.2). However, the humour expressed by the ice pack she presses upon the man with a hangover is entirely Elwell's!

1. Compare this with the curve of the circus ring in Toulouse-Lautrec's *At the Cirque Fernando: the Equestrienne*, 1888, at The Art Institute, Chicago. Illustrated in D. Sutton & D.M. Sugana, *The Complete Paintings of Toulouse-Lautrec*, Penguin Classics of World Art, 1969, Pl.xx.
2. e.g *At the Moulin-Rouge*, op.cit. Pl.xxviii.

23. PIERROT ET DANSEUSES

Oil on black silk 44.5 x 62.25 cms
Signed Private collection

Elwell's Paris Sketchbook (22) is clear evidence of his interest in performers, and includes sketches seemingly of a ringmaster and a clown, and a danseuse with long tapered arms, wearing spikey shoulder and hair decorations, similar to those depicted in *Pierrot et Danseuses*.

A jovial pierrot is the central character of this dynamic painting, which can be admired both for its representational qualities, and for the clues which it gives us about the artist's development.

The pierrot is portrayed in the act of performing a vigorous high-step towards the audience. His buttoned tunic swings with the energy of his movements. Simultaneously his arms are thrust outwards. The ribbons that decorate the picture are propelled left and right, floating and twisting from his hands. The danseuses[1] receive them with graceful, balletic movements. The scene suggests the parting of the curtains for the pierrot who makes his entrance, acknowledges the ovation and receives the bouquets cast upon the stage.

However, this representational reading of the painting cannot be sustained. The perfect symmetry of the composition, the ordered behaviour of the ribbon and the flowers, the unstable poses of the danseuses and the ambiguity of the space in which they exist is irrational. Although the individual figures are credible, their relationship in space is not, and

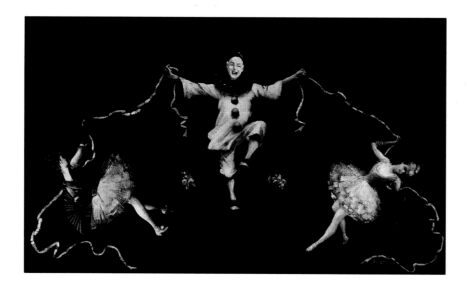

they float against the plain background that provides no painted setting.

One may be closer to an understanding of this painting by considering it as a poster design. The S-shaped female figures and the style of their corsages suggest a date for the painting around the 1890s, when posters were themselves a popular art form. Elwell may have been encouraged in Paris to experiment with design for posters, particularly as his close friend, John Hassall[2], produced them. As poster design, the symmetrical and linear pattern of the ribbon and the stylised bouquets have a more decorative function. Against a background of black silk the motifs are sharply defined to catch the eye. Although the pierrot is portrayed realistically with gradations of tone, the vigorous movement and the striking nature of the image recall Toulouse Lautrec's poster *Jardin de Paris: Jane Avril*[3]. Lautrec was working in Paris at the time of Elwell's training there.

The image of Pierrot was originally painted by Watteau in 1721, as *Gilles*[4], the entertainer of the popular Commedia dell'Arte in Paris. He was dressed in a white baggy costume, buttoned at the front and ruffed at the neck. Elwell's pierrot is similar, though he differs in the colour and distinctiveness of the decoration on his tunic.

Painting on silk, Elwell achieves a delicate grainy effect which enhances the tonality of the pierrot's monochromatic form. Using a large brush for the tulle skirts of the danseuses, the brushstrokes hold their shape and suggest the structure, while the thinly marked edges convey

a sense of whirling movement. Charles Conder (1868-1909), another English artist working in Paris at the same time as Elwell, also favoured the qualities of silk as a support medium.

1. In a similar choice of subject, James Tissot, French painter (1836-1902), painted a performer at the Jardin de Paris in his *Danseuse le Cord*, c. 1883-85, location unknown.
2. Described by Elwell as 'my old friend', Hassall painted Elwell's portrait (Fig. 8) in 1892. He also produced lithographic posters in a breezy, often gaudy style, which the medium demanded.
3. Illustrated in D. Sutton and G.M. Sugana, *The Complete Paintings of Toulouse Lautrec,* Penguin Classics of World Art, 1969, Pl.32.
4. Antoine Watteau (1684-1721), *Gilles*, c. 1721, Louvre, Paris. 'Pierrot' was originally a traditional character in the Commedia dell' Arte, whose appearance was later adopted more generally by clowns and performers.

25. THE DAY AFTER THE FÊTE

| Oil on canvas | 142.25 x 182.75 cms | Dated 1895 |
| Signed | Private collection | |

At a table in a Parisian laundry one woman sits day-dreaming while her companions work. The drab atmosphere contrasts with her red blouse and glinting earring, the only reminders of the 'Mi Carême' Ball of the previous night. She gazes wistfully at the poster, still glued to the wall.

Here, in painting the hard working laundresses, a subject often explored by Edgar Degas (1834-1917)[1], Elwell was not presenting an idealised view of work, as he was later to do in Beverley. Rather, he uses the woman's wishful

thinking to hint at the 'glamour' of life outside the drudgery of the laundry, where her colleagues are ranged in contrast to this way of life.

The colour harmonies of white and grey may be the influence of Whistler.[2]

1. e.g. *Women Ironing*, 1884, Musée d'Orsay, Paris.
2. e.g. *Symphony in White No. 3*, 1867, University of Birmingham.

48. BATHERS

Oil on panel 28.25 x 38.75 cms Dated 1901
Signed Private Collection

A pastoral scene of timelessness and serenity is evoked by a group of nude figures in contemplation at the water's edge. Bathers, a subject explored by Cézanne, Seurat and Matisse, was a favourite with his contemporaries.

Elwell's vision of this theme is, however, located in the more down-to-earth reality of the River Hull at Swinemoor, Beverley, close to a spot popular with leisure-seekers.[1] The river, narrower in Elwell's eye than in reality, follows a placid and sinuous course through flat grasslands.

1. Vid. *Brick Bridge* (385)

181. SANGER'S CIRCUS, AN AFTERNOON PERFORMANCE

Oil on panel 125.75 x 169 cms Dated 1923
Signed On loan to Beverley Borough Council from a private collection

Elwell spent a whole 'tenting season', a period of six months, travelling from place to place in the company of Sanger's Circus. His horse-drawn gypsy caravan assumed the penultimate position in the procession — in front of the blacksmith! It is known that he travelled thus to Liverpool, to Billericay and to Rye. A series of circus paintings[1], of which this is the largest, was produced as a result.

The idea of the artist taking to the road and gaining first-hand experience of the circus was not considered unusual. Indeed, the art critic for the *Liverpool Daily Post*[2] saw it as proof of Elwell's thoroughness.

Elwell professed to his friends a taste for bohemianism, and had already experimented with the circus as a theme in Paris (23). He was not alone amongst his contemporaries in this interest: Augustus John (1878-1961) travelled gypsy-fashion through France and England; Dame Laura Knight (1877-1972) made many paintings of actors, musicians and circus folk; Walter Sickert (1860-1942) was also attracted to the excitement of the performance and to the bright lights which draw ordinary people into an extraordinary world.

In an increasingly mechanised society such themes offered to creative talents a means of discovering pagan energy, exoticism and drama. For Elwell in particular there was the appeal of the horses in

181. Sanger's Circus, An Afternoon Performance

action, and scenes exhibiting powerful contrasts of light and shade. Sickert's *The Circus*[3], 1885, prefigures Elwell's painting in its setting of the Big Top, with a viewpoint from behind the audience to the ring beyond.

In Elwell's painting the scale of the tent interior is cavernous. The viewpoint encompasses the green awning overhead, below which lies the ring, encircled by the dark mass of the audience. An equestrian performance occupies the small and distant inner circle. The performers for the next act, although closest to the viewer, are diminished by the scale. The whole scene is pervaded by a deep green aura, and the entry of light, always skilfully treated by Elwell, is here a very dramatic statement. Great shafts of light cast circular pools upon a floor composed of concentric circles. Jostling pairs of globe lights gleam like cats' eyes under the dark canopy. Glimmers of daylight penetrate the joins in the canvas, and the brass in the orchestra glints in the darkness.

1. Cat. 181-190
2. April 1923
3. Private Collection. Illustrated, K. McConkey, *British Impressionism*, Phaidon, 1889. p.66.

182. PERFORMERS' ENTRANCE

Oil on canvas	50.75 x 66 cms
Signed	Beverley Borough Council

Here, a performer, clothed in exotic costume, rides out of deep shadow into the clear sunlight. His act is over, but others prepare to begin. 'The romance of a big sagging tent', the Spanish girls and bullfighter, and even a leering clown were eagerly remarked upon, when this work was exhibited in 1927 at Sunderland[1].

The performers' entrance is a point of activity, of bright colour and intense contrast of light and shade. From its appearance it might almost be a stage itself. Elwell has seized upon this strange inversion: visually there is drama to be found *outside* the performance. Against the cavernous dark interior, the figures are silhouetted and active. The swirling movement of a red cloak is described by its flowing line and uneven edge in the painting technique. Guy-ropes create a pathway that attracts the viewer into the scene.

The entrance is, of course, that of the Big Top (181) at Sanger's Circus. The white horse, Polly, is the subject of another painting (184).

1. *The [Hull] Daily Mail*, 28.1.1927.

182. Performers' Entrance

183. CARAVANS AT RYE

Oil on panel 30.50 x 38.75 cms Dated 1923
Signed Beverley Borough Council

A free and light-filled, on-the-spot study of Sanger's Circus portrays the backs of caravans parked on the site at Rye. Hazy sunlight conceals detail and Elwell captures the fleeting impression of the scene, using mere suggestions of figures and forms of waggons 'cut off' by the frame.

The brown caravan in the centre is similar to Elwell's own[1]. It was horse-drawn, constructed of wood in 'the cottage style', with carved porch brackets and single side-windows. When standing, steps were fitted between the shafts. The caravan, or 'vardo', in which the painter Augustus John travelled with his family, was like those in Elwell's picture. The experience of the travelling life for an artist was in part fostered by late Edwardian return-to-the-country values, akin to those expressed in Arthur Ransome's dream of the 'broad open road'[2].

1. Vid. Fig. 5.
2. A. Ransome, *Bohemia in London* (1907) 2nd ed., 1912, p.89

185. CORNER OF A HORSE TENT, SANGER'S CIRCUS, RYE

Oil on panel 30.50 x 40.75 cms
Signed Beverley Borough Council

The sleeping quarters of the horsemen are found in the corner of the horse tent at Sanger's Circus. Elwell represents the mêlée of props and washing, horses and men that exists in relative darkness. The obscurity is relieved by the small penetration of sunlight which picks out random objects. The composition's central feature is the vertical tent-pole, around which the other elements of the scene seem to rotate.

186. SANGER'S RING HORSES

Oil on canvas 51 x 61.25 cms
Signed Laing Art Gallery, Tyne & Wear Museums

There is a suggestion of pent-up animal energy in this close view of circus horses in their stalls. Elwell has deftly caught the restlessness of their hind quarters, and the fugitive light upon them, while the great swathe of the tent roof creates a diagonal sweep which effectively contrasts with their receding line.

186. Sanger's Ring Horses

187. HORSE TENT, SANGER'S CIRCUS (or CIRCUS HORSES)

Oil on canvas 101 x 126.25 cms
Signed Beverley Borough Council

The setting relates to that of *Corner of a Horse Tent, Sanger's Circus, Rye* (185). The sleeping quarters shown there are visible here in the foreground. The receding line of animals recalls *The Cowshed* (177). The long and rhythmic series of light patterns, of horses, and of the holes for the tent props above them, give considerable power to the composition.

189. The Farrier's Tent

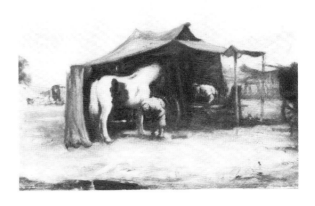

71

189. THE FARRIER'S TENT (or THE CIRCUS FORGE)

Oil on panel 41.25 x 49 cms
Signed Private Collection

A reduced and miniaturised version of this work forms one of the tiny pictures in Queen Mary's Dolls' House[1] at Windsor Castle. Elwell reproduced the central section of this painting, a tent enclosing the rounded and bent figures of the farrier and his assistant, in the process of fitting a horseshoe. The full version of the painting shows the tent more clearly within the context of the circus.

The completed Dolls' House, with its splendid collection of miniaturised objects was put on display at the British Empire Exhibition at Wembley in 1924. Elwell's contribution represented his first link with the Royal Family[2].

1. Information from George Wilson, The Royal Collection, Windsor Castle.
2. Vid. 296, 340 and 430.

209. THE BEVERLEY BAND PRACTISES IN MY STUDIO

Oil on canvas 61 x 76.25 cms
Signed Private collection

This painting was exhibited only two years after Elwell's travels with Sanger's Circus, and is the result of a similar first-hand involvment. He regularly invited the Beverley Band to use his studio in Trinity Lane as a rehearsal room. Typically, he generated much goodwill: he bought uniform caps for the players and became their best patron.

Some of the devices Elwell used in his circus paintings actually appear in this work. The band is seated around the perimeter of Elwell's studio, and he includes, at the centre, a pool of light which dramatizes the position of the conductor to that of ring-master. His grandiose pose is illuminated against intense darkness, and the brass instruments glint within the shadows of the room.

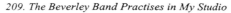

209. The Beverley Band Practises in My Studio

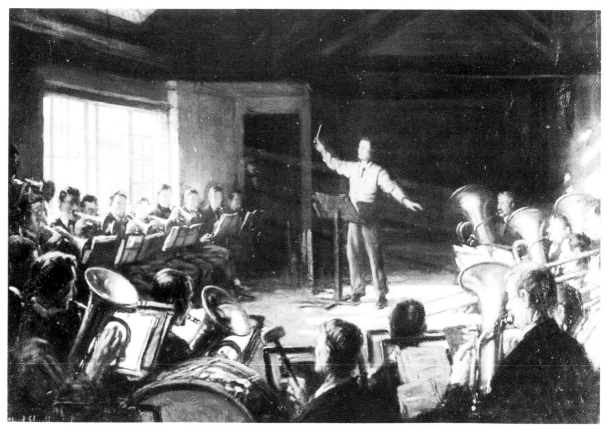

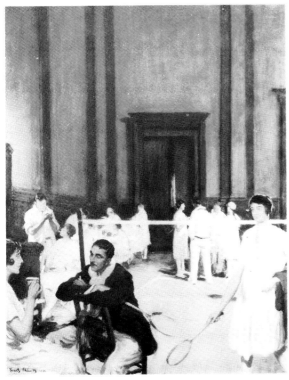

229. A Badminton Court

More typical of Elwell's approach to a painting are, however, his formal considerations, and in particular the effects of light. Here, for instance, these are found in the glowing stove and the man nearby who lights his cigarette, illuminated from two very different sources. His freshly struck match casts a golden glimmer. A whiter light reaches him from a high, unseen window.

The badminton court of the painting was probably part of the Assembly Rooms[2] in Norwood, Beverley.

1. Tony Rae, *Arts Yorkshire*, January 1982.
2. Demolished in 1932 and replaced by a cinema.

229. A BADMINTON COURT

Oil on panel	91.50 x 71.50 cms Dated 1926
Signed	Ferens Art Gallery, Hull City Museums & Art Galleries

During a break from playing badminton, players gather around the court. A youthful Twenties attitude is evoked by the women's fashionably low-waisted dresses and bobbed hair, and the casual attitude of the man astride the chair in the foreground. A critic has described this man as 'someone who has bor-rowed a racquet off a friend just to get at the girls in the team'.[1]

Indeed, Elwell's fo-cus is not upon the game itself. The gestures and poses of the figures suggest the tensions of social interaction. The divided composition, in which the players occupy only the lower half of the painting, hints at a lack of harmony. Those in the foreground are cut off by the frame, like a more spontaneous photograph. The curious arrangement of figures around the empty centre of the court implies a space left open for the final positions of the players in this game of social intrigue.

245. A PALAIS DE DANSE

Details and location unknown

When Elwell showed couples whirling over a vast dance floor under a myriad of lights, the setting was that of the Palais de Danse[1], converted from the Lyric Theatre, in Anlaby Road, Hull. This most fashionable dance hall, with a well sprung floor that accommodated 2,000 dancers, had opened only a few months before. Its lighting effects, modelled on those of the London Kit-Cat Club, incorporated 40 changes, and the Moorish architecture was decorated in soft shades of red and blue.

His viewpoint was taken from the terrace, occupied by spectators at tables, and looked across a balustrade to the action and light upon the dance floor. A similar compositional device appears in *Sanger's Circus, An Afternoon Performance* (181), produced only four years earlier.

The Palais de Danse had opened with the expectation of being 'the most popular and up-to-date in England'. Sadly, it survived but four years. A fire in January 1931 completely gutted the building, and its destruction, watched dejectedly by the Palais Orchestra, took no longer than thirty minutes.

1. Information from Marjorie Robson, and from *The [Hull] Daily Mail*, 29.10.26 and *Hull Times*, 17.1.31

385. BRICK BRIDGE

Oil on canvas 71.12 x 91.50 cms
Signed Beverley Borough Council

In the commonland of Swinemoor, where 'Brickie Bridge' crossed Barmston Drain, there was a traditional recreation spot for day-trippers from Beverley.

Elwell evokes the lido atmosphere of a popular open-air place — the bathing, people's carefree attitudes and the constant activity. A light, summery effect is enhanced by impressionistic dabs of colour, suggesting reflections upon rippled water, and the blurring of features seen through the hazy atmosphere of the outdoors.

Elwell seems here to have been influenced by Georges Seurat's *Bathers, Asnières,*[1] in which urban day-trippers were portrayed at leisure by the River Seine, close to a bridge. Seurat used the bridge compositionally to create a horizontal axis that almost closed the view of the horizon. Elwell does the same in *Brick Bridge*. He even captures some of the paleness and gauchness of Seurat's figures, who, as town-dwellers, normally worked indoors.

Elwell was seen[2] to paint *Brick Bridge* during wartime, when several hundred people, mostly children, were in the vicinity. The Drain, always amply filled by winter rain, was the only public place for swimming during the Second World War. Beverley's baths were occupied by troops.

1. 1883-84. National Gallery, London
2. The artist was watched by Tom Collins of Beverley.

22. Paris Sketchbook, Violinist

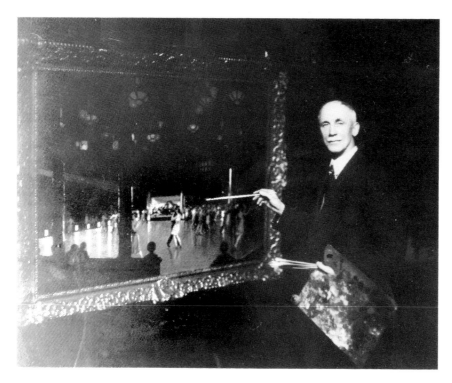

245. Elwell painting A Palais de Danse

74

Town, Country and Sea

Elwell recognised the beauty and wonder of the world about him, and was moved to paint it believing fundamentally in being true to his observation.

The public came to share his beloved Beverley through his portrayal of it: sailing barges on the Beck, the Saturday Market, its thoroughfares and the Minster. It was as if he was its ambassador: after an exhibition of Elwell's work at Sunderland in 1927, which included many images of Beverley, the show was declared a glorious victory for a very quaint old town.

His practice of painting out-of-doors on the site was probably begun as a student in the French countryside. On returning home he devoted himself to painting landscapes of the East Riding. They were woven into the texture of his life, which involved sailing his own boat through local waterways, staying with friends near Driffield, and exploring country and coastal places with a local naturalist, Thomas Audas.

After his marriage to Mary, her wealth enabled a new pattern of regular travel abroad. By 1921 the couple were spending several months on the Continent together, painting the places they visited. New subjects emerged: Alpine peaks and scenes of bright colour intensity, places like Albi, Cahors, Avignon and Les Baux, which broadened Elwell's range of landscape painting.

His choice of subject often included water. In *Beverley Beck* (40) of 1898 the still image of a barge in luminous water created a striking motif. In the 1940s, for *St. Fillan's Perthshire* (386), he studied the richly coloured natural scene of heathered hills reflecting and shimmering on the river's surface.

14. JANUARY PACKET, 1891

Watercolour on cardboard 23 x 17.5 cms
Unsigned Private Collection

The strikingly tall mast of the *January Packet*, with its brown flapping sail, gives the composition a vigorous central form. It is set within a colour harmony of cream, grey and blue.

The sailing boat is anchored, while tiny figures board her from a smaller craft moored alongside.

14. January Packet

A slack line leads from the stern to an anchor buoy, and pictorially this creates a balance with a small rowing boat at the opposite side of the foreground.

Although the watercolour technique of this image is highly skilled, it appears to be the product of a game. A few clues on the reverse of the painting suggest how the game was played. One player provided the title *January Packet, 1891*, and Elwell was expected to match it with a quotation. What he submitted were words plucked from Shakespeare's *King Lear*, Act IV Scene 1:-

> '*There is a cliff whose high and bending head looks fearfully in the confined deep.*'

The painting represents the cliffs of Dover, below which lies 'yond tall anchoring bark'[1], but also depicts the packet boat of the title.

Sailing was a personal interest of Elwell's, and this is reflected in the recurring image of sailing craft in his work of the 1890s, most notably in his Paris Sketchbook (22), *Beverley Beck* (40) and *Path to Beverley* (240).

1. Shakepeare, *King Lear* Act IV Sc. vi

16. ORCHARD

Oil on canvas 31.75 x 40 cms
Unsigned Private collection

It is thought that during the artist's period in Paris, in 1892-96, he travelled around France, painting and sketching. *Orchard* is likely to be a product of this time. Elwell was interested in some aspects of French Impressionism[1], and the informal, non-academic painting, produced *en plein air* (in the open air) was an appropriate vehicle for experimenting in this field.

By applying dabs of colour he achieved a quality of freshness. A lightness of tone, such as that of the whitewashed well and the nebulous profusion of cherry blossom against a blue sunlit sky, evokes a feeling of the open air. Blue-grey shadows that streak across the orchard path describe the effects of sunlight. Around the boundary hedge, forms are loosely defined and coalesce, as the artist is rapidly painting a brief moment of vision, which the shifting outdoor light causes constantly to change. The quality of the movement, inherent in that effect of light, is also seen in the small fleeting animal, painted in a cursorily broad curve, as if its speed prohibits a clearer focus. Threads of straw apparently float in the wind, from the thatch by the well.

This is surely Elwell's most impressionistic painting, capturing the freshness and movement of nature observed *en plein air*.

1. Vid. *Beverley Beck by the Lock* (17).

16. Orchard

17. BEVERLEY BECK BY THE LOCK

Oil on canvas 63.5 x 50 cms Dated 1893
Signed Private collection

By today's standards this scene of Beverley Beck in 1893 appears gentle and rural, yet it reflects the bustling activity of the period. Elwell brings smoking factory chimneys into view, and a breeze propels the smoke sharply sideways. On the Beck itself, Humber keels are under way, and the surface ripples and carries snatches of reflected colour.

Although Elwell worked on this painting in Beverley, his influence came from Paris, where he was still a student. The work of the French Impressionists, and particularly that of Camille Pissarro (1830-1903), seems to have impressed him. Pissarro embraced industrialization as a modern subject, and this was associated with a general sense of movement found in rippling water, in reflections, and in the air. Elwell's veering plumes of factory smoke link him especially with Pissarro's work, such as *The Oise at Pontoise, grey weather*[1].

This painting of Beverley Beck is the first

17. Beverley Beck by the Lock

signed and dated work that resulted from Elwell's direct observation of a scene.

The view encompasses the Beck, or canal, from its intersection with the River Hull (on the left foreground) to its approach to Beverley. The chimneys appear to belong to (left to right) the gasworks, Hodgson's Tannery in Flemingate, and the ropery.

1. 1876. Boymans van Beuningen Museum, Rotterdam. R. Thomson, *Camille Pissarro*, The South Bank Centre and Herbert Press Ltd., 1990, p.33.

40. BEVERLEY BECK 1

Oil on canvas 96.5 x 76.25 cms Dated 1898
Signed Private collection

Although similar to the view represented in the previous painting (17) (this is the same waterway, closer to Beverley), Elwell's approach is nevertheless very different. Five years on, he had settled permanently in his hometown, and had loosened his earlier ties with modernism.

In the atmosphere of evening, with dramatic lights and darks, and warm rich colour, the scene is idyllic. A luminous pathway of water conveys the idea of a prospect, and directs the viewer to the spectral towers of Beverley Minster enveloped in sunset. A sailing barge, deeply in shadow, from high mast tip to the base of its reflection, offers an image of striking drama. Above the rooflines its mast rises amongst the distant chimneys, whilst, below, its reflection plunges into the tranquil water of the Beck.

The boat, and the still luminosity of the water surface link this painting more closely to *January Packet, 1891* (14) than to any intervening work. In both, a Dutch tradition is woven into the texture. The rich and mellow hues of warehouse buildings beside this Beverley Beck might be compared with Meindert Hobbema's (1638-1709) buildings by Haarlem Lock[1]. Indeed the waterway-crossed open landscape of Holland conforms well with Elwell's native East Riding, and the inspiration of Dutch landscape painting was fitting.

In this work the appearance of Beverley Minster as the motif which terminates the vista was established, and would recur in later paintings, such as *Path to Beverley* (240).

The calm mood of this painting belies the extent of traffic along the Beck in 1898. Opposite

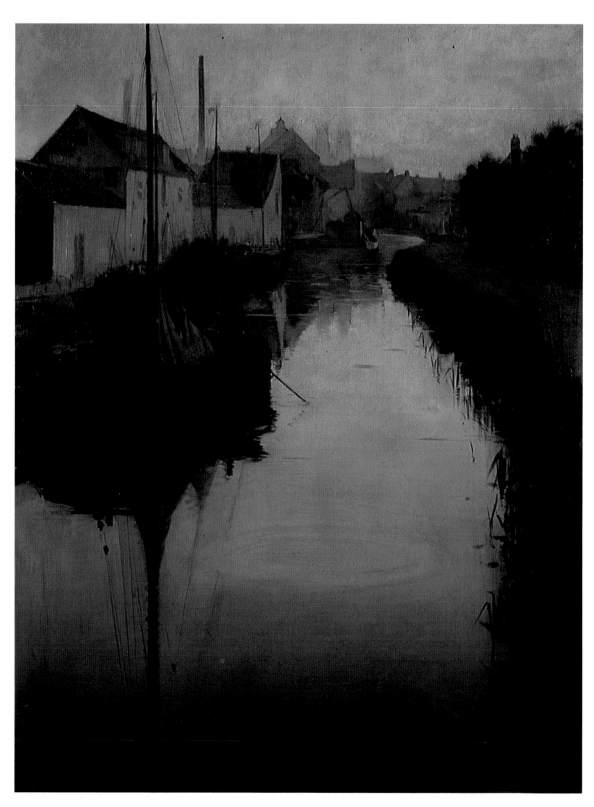

40. Beverley Beck 1

the curve in the distant course of the waterway is the wharf and projecting hoist of Barker & Lee Smith's, animal food producers. The far chimneys belong to Hodgson's Tannery. Tanning employed more men than any other occupation in Beverley[2], and was a long-established industry. Hodgson's was the largest, employing 450. Its position at the head of the Beck gave easy access to a supply of imported hides, delivered from the port of Hull, probably by such a barge as is represented in this painting.

1. c. 1665. *A View of the Haarlem Lock and the Herring Packers Tower, Amsterdam*, National Gallery, London.
2. In 1901 *The Victoria History of the County of York East Riding*, Vol VI: Beverley, Oxford University Press, 1989, p.138.

46. DRIFFIELD TROUT STREAM 1

Oil on panel 29.75 x 40.50 cms Dated 1901
Signed Private collection

This is one of several landscapes of the East Riding countryside that were purchased by Dr. William Stephenson early in Elwell's career, and features the Driffield Trout Stream.

Muted pink-green hues, applied to a cream-coloured base, convey the tranquil stream and lush vegetation in the evening light. Rising land beyond the flat country shows the proximity of the Driffield wolds.

55. LEVEN CANAL

Oil on panel 25 x 38 cms Dated 1904
Signed Private collection

The artist depicts the dramatic state of the weather, the flatness and the expansive skies of the East Riding countryside. The yellow-tinged sky that follows a recent storm casts its coloured light upon the water of Leven Canal, and highlights the lockgate beams and boat decks. Adjoining the towpath, the Lock House dominates the skyline.

The canal is shown at the point where it joins the River Hull at Leven Lock, though the river itself passes unseen below the lock. The canal was built by the Bethell[1] family to allow barges carrying coal, bricks and grain, to penetrate eastwards from the river as far as the village of Leven. It was a busy thoroughfare, crossed by a swing bridge and with warehouses at the turning point at its head. Lock House was a three-mile

walk along the towpath from the village. Despite its remoteness, the lock-keeper's wife, Mrs. Simpson[2], was noted for being very hospitable.

Lock House is a single-storey building, with a loft, of a type familiar in the area. Beverley Minster is represented, somewhat vaguely, in the distance.

1. Landowners of Rise Park. Vid. *Capt. Adrian Bethell, Master of Holderness East Hounds* (369).
2. *Lady with Black Cap* (56).

62. RIVER HULL NEAR WILFHOLME

Oil on panel 30.25 x 40.25 cms Dated
Signed Private collection

This landscape, in which the River Hull meanders into the distance, is characterised by extreme quiet and flatness. The foreground is empty except for the almost calligraphic forms of rushes. The river vista terminates in a very distant view of Beverley Minster.

The artist's observation of elements of local weather, such as the weak light penetrating a grey overcast sky, is particularly apparent.

71. THE RIVER HULL AT BRIGHAM

Oil on panel 38.75 x 28.50 cms Dated 1905
Signed Private collection

On the upper reaches of the River Hull at Brigham, Elwell 'had a houseboat on the river . . . and did quite a lot of sketching thereabouts'.[1]

He paints the sweeping dark tower of a tree as it looms above the gleaming white water surface. The building on the left, by a white wooden bridge, was an inn.

1. Letter of 1950, from Elwell to the artist Kenneth Beaulah of Hessle.

75. PALLAS ATHENA OWL

Oil on panel 45.75 x 45 cms Dated 1905
Minerva Lodge, Hull

Surely Elwell's most unusual landscape is a view of the Acropolis at Athens, painted as the background, in a glass case, for a stuffed owl. As a brother Mason, it was his contribution to a presentation to the Minerva Lodge, Hull, made by F.G. Hobson (44)[1]. The Pallas Athena Owl

remains on display there as a symbolic reference to the goddess Minerva.

Pallas Athena, being the equivalent to Minerva, was one of the major deities of Ancient Greece, and one who bestowed a benevolent and civilizing influence. She was also patron of Athens, and the Parthenon, included in Elwell's painting, was her temple. As goddess of wisdom, her owl was perched near her, itself becoming a symbol of wisdom.

1. F. G. Hobson was a member of the Minerva Lodge. He made the presentation on 22.11.1905.

92. STAITHES

Oil on panel 39 x 29 cms Dated 1907
Signed Private collection

A high viewpoint of the village of Staithes, on the east coast of Yorkshire, may have reminded Elwell of Cézannes's *View through Trees, L'Estaque*[1], and he has conceived a similarly vertical plunging view through the framework of a sweeping, V-shaped valley. He uses the complementary colours of orange and blue for roofs and sea, and allows his brushstrokes to follow the pitch of the roofs.

Although painted with unusually long and fluid brushstrokes to shape the valley, the landscape nevertheless includes carefully painted details, like the chickens pecking between the houses.

1. 1874-86. Private collection (on loan to the Fitzwilliam Museum, Cambridge). Illustrated in R.Kendall, *Cézanne by himself*, Macdonald & Co. (Publishers) Ltd., 1988, p.132.

92.1. LOOKING UP THE DRIFFIELD CANAL, BY THE TROUT, WANSFORD

Oil on panel 33 x 53.25 cms
Signed Private collection

Elwell painted a series of East Riding landscapes in the countryside around Driffield, when he stayed with Joseph Butterell, a Hull solicitor who lived at the Manor House, Wansford. The house is visible in this painting beyond Elwell's own sailing boat, *Spowder*, and a white wooden bridge. He was a popular guest at the Butterells' tennis parties, and typically, this painting was given to his host.

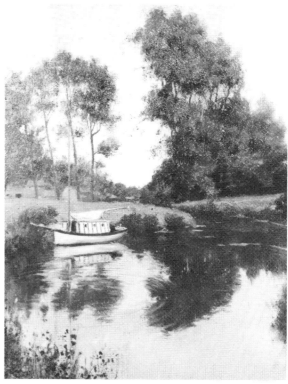

92.2 River Hull Near Brigham 1

The Driffield Canal is seen at its most placid. The stillness is reinforced by the symmetry of the composition and reflections of dark masses of foliage. This is fishing country, and the public house on the right is appropriately the Trout Inn.

92.2. RIVER HULL NEAR BRIGHAM 1

Oil 38 x 29.25 cms Dated 1908
Signed Private collection

The artist's own sailing boat *Spowder* again features in this painting of Brigham on the River Hull. A figure is fishing over the stern as the boat, its mast and sail lowered, is at rest. A redbrick farmhouse, typical of the East Riding, is visible beyond a windbreak of trees.

In the still water a large circular eddy curls the reflections around the haven of the boat's mooring.

His boat was a yawl. being pointed fore and aft, and converted into a houseboat. it was officially registered under the name *Callathumpian* in the lists of the Humber Yawl Club[1], of which Elwell was a keen member. artist members frequently

used their paintings as illustrations for its Year Book, in which this painting appeared in 1909.

1. Information from Tony Watts.

96. AN OLD PALACE IN VENICE

Oil on panel 38 x 28 cms Dated 1909
Signed Private collection

On one occasion, recalled by a previous owner, Elwell turned and quickly recognised this picture, on a visit to her home, saying, 'Oh it's good to see that old painting again. I only did three in Venice, and that's one.'

In 1909, when the work was painted, he was not generally making visits abroad. It is a remote possibility that there was a link with William Logsdail, who, after training like Elwell at Lincoln and Antwerp, lived in Venice for periods of his early painting life. This painting, its diagonal organisation of the Venetian scene and detailed attention to architecture, might be compared with Logsdail's *Venice*.[1]

This is the first painting in which Elwell realised the Mediterranean intensity of light.

96. An Old Palace in Venice

With a new palette, he created the cloudless cobalt sky and sunlit orange-tiled roofs. He discovered the strong tonal contrasts between surfaces in sunlight and those in shade, and observed how a narrow shaft of sunlight between buildings reflected as a clear-cut golden form. Reflections in the green water, of black and orange, were treated with impressionistic strokes and the merest hint of gold shimmer.

The palace itself is richly designed with Byzantine flamboyance, having pointed arches and balconies about a central mass of windows. On the first floor, or *portega*, orange shutters exude their own mellow warmth. An air of silent siesta pervades the unpopulated view: shutters are closed and, at the water entrance, a gondola waits.

1. 1880s. Usher Gallery, Lincoln.

112. MUSTARD FIELD

Oil on canvas 50.75 x 73.75 cms
Signed Private collection

From a shaded foreground, to a path, through colourful mustard flowers and poppies, the eye is led towards a distant prospect with a feeling of optimism. The painting is charged with the languor of long hot summer afternoons. In viewing the carthorse being slowly ridden from the field, and the harvester, his scythe over one shoulder, we witness a small episode of rural life.

Seemingly far removed from the concept of industrialisation, the 'ideal' treatment of this scene nevertheless reflects it. Elwell was bowing to a Victorian taste in landscapes, in which industrialists wanted to feel nostalgia for the life they had abandoned. As rural life was being encroached upon by the pressures of industrialisation, it was also becoming more highly valued.

This painting may originally have been intended for the offices of Reckitt & Colman whose products include mustard.

113. CALVES IN A FIELD

Oil on canvas 44.50 x 34.25 cms
Signed Scunthorpe Museum & Art
 Gallery

As in the landscape, *Mustard Field* (112), the countryside is idealised. Calves contentedly

inhabit an area of lushness beneath a tree in blossom, to suggest the season of regeneration.

135. THE GARDEN, BAR HOUSE

Oil on canvas 73.75 x 62.25 cms Dated 1914
Signed Beverley Borough Council

After their marriage in 1914, Fred and Mary lived at Bar House, the subject of many paintings. In this view of their well-loved garden, Fred emphasises its formal nature, while dappled light across the path creates its own rhythms.

In the background, the four-storeyed house, with its garden door, is visible beyond lime trees. Adjoining it is a kitchen wing, the setting for *Maids with Pigeons* (146). At the far right is the tower of St Mary's Church.

169. CONTINENTAL LAKE WITH FIGURES ON A JETTY

Oil on panel 25.50 x 38 cms
Signed Private collection

From 1921, Fred and Mary began taking holidays together in Europe and Elwell's continental landscapes became more prevalent.

Even though the far surface of this lake appears muted and still, and the steeply bare rock inaccessible, the closer side of the water is filled with movement and the presence of people. An impressionistic style evokes transitory reflections of bright colour on the water and the sense of the figures on the jetty being momentarily caught in movement in the open-air light. Some of the feeling of Wilson Steer's *Girls Running, Walberswick*[1] is present.

1. c.1889-94. Tate Gallery, London. Illustrated, B. Laughton, *Philip Wilson Steer*, Oxford University Press, 1971, Pl.80.

170. ITALIAN SCENE WITH LAKE

Oil on panel 29.25 x 39.50 cms Dated 1921
Signed Private collection

In a scene evoking crisp late-autumn weather, the artist paints the various rich tints of the trees and the blue-white mountains that echo their shape in the background. Both are reflected in the lake water, setting warm tones against cold.

A thin band of low cloud, that settles in the early morning, wafts across the lower slopes of the mountains, and follows the line of the rocky spit below.

175. RAMSEY HARBOUR, ISLE OF MAN

Oil on canvas/panel 29.25 x 39.25 cms
Signed Private collection

As a barge enters Ramsey Harbour, the weather has changed from rain to a moment of hazy sunshine. The tall quayside buildings are now roofed with glistening white. Each wettened pole lining the harbour is tipped in highlight. The rippled water is a myriad of reflections, which the artist has dabbed on to the picture surface with a thickly laden brush.

176. THE GARDEN PARTY

Oil on canvas 75 x 61 cms
Signed Private collection

The Dr. Barnardo's tea-party was held annually in the Elwell's garden, at Bar House. In the painting two long tables are set crossways for this event in the shade of the lime trees, and the ladies seated around them are being served by uniformed maids. It is an atmospheric setting in the early 1920s, where crisp damask cloths bring elegance into the open-air.

In the hot summer afternoon, Elwell paints the golden sunlight on the lawn and shows the effect of haze around the poplar trees. A deep shade, dappled a little, lies beneath the tall, luxuriantly leafed limes.

193. ALBI CATHEDRAL, TARN, SOUTHERN FRANCE

Pastel on sandpaper 40.75 x 54 cms
Signed Private collection

Sharing with his friend Richard Jack[1] a fondness for Albi, Elwell painted his medieval subject there. The Cathedral of St. Cecilia rises vertically like a fortress from the hill above the Town.

The most unusual support medium of sandpaper has successfully charged this pastel drawing with intense colour. A richly orange-hued bridge and profoundly blue stretch of river exude a sense of summer heat.

1. Vid. 'Master of the Forgotten Art of Living'.

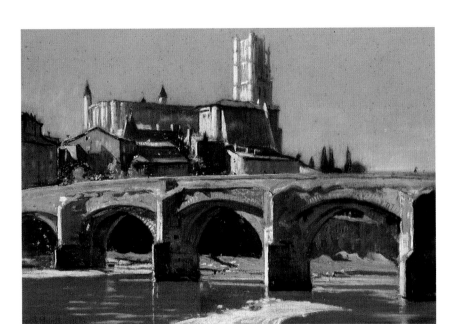

197. ITALIAN SCENE

Pastel 75.25 x 52 cms
Signed Private collection

From an extremely high viewpoint, the artist looks down past the white blossom to a wide shimmering bay, skirted by a resort of pastel-toned buildings and a tall campanile. The sunlit scene contrasts with the mountains pressing up from behind the town, and lying in mysterious shadow. A massive, V-shaped valley between the mountains is matched in scale by the wide curve of the bay, yet its wildness contrasts with coastal civilization, and its darkness against light.

200. AN OLD STREET, CAHORS

Oil on panel 49 x 33.75 cms Dated 1925
Signed Private collection

From the dark and winding old street the eye is drawn to the blue sky and sunlit prospect. Buildings, overhung by eaves, flank the composition, and we are drawn to the central narrow chink which the buildings have shaped. It was for its striking qualities of perspective, balance and light that this painting was admired when it was exhibited at Sunderland in 1927[1].

 Unusually, the varnishing technique contributes to the effect. The view beyond the houses, which occupies the airy space of lighter

tone, is left unvarnished. Buildings in the foreground, treated with varnish, appear solid, tactile and heavy by contrast. Deep shadows beneath the eaves are the most heavily treated, intensifying their dark-ness of tone.

1. Peter Delmas, *The [Hull] Daily Mail*, 28.1.1927.

209.4. CASTLE OF LES BAUX, PROVENCE

Oil on panel 48.25 x 54 cms Dated 1925
Signed Private collection

Many of Elwell's Continental landscapes, including scenes of Como, Albi, Cahors, and Avignon, as well as Les Baux, were exhibited in a one-man exhibition at the Usher Gallery, Lincoln, in 1928. The fact that 39 of the total of 65 paintings in the exhibition were such landscapes, indicates that they were significant themes in Elwell's work.

This particular subject, painted in the late afternoon, was also represented in another work,

in the morning (209.2), and again on a grey day (209.3). He was drawn as much towards the revelation of light as he was towards the places themselves.

The subject is the fortified village of Les Baux, built on a limestone outcrop, looking south over the Carmargue. The rock, steep and thrusting, and weathered like an old bone, merges with the buildings set upon it. It is a powerful image. Appearing to grow out of the picture's lower frame, the crag is seen against a distant ethereal haze.

The drama of Les Baux is intensified by bold highlights and deep shadow in the late afternoon light.

215. AVIGNON FROM LES ROCHERS DE JUSTICE

Oil on canvas 30.50 x 48.25 cms
Signed University of Hull Art Collection

From the west of Avignon, Elwell depicts a view of the narrow southern end of the Ille de Piot (dividing two channels of the River Rhône), and the Cathedral and Papal Palace of Avignon itself.

He would have been familiar with the view of Avignon by the French painter, Corot, *Avignon from the West*[1]. His own work seems imbued with aspects of Corot's style in relation to the place. He has taken a similar viewpoint, and has represented the town as a distant prospect that is part of a harmonious

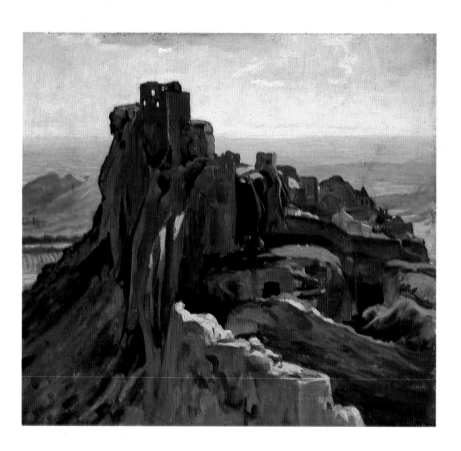

209.4 Castle of Les Baux, Provence

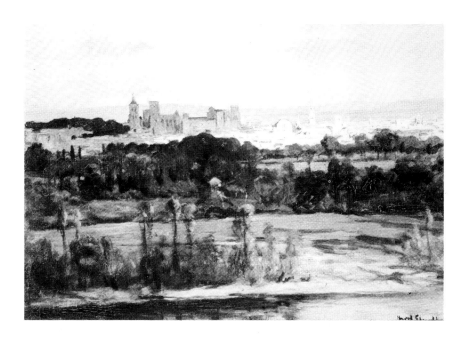

and systematic landscape, placed in relationship to a pale blue sky overhead.

Corot used interlocking blocks of colour in which tones were simplified and clear. In Elwell's landscape, a shaded grey section of the town, with an adjacent block of dark trees, forms a taut mosaic that is reminiscent of Corot's work. Layers of water, trees and grass lead successively into the picture space. One row of trees answers another, and prepares the eye for the indented line of the buildings beyond.

Elwell produced many paintings of Avignon in the years from 1922 to 1926, but not all in Corot's style.

1. c.1836. National Gallery, London. Jean Baptiste Corot (1796-1875).

222. THE PALACE OF THE POPES. AVIGNON: AFTERNOON

Oil on canvas 39.25 x 54 cms Dated 1926
Signed Private collection

A closer view of Avignon, from across the Rhône, gives centre-stage to the Papal Palace and surrounding buildings. Their sunbleached stone creates a harmony of cream against liquid and vaporous blue.

237. THE MARKET CROSS, BEVERLEY 1

Oil on panel 47 x 34.25 cms Dated 1927
Signed Private collection

Elwell portrays the quiet charm of his hometown in the afternoon sunlight. The expanse of the Saturday Market, with its 18th-century Market Cross, lies ahead, and St. Mary's Church tower rises from behind the shops on the north side.

In 1927 the parking space was more than adequate for one solitary car!

239. BEVERLEY MINSTER

Oil on panel 40 x 54 cms
Signed Private collection

This view of the whole of Beverley Minster from the north-east would be quite unattainable today. In around 1927, Elwell could see it from a distance over a grassy and vacant foreground that had been the site of a woodyard, and could include in his composition buildings which were probably those in Highgate and Wednesday Market.

From this viewpoint the cluster of domestic buildings can be perceived in close relationship with the great church — gable with transept, chimney with spire, and their highest point with the tall tower of the Minster's west front. It was a

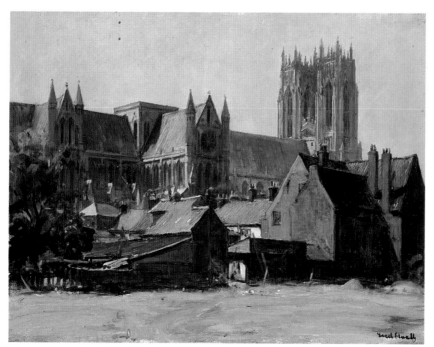

relationship which Mary also explored in her *Minster from the Friary*, 1934, to enable the mighty Minster to be viewed at its most human scale.

Under a sunlit blue sky, the roof tiles of the houses glow. Smoke issues gently from chimneys. The effect is harmonious and peaceful.

240. PATH TO BEVERLEY 1

Oil on canvas 50.75 x 59.75 cms
Signed Private collection

A yacht rests on a peaceful stretch of Beverley Beck, pervaded by sunlight. A funnel smoking in the vicinity is probably evidence of a small tug behind it. Boats are clustered there, while the

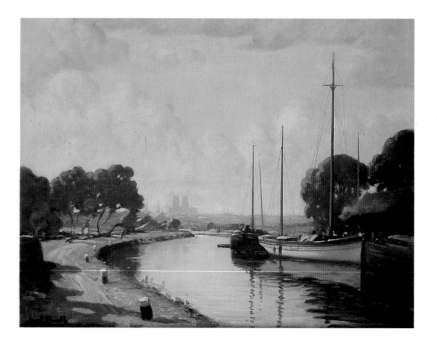

240. Path to Beverley 1

towpath to Beverley is clear, and the elegant curve of the Beck is untramelled.

Curvilinear shadows, trees and clouds make us conscious of their echoes of form, and suggest an ensuing sense of order. The river sweeps towards the Minster, which is the far prospect.

The Beck was a lifeline to Hodgson's Tannery[1], and a version of this painting (probably larger, but as yet untraced) hung at the company's premises, at Flemingate House.

1. Vid. *Beverley Beck* (40).

241. PATH TO BEVERLEY 2

Oil on metal 13.25 x 21 cms
Signed Private collection

This slightly reduced version of the previous painting (240) was painted on a metal plate. It was a gift to a friend whose own Beck House was close to the scene.

257. SCARBOROUGH HARBOUR

Oil on panel 42 x 54.50 cms
Signed Beverley Borough Council

Elwell's enjoyment of rooftops is particularly obvious here. He takes a high viewpoint of buildings, which are staggered down to the sea, and exploits the array of forms and unevennesses, and the harmony of orange and grey-blue, palely recalled in the distant sand and sea.

Fred and Mary were attracted to Scarborough in North Yorkshire. It was where they had spent their honeymoon, and several paintings were inspired by its expansive coastal scenery. In 1931, 55 of his works were exhibited at the Scarborough Public Library, to mark his election to the Associateship of the Royal Academy.

This scene encompasses the Old Harbour, set in the wide enclosure of South Bay, and the hill of Oliver's Mount on the far shore.

266. AN ALPINE LANDSCAPE

Oil on panel 31 x 41.25 cms Dated 1929
Signed Private collection

This landscape of Cortina d'Ampeggo in the Dolomites is one of a series which Elwell painted from or near the Park Hotel, in 1929. He explores the likeness of form between the pointed tops of

the firs as they rise on slender trunks and the soaring knife-edged and creviced peaks behind. These vertical accents, sharply illuminated in the sunlight, give the whole composition a feeling of optimism.

273. ADAMELLO MOUNTAINS, NORTH ITALY

Oil on panel 30.50 x 40.75 cms
Signed Private collection

From the rocky river bed edged by high grassy spurs, the view forward is closed by the Adamello Mountains, rising darkly to a tooth-like edge. The mountains (3554 m.) form part of the High Alps, north of Lake Garda.

Long, fluid brushstrokes mould the descending surfaces of the spurs. The greenness of natural forms prevails.

309. NORTH BAR WITHIN

Oil on canvas 42 x 63.50 cms
Signed Private collection

'Where can you find a lovelier street?' Elwell would pose this question with satisfaction as he looked up Beverley's North Bar Within.

He could catch a similar view to that of this painting from a position close to the medieval gateway to Beverley which adjoined his own Bar House. He loved the wide thoroughfare, its elegant Georgian houses with steps and iron railings to each front door, culminating in a view of the Market Cross, and the distant towers of Beverley Minster.

Shown in the painting's middle distance, on the sunlit side, is the Elwells' parish church of St. Mary. Opposite is visible the porch of the Beverley Arms, whose kitchen Fred returned to paint time after time.

310. A VIEW OF NORTH BAR WITHIN, WITH ST. MARY'S CHURCH

Oil 34.25 x 44.50 cms
Signed Private collection

Moving closer to the Market Cross, and later in the day than in the previous painting (309), Elwell draws attention to the sunlit passageways along North Bar Within. The second, by the Beverley Arms, denotes Waltham Lane, where

'Widdalls' (250) was painted. A street by St. Mary's Church contains Arden's Vaults, the setting for *Inventory and Valuation for Probate* (411). A gas lamp stands on the pavement outside the arched colonnade of the gas works.

312. NORTH BAR

Oil on canvas	35 x 50.75 cms
Signed	Beverley Borough Council

From a viewpoint in North Bar Without, the artist looks back towards the town of Beverley. The 14th-century brick gateway of North Bar, that traverses the street is perceived in silhouette as the artist faces the strong sunlight. The stepped battlements and arches of the Bar and the rooflines and chimneys of adjoining buildings point up against a hazy sky and the distant town.

The scene is crowded with associations. Fred and Mary's home, Bar House, is visible on the right of and adjoining the Bar. Over the central arch of the Bar itself, the lancet windows indicate a narrow guardroom within. This room was an integral part of the Elwell house, and was restored by their friend, the architect Richard Whiteing.

The Elwells loved to relate the history of the Bar. They talked of grand processions, notably that of Henry V and his retinue arriving to give thanks at Beverley Minster for his victory at Agincourt[1]. They relished the fact that Charles I, having been turned away from Hull by Sir John Hotham, took refuge at the home of Lady Gee, which was, in 1642, on the site of the present Bar House[1].

Near the foreground on the left is a house which was firstly the home of the artist's parents, James and Annie Elwell, when James was actively engaged there in his woodcarving business. Before 1914 it became occupied by their son, Ted Elwell, and his wife Kitty. The front of the building is immortalized in *A Curiosity Shop* (283).

1. *Yorkshire Illustrated*, January 1953, p.16

331. BEVERLEY MINSTER FROM HALL GARTH

Oil	63.50 x 76.25 cms
Signed	The National Trust of Scotland, Pitmedden House

Happily, a photograph exists of Elwell at work on the site in Hall Garth (Fig. 8). He painted the south-west view of Beverley Minster as it rises beyond a cluster of pantiled outbuildings. It is a domestic view that plays on the correspondence

of the Minster's transepts and pinnacles with prosaic buildings which are closer to the viewer and therefore relatively tall.

It was an approach which links this painting with *Beverley Minster* (239) where both town and Minster are integral.

336. CATHEDRAL AT AVALLON

Oil on panel 38.75 x 29.25 cms Dated 1936
Signed Private collection

The red accent in the foreground animates the cool purity of the cathedral. Tiny figures near the doorway are associated with a dramatic pool of light.

Elwell often dwelt upon this corner of Avallon in Burgundy, revelling in its variety of towers and doorways, and patterns of light and dark.

336. Cathedral at Avallon

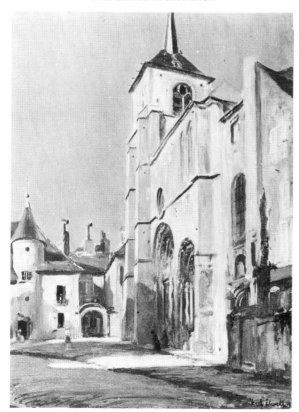

366. ZERMATT: AFTERNOON

Oil. on panel 39 x 28.50 cms
Signed Beverley Borough Council

Several paintings by Fred and Mary of the region of Zermatt and the Matterhorn in the Swiss Alps were produced in the period 1937-9. At least one sojourn there was made at Christmas. Friends who received gifts of these paintings told of the difficulties which the Elwells experienced escaping from Switzerland at the outset of the Second World War.

In the crisp, clean air the features are sharp. The roofs of Zermatt are angled and catch the light, like the landscape behind them. The church, like a mountain peak piercing the sky, belongs to the landscape.

386. ST. FILLAN'S, PERTHSHIRE

Oil on panel 40.75 x 30.50 cms
Unsigned Private collection

There is an impression of richly coloured depth in the reflections upon the River Fillan. The view across it to the heathered hills of Straith Fillan, has at its centre the small clearing which is the site of St. Fillan's Chapel. Lively brushwork, with flecks of white, suggests the reality of the Scottish scene as it subtly changes and sparkles in the sunlight.

407. SWEDISH COAST

Oil on canvas 47.50 x 74.25 cms
Signed Private collection

Through the silent and watery foreground to the sharp clarity of the flat, indigo sea beyond, Elwell has been moved to capture the intrinsic stillness of the Nordic coastline.

From the inscription it is known that the painting was produced in Sweden, but there is a natural abstract and unanchorable quality in the landscape itself which, unusually for Elwell, makes the particular location irrelevant.

Fred may have painted this seascape in about 1946, when he and Mary went together on one last holiday, believed to have been in northern Scandinavia. Mary had already suffered strokes,

and one of her maids was concerned about her making the journey. These circumstances might also account for the artist's approach to this subject, one that is contemplative in mood.

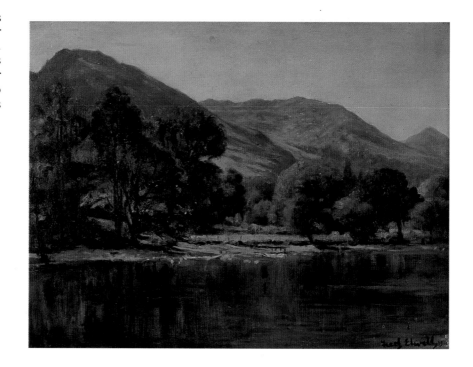

386. St. Fillan's, Perthshire

407. Swedish Coast

A Sense of Place

After returning to Beverley in around 1896, Elwell resumed an interest in the rich tones and dark ambience particularly evident in Dutch interior scenes. *Artist in his Studio* (38) carries this influence to evoke a strong sense of place.

The development of this close relationship between the figures in his paintings and their appropriate settings became increasingly more evident. Elwell's portrayals of working life began to explore the surroundings just as much as the kitchen maids or woodcarvers who inhabited them. His wider interest in the interiors themselves then evolved to make them more than backdrops, and instead they became the main focus of attention.

When, in 1917, he was moved to include in his painting of Lord Kitchener's memorial service the impressive surroundings of the nave of Beverley Minster (141) he was following a Dutch tradition of giving prominence to church architecture in the composition. Artists like Peter Saenredam (1597-1665) were the greatest exponents of this art form. Events such as the Garter Service (353) or King George V's lying-in-state (340) were most effectively portrayed at a distance, allowing the scale and architectural grandeur of the church interior to instil in the scene a sense of larger than ordinary values.

Elwell was particularly attracted to structural form, whether decorative or functional. The exposed timbers of *A Curiosity Shop* (283) were as important to him as the main subject matter, just as the workshops (250) and barns (346) which appear in the section 'Scenes of Working Life' can be seen as careful studies of the inner construction of buildings.

The meticulous and unified style of painting which Elwell achieved with *The Last Purchase* (156) was the key to his becoming a more purist painter of interiors. With the narrative element removed, the focus of attention becomes the sharpness of definition, the differentiation of light and shade, and the enticement to the viewer to explore a series of spaces. There also comes an increased focus upon objects within such scenes which, in *Bric-a-brac* (289), were able to replace the figure in the composition.

This meticulous style appealed to Elwell's wealthy patrons. In the interior of Burton Constable Hall (286), for example, it was important to the Chichester-Constable family that the craftsmanship and elaborate detail of the interior should be recorded with accuracy and precision.

A further approach evolved later, for *Drawing Room, Masham* (396), where he painted the softer edges, tones and colours of nature.It is as if the landscape through the window had inspired Elwell to view the scene with the eye of a landscape painter.

38. ARTIST IN HIS STUDIO

Oil on canvas	37.50 x 50.25 cms
Signed	Beverley Borough Council

Elwell himself is the smocked artist at work on a large canvas in his studio at Wood Lane, Beverley. The easel is arranged at right angles to the limited source of light. Around him are his finished works, including *Girl with a Kitten* (35), and a collection of items useful as subjects for still lifes.

In choosing the theme of the artist in his studio

Elwell was following a long tradition, but may also have wanted to convey the image of himself as an established artist, having obtained his first studio. After a troubled spell in London he was determined that he would succeed here, and his interior painting evokes a strong sense of place.

He preferred a dark studio, claiming that, as he highlighted images on the painted canvas, they could shine out. The dark and rich effect of this painting also recalls Elwell's early interest in Dutch portrait and interior painters like Rembrandt and Frans Hals.

141. EVENSONG, BEVERLEY MINSTER 1 (or MEMORIAL SERVICE TO LORD KITCHENER)

Oil on canvas	111.75 x 86.25 cms	Dated 1917
Signed	On loan to Beverley Borough Council from a private collection	

A building of architectural magnificence and challenging perspective gave Elwell his first opportunity to explore a church interior, the eastward view of the nave of Beverley Minster. The nave forms a massive receding tunnel of

141. Evensong, Beverley Minster 1

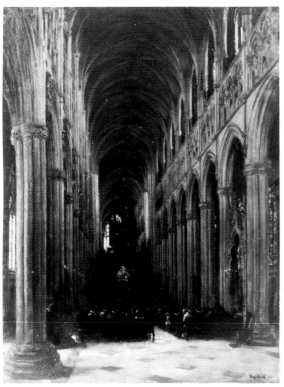

double arcades surrounded by a high-pitched groin vault. Elwell defines and enlivens the scene with light — it strikes each architectural member in succession and emphasises the depth of the structure.

Dwarfed by the architectural scale is the kneeling congregation on the occasion of the memorial service for Lord Kitchener, held on 13 June 1916. The British Field Marshal and statesman died when the ship carrying him struck a mine. This was a national calamity which touched every town in Britain.

The Minster was important as a unique symbol of Beverley's character and history. No doubt a sense of pride inspired Elwell's painting of it. At his 1927 exhibition in Sunderland, which was declared 'a glorious victory' for Beverley, *Evensong, Beverley Minster* had, said the reviewer, 'captured some of the soul of a noble dignity'[1].

At the far end of the nave is James Elwell's intricately carved organ screen, designed in the Gothic style by the renowned architect Sir Gilbert Scott. The execution of the screen in 1880 was James' *magnum opus*.

1. *The [Hull] Daily Mail*, 28.1.1927.

228. 'TO BE SOLD BY AUCTION'

Oil on canvas	76.25 x 91.50 cms
Signed	Private collection

In 1925 the Barnard family departed from Cave Castle[1], in the East Riding, which they had occupied since the mid-18th century. It was a Gothic style country house, embellished with turrets and battlements, and situated in its own park. The rooms Elwell represents in this painting were on the first floor, overlooking a lake.

The contents of the house, arranged for auction, have provided Elwell with an accumulation of interesting objects to paint. He records these in meticulous detail, like those of *The Last Purchase* (156). The recurring theme of buying and selling antiques is appreciated by Elwell the curio collector, as much as by Elwell the artist.

Although the interior is uninhabited, the presence of the objects is not entirely passive. A figurine group takes the place of foreground figures. The blue tapestry seats lead the viewer into the painting, as their colour is echoed into its

deeper space. A ticket attached to the stool points to the centre aisle that leads to the second room.

Some of the original elegance of the interior, including the cornices and vaulted ceilings, decorated in blue and gold, is visible. The country-house interior was for Elwell a useful new direction which would lead to commissions for portrait-interiors in the future.

1. More recently Cave Castle Golf Hotel, South Cave.

280. MY NEIGHBOUR'S HOUSE

Oil on canvas 100.25 x 125.75 cms Dated 1929
Signed Bristol Museums & Art Gallery

At a first glance, like *'To be sold by Auction'* (228), we could read this as an uninhabited interior. The wide-angled view, and the inviting series of spaces, encourage the viewer to move about the painting, picking up points of detail in the furnishing and architecture. In so doing we discover the slim, blue-clothed figure on the stairs. So little does she intrude that she almost blends into the composition, an echo, in form, of the hallway arch and an indicator of the space of the staircase which might otherwise have been lost.

The interior, defined in meticulous detail, reveals the view from the front door of St. Mary's Close[1], at 7 Hengate, Beverley. Elwell highlights the reflective surfaces, such as the 'barley-twist' uprights of the staircase, and the glittering chandelier. The stone flags of the hall[2] lead from a corner fireplace to the archway, then to a 17th-century cupboard on the right, and finally to the vista of light from the French windows of the lounge. By substituting the plain floor that actually existed there with a pattern of marble insets, Elwell draws attention to the progression of depth in the composition, much in the manner of the Dutch interior painter Jan Vermeer (1632-1675).

The house[3] was built in 1709, and became the town house of the Constable family of Wassand in the East Riding. Henry Constable had initiated the custom of scratching on the breakfast-room window the names of distinguished visitors. Fred Elwell's name was added , presumably when it was the home of his friends, the Whiteings — Richard (who features in *The Birthday Party*, 319) and Madge, his sister. In this painting it is their mother, Mrs. Whiteing, who is descending the stairs.

A painting circle grew around the Elwells and Whiteings in Beverley. Richard Whiteing was Resident Architect to Beverley Minster. Madge painted in watercolour and drew with pen and ink. She had known Fred from the time of his training in Paris.[4]

1. Mary Elwell also painted this view, from the opposite direction, in *Interior*. Compared with Fred she saw a sharp tonal contrast. The arch was conceived as black, intensifying its form in the overall design.
2. Information about the interior from Elisabeth Hall and Pat Deans.
3. History from *Country Life*, 1965, p.143.
4. Vid *Master of the Forgotten Art of Living*.

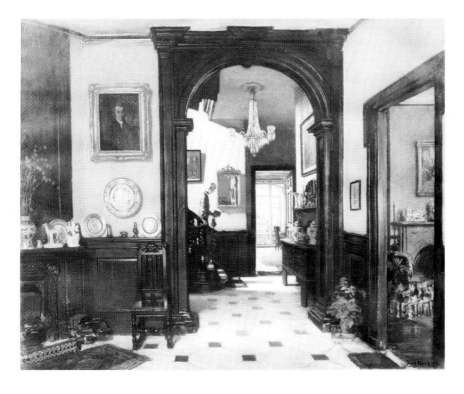

280. My Neighbour's House

283. A CURIOSITY SHOP 1

Oil on canvas 102.75 x 128.25 cms Dated 1929
Signed Harris Museum & Art Gallery,
 Preston

The setting for this painting is a shop at No. 4
North Bar Without, Beverley, which, in 1893,
was known as the 'Old Curiosity Shop'. At that
time it was owned by the artist's father. Above it
there was comfortable living accommodation.
Behind that, accessed by a little bridge, was the
first floor workshop of *A Woodcarver's Shop*
(155). A reporter for *The Sketch*[1] in 1893 found
the whole building 'a fine specimen of timbered
work, with richly carved mouldings and cornices
right up to the roof ridges'. It beamed 'in sudden
surprise upon you behind the 14th-century North
Bar' from the approach of North Bar Within. It
was, he said 'a quaint corner . . . made still
quainter by Elwell's shop'.

By 1929, the date of this painting, it belonged
to Edward (Ted) Elwell, whose cabinet-making
business was carried on in the workshop behind.

Elwell revels in the shop's interior, which is
filled with numerous curios, for him the true
elements of a still life. He exercises great skill in
reproducing the sparkling transparency and fine
detail of the glassware, and the way it reflects on
a polished oak surface. He is also painting with a
collector's eye, as one accustomed to making
close and critical inspection.

This interest is wittily stated — the figures of
Fred and Mary Elwell peer in through the shop
window, as potential customers, while the viewer
is invited inside.

1. *The Sketch*, 4.10.1893

286. THE LONG GALLERY, BURTON CONSTABLE

Details and location unknown

*'There are several pictures of Burton
Constable, that magnificent Tudor mansion
in Holderness. Despite the traditional ghosts
— which he had never seen! — Mr. Elwell
spent hours alone in this ancestral home,
especially in the Long Gallery.'*[1]

According to John Chichester-Constable,
Elwell was a family friend at the time of his
grandfather, Brigadier Raleigh Chichester-
Constable. Portraits of both men, painted by
Elwell, hang at Burton
Constable Hall (414,
367).

Elwell's view of the
Gallery encompasses its
full length of 120 feet,
lined with panelling and
a well-stocked library.

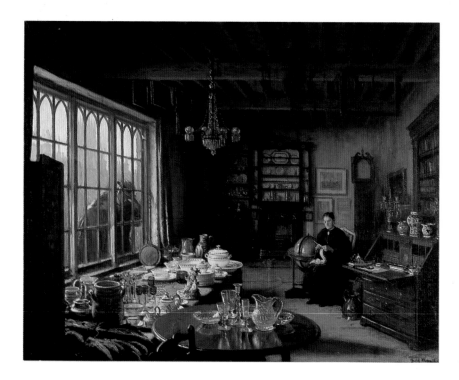

283. A Curiosty Shop 1

Its frieze is copied from that of the Bodleian Library, Oxford. Oriental pottery and Chippendale furniture furnish the side walls[2]. The composition emphasises the length and symmetry of the Gallery, while permitting two elements of eye-catching disorder. One is the effect of light cast on the floor in bold patterns. The second is the arrival of two nuns who are being shown around.

The latter is a reminder that Burton Constable has for long been a Catholic house, yet perhaps there is also a suggestion of the family ghost, a nun, about whom Elwell had been told. It might be that he had visions of the nun when he was locked in this same part of the house by mistake and had to climb out through a window[3]!

The report in the *Dalesman*[1] also referred to *Reading the Will* (305), in which a lawyer reads the will to 'an assembly of bereaved relatives, with rows of ancestors looking down from their gilt frames', as being set in the Long Gallery. There are indeed clear similarities in the setting, particularly in the panelling, bookcases, pottery and the distinctive frieze. Perhaps the obvious differences, however, such as the pattern of the ceiling, have been introduced deliberately by Elwell so that the narrative of *Reading the Will* is not place-specific.

This work was reproduced on the centrefold of the *Illustrated London News*[4].

1. *Dalesman*, March 1958.
2. *Hull Times*, 10.1.1931.
3. Described in *The Lady*, 6.4.1961.
4. 11.7.1931.

289. BRIC-A-BRAC

Oil on canvas 91.50 x 71 cms Dated 1931
Signed Lincolnshire County Council, Usher Gallery, Lincoln

Through quiet spaces the viewer is led along a passageway, through the geometry of doorways and into the slanting rays of the sun. The scene is peaceful and ordered. As in *'To be Sold by Auction'* (228), a group of figurines invite us to enter the composition, and in the distance there is added a hint of red to attract the eye.

Fred's interest in the uninhabited interior was particularly shared by Mary, who painted similar views of homes in Beverley and beyond.

322. THE ARTS CLUB, DOVER STREET

Canvas Formerly at The Arts Club, London (destroyed in the blitz 1940)

As an Associate of the Royal Academy, Elwell was privileged to become a member of The Arts Club in London. By 1935, when his painting of its drawing room was exhibited at the Royal Academy, and he had acquired a studio in London, he was able to dine there after Royal Academy elections and varnishing days. Alfred Munnings would share the 'happy company' which included 'Elwell from Beverley' and 'Lamorna Birch from Cornwall'[1]. The Club, which had previously numbered Whistler and Rossetti among its members, served as a meeting place for a circle of like-minded artists.

This painting, viewed in Beverley in 1935 by Kate Hobson, was 'an interior with figures painted of the lounge of the Club in Dover Street — that spiritual home of so many famous artists — with a vista through a further door [and] the light . . . diffused through long windows over the quiet room'.[2]

The setting itself was, said Munnings, 'a room to live up to'. He praised the 'mellow crimson walls, crimson damask curtains, fine pictures, Chippendale chairs, soft settees, . . . and, crowning it all, the glittering Waterford chandelier hanging from the centre of the ceiling'. He spoke of the 'crowded gatherings . . . held in that room when a man, who could afford it, stood champagne to the company after he had been elected a Royal Academician'.[3]

In September 1940 the Club took a direct hit from a bomb. Sadly, the drawing room suffered damage, and the painting was destroyed. Much later, in 1955, Elwell presented to the Club a second version, *Arts Club Smoking Room* (405) to replace the earlier painting. This was produced from memory and photographs of the original work. It still hangs at The Arts Club as a testimony of how the room appeared before the blitz.

1. A. Munnings, *The Second Burst*, Vol II, Museum Press Ltd., 1951, p.197
2. *Beverley Guardian*, June 1935.
3. A. Munnings op. cit., p.196.

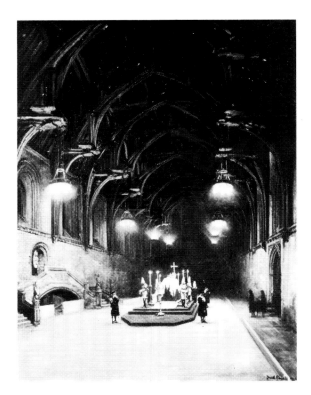

340. The Lying-in-State, Westminster Hall

340. THE LYING-IN-STATE, WESTMINSTER HALL

Signed Location unknown

Elwell enjoyed his encounter with H.M. King George V, who had sat for his portrait (296) in 1932, and may have painted the lying-in-state as a homage to him.

He depicts the catafalque on a torchlit dais in a sombre Westminster Hall, beneath its magnificent 14th-century hammer-beam roof. The scale of the composition recalls Elwell's earlier interior works, particularly *Evensong, Beverley Minster* (141).

Westminster Hall was the seat of the chief law court of England for centuries, and witnessed the trial of Charles I.

King George V, who reigned from 1910, died in 1936.

353. THE GARTER SERVICE, ST. GEORGE'S CHAPEL, WINDSOR, 14th JUNE 1937

Oil on canvas 91.50 x 71 cms Dated 1937
Signed Private collection

Elwell acquired his London studio in 1935, and was therefore close at hand to paint such scenes as this and *The Lying-in-State, Westminster Hall* (340). His painting of the Garter Service at Windsor could have had its roots in Elwell's earlier meeting with the 14th Earl of Strathmore, whom he painted in his drawing room at Glamis (293). The Earl, the father of the new Queen Elizabeth, was one of those invested in Coronation Year, 1937, when this painting was executed.

Each year, on a Monday in June, the Sovereign and the Knights Companion of the Order of the Garter walk in procession through Windsor Castle to St George's Chapel for a service of thanksgiving and the installation of new Knights. King George VI and Queen Elizabeth occupy the Royal pew. The Military Knights of Windsor stand out in their scarlet swallow-tail coats with white cross sword-belts. Each Knight of the Garter has, by tradition, taken possession of a stall beneath his personal banner. Elwell shows the Garter Service about to begin[1].

He conveys the sense of occasion and immense space, his vertical, wide-angled view of the Chapel enabling us to see the magnificence of its fan vaulting, as it soars upwards and fades in the far distance. Elwell presents this in relation to the receding line of banners and the pageantry of the Knights below.

The 'Most Noble' Order of the Garter[2] originated when King Edward III created the first Knights at Windsor[3]. The Order subsequently became very exclusive, and to this day remains in the personal gift of the Sovereign. St. George's Chapel was built in the Perpendicular Gothic style to house the Order, and is one of the greatest Royal ecclesiastical buildings.

The Military Knights[4] originated at the same time. Edward III provided for 'poor or decayed' Knights to be accommodated at Windsor Castle as part of the Order. In return they were required to relieve the Garter Knights of a restrictive duty by representing them at the compulsory daily Mass in St. George's Chapel. They now live conveniently opposite the Chapel, to the south. Thirteen in number, they are appointed by the Sovereign from among Retired Army Officers

with distinguished records. It is they who lead the Garter Procession.

1. Details from Commander B. Bland, whose uncle, Major Henry Clough, O.B.E., was one of the Military Knights at the time.
2. Reference: J.H. Plumb and Huw Wheldon, *Royal Heritage*, BBC, 1977.
3. Their motto, *'Honi soit qui mal y pense'* (shame to him who thinks evil of it) originated when King Edward III picked up a lady's garter.
4. J. Paget, *The Pageantry of Windsor*, Michael Joseph, London, 1979.

396. DRAWING ROOM, MASHAM (or THE GREEN ROOM)

Oil on canvas 63.50 x 76.25 cms
Signed Private collection

This fine interior shows the drawing room of Reginald Brundrit, R.A. (1883-1960) at The Old Vicarage, Masham. Here, he lived and painted the Yorkshire landscape.

The window, which embraces a view of the light-filled countryside, is the focal point of the interior, an altar to nature. From it, sunlight is cast upon the polished surfaces and bathes the room in a soft aura.

Brundrit was a fellow Academician and a close friend, who frequently visited Bar House. Mary produced a portrait of Fred (probably in the 1940s) at Brundrit's home. His style of painting has been considered essentially English[1].

His landscapes tended to be dour in colour and the paint was applied in thick impasto and rubbed with a rag. They were often characterized by bright highlights and dramatic *chiaroscuro*. He depicted above all the stark terrain of the Yorkshire Pennines. Elwell has included a painting by Brundrit, of the stepping-stones at Grassington, on the right of his own composition.

1. *The Edwardians & After,* Royal Academy, London, 1988, Weidenfeld & Nicolson, p.68.

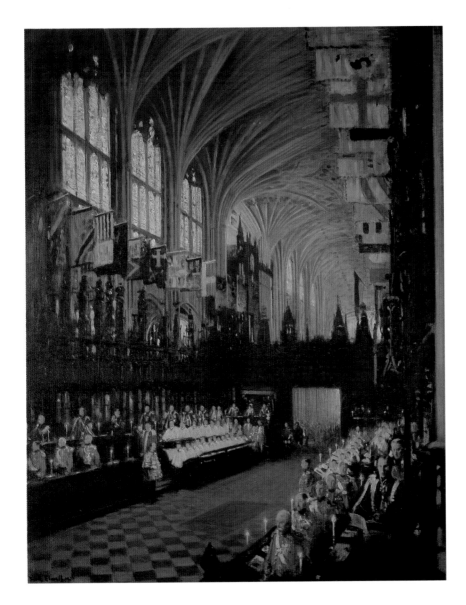

353. The Garter Service, St. George's Chapel, Windsor, 14th June, 1937

97

A Window on Work

If Elwell revelled in the subject of work it was partly derived from his admiration of Northern European genre painting, and related also to his desire to represent the familiar and everyday activities of his native Beverley.

Elwell also had a particular belief in the intrinsic value and dignity of work, and had inherited from his father an enthusiasm for skilled craftsmanship. He was able, in *A Woodcarver's Shop* (155), to reveal the creative energies of craftspeople. Attracted by the process, he would include details like the pipemaker's 'gin-press' (51), providing a valuable historical record of working practices in the town. He was a traditionalist who was fascinated by the old methods of production.

One of the further treasures found in Elwell's understated subjects is the unexpected beauty he was able to disclose, whether in the vitality of the figures in *Preparations* (401), the great rafters of *Armstrong's Garage* (160), or in a simple accident of light. Throughout all of these, the clutter of objects provided the opportunity for a wondrous indulgence in still life.

He first approached the subject of work in 1903 with *Pot Boy* (50), a robust, rather Flemish image of cheerful disorder, with a figure surrounded by pots.

Perhaps it was then the peaceful ambience of Beverley, or his own maturing view of it, which brought about a change of mood. He began to paint the sympathetic relationship between worker and workplace. To achieve this he needed to take a step back from the figures, in order to include their working environment in equal measure: in this, his approach paralleled the development of his portrait interiors.

His Beverley Arms paintings now began to echo the serene and ordered domestic interiors of Pieter de Hooch (1629-after 1684). He admired the enclosed world of the kitchen, its workers adhering to its traditions and wrapped in an apparent sense of security. Elwell wanted to capture its life on canvas, and for his subjects to continue their tasks, seemingly unaware of his intrusion.

There is, however, a paradox in Elwell's approach, since in fact he often used models to stage these scenes of 'reality'.

50. POT BOY

Oil on canvas 106.75 x 165 cms Dated 1903
Signed Private collection

Like *The Butler takes a Glass of Port* (6) of 1890, this painting bears the mellow colouring and glowing light against darkness of Northern European art, and seems most associated with the genre painting of David Teniers the Younger (1610-1690) of Flanders. Scattered, as if at random, are found numerous incidental objects and utensils. Everything, down to the straw emerging from a basket, is imbued with Elwell's delight in realism. There is an air that approaches the burlesque in the pot boy's jaunty expression, as he sits astride the tub, on the puddly and cluttered floor; his hat lies at a rakish angle, and his waistcoat glows a cheerful red.

He is washing and polishing brass and copper pots at the Beverley Arms Hotel. Elwell would later paint many scenes of working life at this site, but this early view is different. Only in this one does the figure address us directly. There is a bright acceptance of disorder that was not to

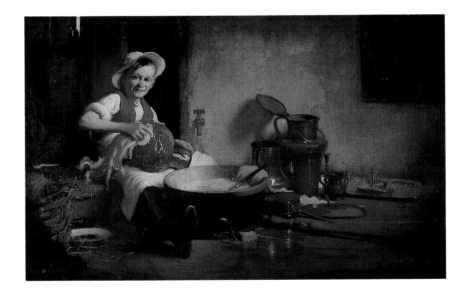

occur again in Elwell's approach to such a subject.

Diagonals, such as his leg and the turned wooden implement, create a composition of movement, and their arrangement, often with a touch of emphatic red, is the result of a much more careful structuring of the scene than the general appearance of disorder suggests. The swirling effect of the polishing cloth is achieved with vigorous arabesques of the paint.

51. THE LAST BEVERLEY PIPEMAKER

Oil on canvas 76.25 x 63.50 cms
Unsigned Wilberforce House, Hull City
 Museums & Art Galleries

Exactly 12 clay pipes, newly moulded by the last Beverley pipemaker, rest upon a 'dozening board' in the foreground. Tobacco pipes were traditionally sold, and therefore treated, in dozens. Their placing in the composition of the painting suggests the depth of space in the scene, and draws attention to the hirsute figure working at his bench.

To make such pipes[1], a piece of malleable clay (like that shown at the pipemaker's right side) is rolled to form individual stems, closed at one end by a lump. These are collected on his left. In the painting he is shown sliding a wire part way down a stem, to create the stem tube. To excavate the bowl of the pipe and shape the pipe correctly, he uses a two part mould, put in a rectangular box and clamped tightly in the levered machine on his

left, known as the 'gin press'. Then, releasing the clamp, he slides the wire further up the stem, reaching the bottom of the bowl, and pulls it free. To remove the pipe from the mould, he uses 'neats foot oil' from the small dispenser by his right arm, and refills the dispenser from the bottle. The pipes on the 'dozening board' are now ready for trimming and smoothing by an apprentice who adds their slight curve before firing. The pipes represented are neither the shortest 'cutty' nor the longest church warden's (of up to 28 inches) which the pipemaker could produce.

The last Beverley pipemaker was John Goforth Junior, who traded until 1910 in a small workshop in George & Dragon Passage (since named Monk's Walk), leading from Highgate to Eastgate[2]. The painting would therefore have preceded 1910 for Elwell to paint him, and compositionally it has links with *Pot Boy* (50) of 1903. This nostalgia for 'the last' of a kind would recur later in Elwell's work.

1. Information on clay pipemaking from Flight Lieutenant P.R. Rayner.
2. Information from John Markham.

101. THE DRESSMAKER

Details and location unknown

The intimate scene of the dressmaker in her everyday surroundings is one which resembles *The Harbour Window*[1], by Stanhope Alexander Forbes (1857-1947), an artist of the Newlyn Group. The latter was exhibited at the Royal Academy in 1911, when Elwell was also an exhibitor. Elwell shared the preoccupations of the Newlyn Group in studying humanity in relation to its surroundings. Here he represents

the young woman at her table, with the tools of her trade taken from a workbasket as she prepares to place a paper pattern upon the fabric. Visible in her sitting room is a mantelpiece curtained by a frill, in the typical style of the period.

The model is Florence[2], Elwell's niece, whose portrait (33) he painted when she was twelve years old. Florence Elwell (1885-1970) frequently visited his studio, and modelled for paintings. She married Abner Blyth in 1908. When she first met him he was apprenticed, like James Holmes[3], to James Elwell, her grandfather, and he became a cabinet-maker. She was petite, a gentle but strong character, with a sense of fun. She learnt tailoring from her parents-in-law, at 6 Hengate, Beverley, thus her inclusion as the subject of this painting is not inappropriate. Her first home after marriage, and where two sons[4] were born, was 6 Mill Lane Beverley. This is probably the setting for the painting.

1. 1910. Royal Academy of Arts, London. Illustrated in *The Edwardians and After*, Royal Academy of Arts, London, 1988, p.39.
2. Information from her son and daughter, Abner Elwell Blyth, O.B.E., C.E., F.I.C.E., and Nora Blyth.
3. Vid. 4.
4. The second son, Alan, and herself, were possibly to be featured in *A Mother and Child* (126) of 1915.

144. A JAM FACTORY

Oil on canvas 81.25 x 109.25 cms
Signed Location unknown

At the outbreak of the First World War, Fred was, at 44, too old for military service. He and Mary used their gypsy caravan as a base in the East Riding town of Driffield, to enable him to perform 'war-work' at Field's Jam Factory. The factory was to become the subject of this painting, in which he captures the mood of its bustling activity.

The painting is an early example of Elwell's treatment of the theme of work. Men and women are transporting fruit to large wooden vats, and stirring the jam as it heats in copper vessels. The primitive flagons and wooden tubs are still, in 1918, part of the factory process. The woman in the foreground demonstrates clearly that jam-making is a strenuous task, as she tilts her back to take the strain of the heavy bowl of fruit.

From the artist's point of view, the subject offers a variety of poses and justifies an assemblage of still life. He shows the effect of light passing through steam, and reflections cast upon the highly polished factory floor.

The factory[1] (now demolished) was in Kings Mill Road, Driffield. It was built on the site of a strawberry garden, enabling the fruit to be picked and made into jam on the spot. During the War the fruit was to be supplemented with turnips. The jam sold for

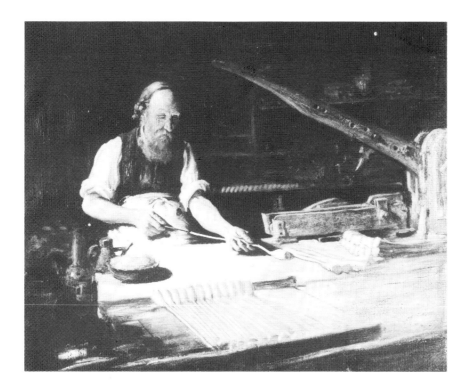

51. The Last Beverley Pipemaker

one shilling a jar. A workforce of 50 was employed there.

The painting itself was found damaged in 1976, and was photo-graphed in this con-dition[2]. Later, retouching by another hand obscured some of the features. One of the pottery flagons near the foreground figure was painted out. Since then a local artist, Kenneth Beaulah, has restored the work, aiming to redress the problems of the earlier retouching. The right arm of the foreground figure was entirely repainted. As the photograph had not then come to light, he had no knowledge of the flagon, and its image is still missing from the work.

1. Information from Christine Clubley, Driffield local historian.
2. Photograph published in V. Wise, *Frederick Elwell 1870-1958*, Hutton Press Ltd., p.19.

146. MAIDS WITH PIGEONS (or HILDA AND MARY)

Oil on canvas 127 x 101.50 cms Dated 1918
Signed Beverley Borough Council

After Fred's marriage in 1914, he recorded the maids at work in the kitchen of Bar House, which

146. Maids with Pigeons

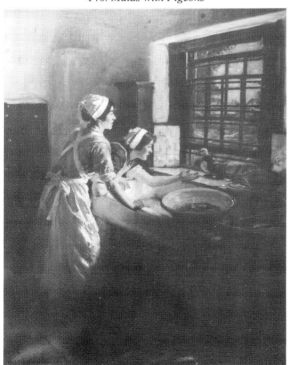

was then his home. He observed every detail of their work, like the immersion of potatoes in a large bowl. By the judicious use of highlight, the water appears convincingly wet. Light enters the scene through the window to bathe the kitchen within.

The effect of the light in this work is very different from the more dramatised light upon the *Pot Boy* (50) of 15 years earlier. The boy might also have been performing for our benefit, as he engaged our attention. In this later painting a more subdued naturalism prevails. The maids, oblivious of our presence, continue their business of feeding the birds. Inadvertently almost, we seem to witness the continuum of their actual life.

Elwell was, however, fully aware of the composition as always. The encounter of the maids with the birds created a balance between two distinct elements. At the interface of the window two opposite worlds meet: the inner domestic one and the outer sunlit garden.

The girls were actually the Elwells' maids: Hilda Harrison is on the left, and on the right is the Scottish maid, Mary Agar, whose golden hair was the cause of Elwell having to procure pigment specially.

150. THE 'BEVERLEY ARMS' KITCHEN (or AN OLD INN KITCHEN)

Oil on canvas 128.25 x 102.25 cms Dated 1919
Signed Tate Gallery, presented by the Trustees of the Chantrey Bequest

The Beverley Arms Hotel presented a dignified frontage to the main street of North Bar Within, close to Elwell's home. It was a place with which he was very familiar, a rendezvous for lunchtime conversation with Beverley friends, where he was on amicable terms with the proprietors, the Morley[1] family. That the 18th-century building retained qualities of the original inn, particularly in the kitchen, is indicated by the alternative title of this painting, *An Old Inn Kitchen*. The interior, with its uneven flagged floor, arched Georgian window and range of ovens, evokes the traditional mood of the country town of Beverley.

The style and subject-matter of the work owe a great deal to Dutch genre painting[2], and to Chardin[3] who was in turn influenced by it. From these sources Elwell derives the domestic subject and the strength of detail with which he lovingly depicts the utensils, their textures defined by the effects of light. From Pieter de Hooch may come

the mood of serenity, and the image of the open door which extends the impression of space beyond. The quality of absorption, seen in the maids engaged in their daily routines, speaks of the domestic scenes painted by Chardin.

Elwell's perception of the kitchen and its customs provides detailed evidence of the working methods of the period. The chicken is being plucked, for instance, after immersion in hot water. But the painting is also remarkably well-ordered as a work of art. In the foreground the two figures and the earthenware bowl on the floor are massed together in the classical composition of a triangle. The path of light along the flagstones invites the eye into the painting's recessional space. Elwell is both recorder and artist.

Considerable interest was aroused amongst the workforce of the Beverley Arms while Elwell worked on the site. Phyllis Downham[4], who modelled the standing figure, was Mary's god-daughter, and Miss D. Foster[5], plucking the chicken, was a member of the Elwell household. It was reported that Mrs. Morley was piqued, as a professional caterer, because the bird being plucked on her premises appeared to be an old cockerel. 'But it was such a nice colour,' protested the artist in defence!

The completed painting was distinguished in being selected by the Chantrey Bequest for the Tate Gallery[6] in 1919. This fund, administered by the Royal Academy with the collaboration of the Tate Gallery, was designated to purchase British works of the highest merit for the Nation.

1. References to Elwell re the Beverley Arms and the Morleys in *The Beverley Arms. The Story of a Hotel* by John Markham, Highgate Publications (Beverley) Ltd, 1968, p.17.
2. Particularly Pieter de Hooch, e.g. *A Boy bringing Pomegranates*, c.1662, Wallace Collection, London.
3. Vid. *Girl Returning from the Market*, 1739.
4. Also modelled *The New Frock* (147), *The War Worker* (148).
5. Also modelled *An Old Inn Kitchen* (172).
6. *The Times*, 27.6.89.

155. A WOODCARVER'S SHOP

Oil on canvas	101.50 x 127 cms	Dated 1920
Signed	Paul Tomasso, Fine Art Dealer, Leeds	

Lively brushstrokes capture the immediacy of this active workshop, with its movement and clutter, and atmosphere of enthusiasm. The artist describes the woodcarver's shop of Elwell & Sons, at No. 4 North Bar Without, Beverley, owned by his father. This was a scene he knew well.

The man wearing a trilby is James Elwell[1], who has unrolled plans on the bench, and consults with his cabinet-maker, Harry Metcalfe. Both are entirely engrossed in their work. A joiner wields a mallet by the far window. James

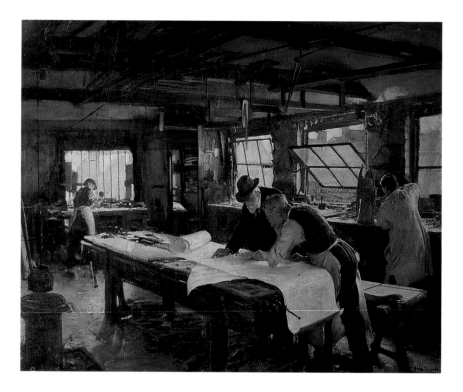

155. A Woodcarver's Shop

Holmes[2], in a smock, carves an angel. A partly-worked pew-end is supported on trestles behind him. The glue-pot is suspended over an iron stove, to be constantly warm and melted for use.

The work in hand is ecclesiastical, of the kind James Elwell particularly enjoyed. By the time of this painting he was 84, and the level of activity was reduced. Earlier in his life he had made screens and stalls for numerous churches, including Lincoln Cathedral and Holy Trinity Church, Hull, and undertaken major woodwork restoration at Driffield Parish Church. He had also carved the largest organ case in the world at that time, which was despatched to Sydney, Australia. His *magnum opus*, however, was the Victorian Gothic choir-screen, carved in oak, for Beverley Minster, and designed by Sir Gilbert Scott.

In 1893 a reporter for *The Sketch* had entered the workshop via the bridge which linked to the house and family antique shop (*A Curiosity Shop*, 283). He perceived a place 'full of sound [and] scents of pine and cedar'. At that time some 50 craftsmen were assiduously working on the premises.

Miss M. Holmes, the daughter of the man carving the angel, has testified to the realism of *A Woodcarver's Shop*. She recalls the floor of the workshop being permanently covered with wood shavings. James Holmes' father was the sawyer on the premises, where he maintained large quantities of wood for the period of seasoning. This was stored in the area below the workshop, and the two floors were linked by a step-ladder. Although her father is portrayed wearing a smock, he rarely did so in reality. Perhaps Elwell was taking yet another nostalgic view.

1. Of *The Last Purchase* (156) and various portraits.
2. Elwell painted his portrait (4). They had been friends since schooldays.

160. ARMSTRONG'S GARAGE

Oil 99 x 124.50 cms Dated 1921
Signed Williamson Art Gallery and
 Museum, Birkenhead, Wirral

A garage interior enables Elwell to explore the contrast between uneventful space and the concentration of work by two mechanics in the corner. Typically, the roof's interior construction is a significant part of the composition[1], and made visually interesting by the effects of light.

Gordon Armstrong's motor engineer and garage business[2] had been established since 1907/8 on the corner of North Bar Within and Tiger Lane, in Beverley. He was a very practical individual who designed and manufactured a car and built an aeroplane. Attempts to fly the plane from Beverley Westwood were unsuccessful, much to the disappointment of the waiting crowds! During the First World War he worked on munitions and tractors, buying a site at Eastgate, Beverley, for the additional space he needed. He later produced there the famous Armstrong car shock absorbers, which were to become the mainstay of the business.

When this painting was executed in 1921 the original garage was being used for car maintenance and repair. In the foreground,

160. Armstrong's Garage

mechanics are working on a stripped-down engine. Across the central space, others are employed at benches and changing the wheel of an open tourer. Overhead is a drive shaft that provides power for all the machinery in the garage. It is probably driven by a steam engine, which is just visible through the open door at the back.

The painting was hailed as remarkable in 1934[3] when it was viewed in its prominent position at the Williamson Art Gallery and Museum. The present Curator of the Gallery, Colin Simpson, describes it as still being a great favourite.

1. Vid. *'Widdalls'* (250) for another example.
2. Ref. *The Victoria History of the County of York, East Riding, Vol. VI: Beverley*, Oxford University Press, 1989, p. 153/4.
3. *The Artist,* Vol. VI No. 6, February 1934, p.194.

172. AN OLD INN KITCHEN (or MAIDS IN THE KITCHEN, or AN OLD KITCHEN)

Oil 122.50 x 149.75 cms Dated 1922
Signed Trustees of the National Museums and Galleries on Merseyside (Walker Art Gallery, Liverpool)

The theme is the servants' midday meal in the Beverley Arms Kitchen. Probably the entire domestic staff is seated at a long table that occupies the full depth of the kitchen. At the head, poised to carve the joint of meat, is the old butler; at the far end, beyond the row of maids at both sides, is the cook being served with her stout. Around the figures is ranged the paraphernalia of domestic life: the meat-covers on the far wall, cloths suspended on ceiling hooks and buckets that hold fuel for the ovens.

The receding group round the long table provides a strong composition in its relation to the deep interior. The butler's tail-coat is dark, well defined against the light. Its central form provides a tonal link with the shaded areas behind each row of maids, and anchors the whole composition. As the butler is seen from behind, his significance is emphasised; he resembles the conductor of an orchestra calling up instrumentalists left and right with the gesture of his carving knife and fork. Sunlight through the window appears to streak across the interior and to strike numerous elliptical kitchen utensils, each one echoing the other.

The compositional strength, tonal contrast, and repetition of simple geometrical shapes, all create a sense of order, timelessness and calm[1], the qualities of the stable society in which Elwell lived. Despite a rapidly changing world, this scene represented an outpost of Victorian and Edwardian order, which the artist's brush put on hold.

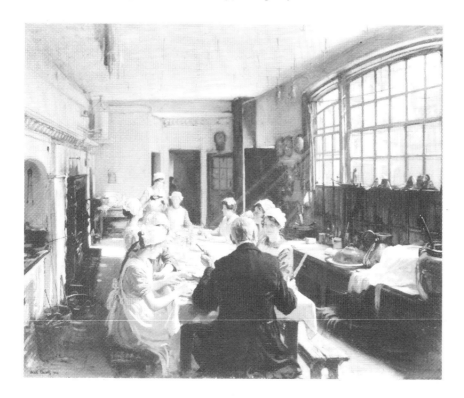

172. An Old Inn Kitchen

The figure of the butler was modelled by Jacob Rainer, who owned an antique shop in Beverley. Miss D. Foster[2] was both the maid in the front right, and her companion. She was part of the Elwell household.

The painting was acquired by Merseyside for the Walker Art Gallery, Liverpool, a city which held a special regard for Elwell. In the Gallery's Jubilee Autumn Exhibition in 1923, this work was 'an outstanding feature'[3].

1. Catalogue to 'Victorian England', Walker Art Gallery, Liverpool, 1983-84.
2. Also modelled for *The 'Beverley Arms' Kitchen* (150)
3. *Liverpool Daily Post*, April 1923.

177. A COWSHED 1

Oil on canvas	101.50 x 127 cms	Dated 1922
Signed	Beverley Borough Council	

The sight of people in their working environment was a continual source of inspiration to Elwell, both for the beauty of the physical presence of his subjects, and for the sense of dignity he perceived as they went about their daily tasks. It was probably for this reason, when *A Cowshed* was exhibited at Sunderland in 1927, that the

reviewer[1] likened it to paintings by the French artist, Jean-François Millet (1814-1875).

In the same review, the painting was admired for the glint of light from the glass-fluted tiles overhead, and the 'peeping sunshine' from the open door, with 'here and there a fugitive slitted light' across an otherwise dark interior.

Typically, Elwell presents a traditional working scene, here an image of milking, as one of great stability and peace, lovingly recorded before the advent of factory farming.

The cowshed was part of Wilson's Mill, close to Beverley on the road to Walkington, and owned by Harry Wilson.

1. *The [Hull] Daily Mail*, 28.1.1927.

250. 'WIDDALL'S'

Oil on canvas	101.50 x 127 cms	Dated 1928
Signed	Glasgow Museums: Art Gallery	
	& Museum, Kelvingrove	

The setting is an antiques repair workshop[1], owned by Henry Widdall, in Waltham Lane, Beverley. Widdall was proud of his business which, on occasions, included export. Only a few years before the execution of this painting, he had sold a picture and a dumb-waiter to Queen Mary, for Buckingham Palace, and pictures to the Princess Royal for Harewood House.

Like James Elwell's workshop[2], Widdall's was on the first floor, in order to benefit from the

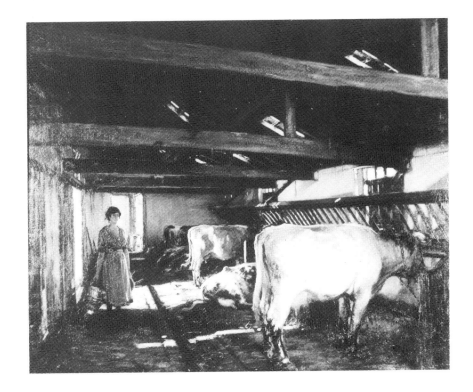

177. A Cowshed 1

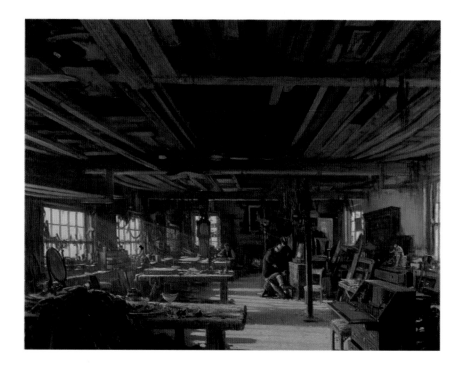

used for large planks (though this is partly covered in the painting), and beyond it on the left is a vice, a treddle fretsaw, a chest of drawers for screws and a mirror frame. In front of the far window, against a supportive pillar, is a long-case clock awaiting repair. The figures in the far centre, intently examining the open drawer of a cabinet, are Henry Widdall (crouching) and his frequent customers, Sir Henry and Lady Samman[3].

The artist has used only minor instances of licence. The still life in the foreground enhances the sense of spatial depth. The Willow Pattern blue is echoed, at the opposite side of the workshop, in a figurine, and more deeply into the picture space as the colour worn by one of the figures. The row of benches emphasises the depth of the interior, and the effect is enhanced by the omission of a pillar between the first and second benches. The placing of a complete mirror in the foreground enforces the form of the mirror frame hanging at the window beyond.

Vera Pickering verified that Elwell painted the scene on the premises. He left his easel and equipment there and frequently returned whenever the light conditions were as he had painted them at first. He and Widdall had been friends since they were boys playing on the Westwood together, so he was able to come and go as he pleased. During the painting period, whether he was there or not, certain objects had to remain. These included the still life on the forward bench, and Widdall's slippers, which marked the spot on the floor for the figure group.

most natural light. On the ground floor was Widdall's shop where he sold antiques. Above the workshop, and visible in the painting, was a false roof of beams, resting upon which were planks of wood in the process of seasoning.

Henry Widdall's daughter, Vera Pickering, supports Elwell's realism, and has contributed her own recollections. The planks of wood, she explained, were hauled up and down by the pulleys shown above the figure group. For large planks, extra hands and muscle were required, and then men from the blacksmith's next door were brought in. Hanging from the roof, conveniently awaiting use, was an array of bits, ropes and chains. As in the painting, a fire was always burning in the grate. Its warmth was necessary for the technique of French polishing, which explains why the figure close to the fire was Charles Widdall of *A Polisher's Shop* (251). It was also required for heating the glue pot. Over the fireplace was a portrait of Disraeli, darkened by smoke. To the right was the cupboard that stored cakes of glue, as well as methylated spirits and beeswax for making furniture polish.

The workshop side, on the right, was filled with items of furniture awaiting repair or restoration. Visible behind the desk in the painting is the lathe used by Henry Widdall's son, Harry. On the left, in the foreground, is the saw

Of all the figures, it was Sir Henry who kept absconding. He was lured by the prospect of a 'tipple at the Beverley Arms' and had to be replaced from time to time by the young Widdall, Harry, who was of a similar build.

1. The building was demolished in 1916. At the time of the painting the entire land and property extended from Vicar Lane to Wood Lane.
2. Vid. *A Woodcarver's Shop* (155)
3. Sir Henry Samman, 2nd Bart., and known as Sir Harry, with his second wife, Kate.

251. A POLISHER'S SHOP

Oil on canvas	101 x 75.50 cms
Signed	Mallett at Bourdon House Ltd.

Charles Widdall[1], a French polisher for the furniture-restoring business, Widdall's, is busily rubbing down the inlaid surface of an antique table. Applying a wad of coarse cotton wool, a jar of methylated spirits to hand, and a canvas apron tied around his waist, he leans determinedly into his skilled job of restoration.

251. A Polisher's Shop

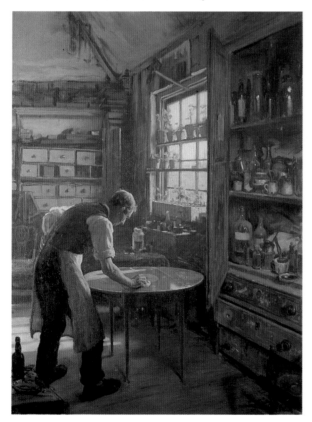

Elwell had previously painted the whole and extensive workshop of *'Widdall's'* (250). *A Polisher's Shop* is set in the far left hand corner of Widdall's, by a window cheerfully adorned with geraniums. In reality, the French polisher worked near the fire which kept the polish warm and smooth. However, Elwell has chosen to replace the fireplace in this work with an open cupboard, in order to indulge in the still life of bottles and jars with which it is filled.

1. Information from Vera Pickering.

254. AN INN KITCHEN (or KITCHEN SCENE)

Oil on canvas	122 x 116.75 cms	Dated 1929
Signed	The National Trust, Nunnington Hall	

Elwell kept returning to the theme of the Beverley Arms Kitchen. Since his work of ten years earlier (150), the differences in this interior are few: running water now makes its uneven progress via downward pipes to the sink, and the maids' uniform has become short-skirted. In this painting, a group shell peas, and one maid is handling a tin of roast meat from the oven.

A preparatory study of that maid, on a folding screen (413), shows how Elwell conceived her white uniform in relationship to the white cloth in the foreground. These light tones were massed together in freely painted strokes. In the final painting he sets these against darker tones, in an effect which is balanced by light against dark on the opposite side.

As in *An Old Inn Kitchen* (172), he repeats geometrical forms, such as the many ellipses which occur around the pea-shelling, and the rectangular reflected panes of glass on the rectangular table.

Elwell's familiar compositional device of a table and one standing figure, first noted in *'For These and All His Mercies'* (99), is here used to good effect.

344. INTERIOR OF A BARN

Oil on canvas	62.25 x 75
Signed	City of Nottingham Museums; Castle Museum & Art Gallery

This is the original painting[1], on the theme of pigs, from which a second and larger version

(346) was produced. It was, Elwell stated, made 'entirely on the spot', and he thought it to be his best of three[2] paintings on the subject.

This and the earlier *'Widdalls'* (250) demonstrate Elwell's interest in the exposed details of a building's construction. The massive roof structure of the long barn occupies the upper two thirds of the composition. The manner in which the barn interior is portrayed suggests the grandeur of a church, with its nave and flanking aisles: the prosaic subject is elevated by this treatment. Within the cavernous structure of the barn the pigs appear particularly small and squat, and the geometry of the timbers contrasts with the natural randomness of the animals eating, sleeping or scratching beneath. There is gentle humour in these contrasts, and in the way the light from the skylight is directed upon a patch on the barn floor as if to place the sleeping pigs upon a spotlit stage.

He may have been influenced in his choice of subject by Sir George Clausen's rural genre painting, *Interior of an Old Barn*, of 1902[3]. Like Clausen, he emphasises the compositional elements of the barn's interior structure, and the darkness of the interior into which the sunlight penetrates.

Elwell's companion, the artist Alfred Munnings R.A.[4] (1878-1959), recalled when *Interior of a Barn* was painted, at the Suffolk village of Thurlow, or Great Thurlow.

Munnings, who was most particularly a painter of horses, had invited Elwell, to whom he referred in his autobiography as his 'old friend from Beverley — Fred Elwell, R.A.', to stay[5] with him in Suffolk. They would visit Newmarket together (Munnings was painting the Aga Khan's grey horse, 'Mahmoud') and then take the car to Great Thurlow Hall, a few miles away. Mr. Ryder, squire of Great Thurlow Hall, owned 'hundreds of pigs — in the largest barn in Suffolk'. After Elwell had painted this picture, Munnings described him as exhausted, 'laid out on that Victorian, green-plush sofa', and professing that he never wanted to see another pig as long as he lived[6]!

Elwell shared with Munnings a quest for capturing the rural scene on canvas, and he called their painting ventures 'going pigging together'. This referred not to the subject, but to their means of attaining it — they adopted a rural life-style.

This painting, *Interior of a Barn*, was acquired by the Castle Museum, Nottingham. When answering the Museum's enquiries about the location, Elwell's memory failed him. It was, he said, 'Thurston or Long Thwiston or Great Thurston but I can't quite remember which.'

For later works, Elwell used pigs at Mount Pleasant Farm near Beverley as 'models'. Ernest Symmons of Beverley took photographs there in answer to Elwell's request:

'Ernest, could you come and photograph pigs for me; I find them very difficult to paint?'[7]

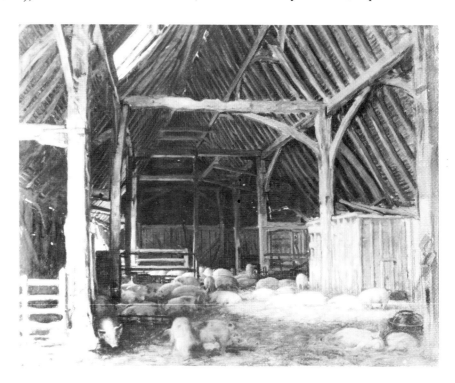

344 Interior of a Barn

He received in return the gift of Elwell's painting *Zermatt: afternoon* (366).

1. Information in letter from Elwell to Nottingham City Council at the time of the Council's purchase of the painting in 1944. He produced the second and larger version as he 'thought the subject was a good one'.
2. A third on this theme is *The Evening Meal, Pigs* (347).
3. Clausen (1852-1944). Exh R.A. 1908. Leeds City Art Gallery.
4. Information from the Munnings Collection brochure, Castle House, Dedham. Later Sir Alfred Munnings, K.C.V.O., P.R.A. Quotations and the account of the combined painting expedition are taken from Munning's autobiography, *The Second Burst*, Museum Press Ltd., 1951, Vol.II, p.262-3 & Vol. III, p.214. In 1944 Munnings was elected President of the Royal Academy.
5. Munnings was himself a frequent visitor to Bar House, during the period of the Beverley Races.
6. Munning's autobiography. Vid. Note 4.
7. Information from Ernest Symmons' daughter, Dr. Saida Symmons. Fred Elwell and Ernest Symmons were close friends and fellow past-Presidents of the Rotarians in Beverley. Ernest, who was a well known cinephotographer of Beverley and North Yorkshire, also photographed most of Fred's paintings for him.

347. THE EVENING MEAL, PIGS

Oil on canvas 90.25 x 90.25 cms Dated 1937
Signed Beverley Borough Council

The atmosphere of working life in the country is faithfully recorded. While the pigs are restrained by the gate, a smocked pig-keeper mixes feed in large, rounded tubs.

The geometric structure of the barn is the organising principle of the composition. The vertical and horizontals of pier and gate converge at the point of activity, and because the format of the painting as a whole is square, this focuses the eyes of the viewer, like those of the pigs, towards their dinner.

349. GIRL POLISHING PANS (or PAN-CLEANING DAY)

Oil on canvas 76.50 x 63.50 cms Dated 1937
Signed Private collection

The array of pans emits a warm coppery glow which pervades the room and perfectly enhances the blue of the girl's dress. She works vigorously, alone. Elwell has captured the swirling action of her cloth and her deft handling of the pan in the crook of her arm. She is engrossed in her duties and unaware of our presence.

The setting is Bar House kitchen, looking little

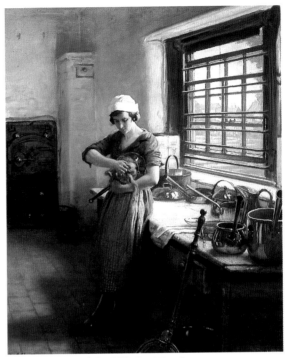

349. Girl Polishing Pans

different from its portrayal in *Maids with Pigeons* (146), nearly 20 years earlier. Where the pans are collected for polishing, the table has replaced the original sink, but the barred window, brick tiled floor and double oven remain as before. Elwell's approach to this subject has not changed.

He has placed the pan handle jutting forward into the viewer's space. The girl's leg, pushed forward as she leans, is parallel to the long handle of the warming pan. Though the scene appears to be realistic, it is in fact carefully considered and staged.

The kitchen was part of a domestic wing to the rear of Bar House.

350. GIRL PLUCKING A GOOSE

Signed Location unknown

Again the theme is the Beverley Arms kitchen. A kitchen-maid, modelled by Ada Curtis, wears the uniform of blue dress, white apron and cap. She is plucking a goose. As the body rests on her lap, and the neck is allowed to drop downwards, the wings are opened as if in memory of flight. The vertical composition of the painting echoes the effect of the single figure and the long neck of the goose.

As the same goose was used day after day when Elwell worked on this painting, Ada complained that it 'smelt to high Heaven'.

373. THE MODEL-SHIP BUILDER (or SPENCE'S STUDIO)

Oil on canvas 69.50 x 90.25 cms
Signed Beverley Borough Council

Engrossed in his activity, the model-ship builder is making a galleon. The hull is completed, with the cannon ports already in position. He is surrounded by the tools and plans and finished pieces associated with his work, much as the craftsmen in *A Woodcarver's Shop* (155) had been.

The alternative title by which the painting was exhibited at the Royal Academy in 1939 was '*Spence's Studio*'. The interior, a hall with minstrel's gallery, has decorative elements: a tapestry and pieces of sculpture. The setting for *The Model-ship Builder* is unknown. It is not a workshop, but an elegant room, and perhaps the studio of a friend. A photograph (on the back cover of this book) which shows Fred with this painting on the easel could have been taken at their studio in London, and the painting may therefore represent a subject closer to London than to Beverley.

375. AN INN KITCHEN: 'ELEVENSES'

Oil on canvas 101.50 x 127 cms Dated 1940
Signed Beverley Borough Council

Once again Elwell takes up the theme he began in 1919 (150) of the Beverley Arms kitchen. The maids are observed as they snatch a hasty meal. The flagstoned kitchen of this Georgian coaching-house was unaltered even in 1940 and undoubtedly appealed to Fred Elwell's sense of nostalgia. He captures the detail; the textural differences of copper pan, glass bottle, chicken feathers and painted ladder-backed chair, and the glistening fish and the plates left to drain, highlighted in white to show us their wetness. The partly sliced loaf and the just-open drawer inform us of the maids' activity, only temporarily suspended.

The viewer's eye is drawn towards the central group seated at the table by the draining board and bench, which create lines of perspective. The figure to which the maids give their attention, and to which ours is also attracted, is the old cook, who pours herself another glass of stout.

Typically the artist organizes his figures around a table, at which one figure is standing[1]. This achieves an inward focus, while the standing figure lifts the whole form into a more classical triangle.

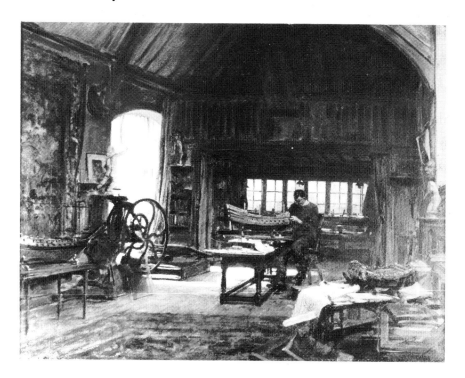

373. The Model-Ship Builder

The cook was modelled by Eliza Barrow[2], who worked as the cleaner for Beverley Library for over thirty years. She was robust, a hard-worker, and well known locally. On the left of the group is Dora Curtis[3], who was urged by the artist to sit so as to display her knees. Recognising that the surface was a hard one he thoughtfully provided her with a cushion. The standing figure was Dora's sister, Hilda, while the other maids were modelled by Hilda Harrison[4], Mary Redhead and Lily Tansey. Once again, Elwell had called upon Beverley people whom he knew.

1. Vid. Pieter de Hooch, *The Card-players* 1658, The Royal Collection, London, for the appearance of this format in Dutch genre.
2. Her grandson, Raymond Tyler of Beverley, contributed information. Eliza Barrow lived opposite the artist's studio in Trinity Lane, Beverley. During World War II, when this painting was produced, she scrubbed blankets for troops at Beverley Cottage Hospital.
3. Also modelled in *'The Squire'* (291).
4. Also modelled in *Maids with Pigeons* (146). She, Mary Redhead, and Hilda and Dora Curtis were maids at Bar House.

379. A WHEELWRIGHT'S SHOP

Oil on canvas 66 x 96.50 cms Dated 1941
Signed Beverley Borough Council

This is the workshop of Fred Thompson, the wheelwright. It was part of an engineering complex known as the Brass Foundry, directed by Charles F. Deans, which could be found in Grovehill Road, Beverley (near the shipyard), between Swinemoor Drain and the River Hull.

Elwell presents the workshop when activity is temporarily suspended for lunch, but he captures, even without the presence of figures, the general minutiae and atmosphere of the wheelwright's craft.

He observes the evidence of activity: the sawdust lying upon the bench, the pot of red paint on the floor after the wheel has been painted, the hub, affixed with spars, perched against a support, and slightly unstable. It almost seems to turn as the light glances upon it. The clutter brings to mind the men who work there. Hanging from the rafters are the wartime hams. A metal combustion stove heats the glue-pot. The open door seems to invite the men's imminent return.

The wheelwright's nephew, J. Thompson of Beverley, testifies to the accuracy of the painting and adds his own recollections of the workshop.

Fred Thompson's trade chiefly involved the production of wheels for farm waggons. His bench can be seen on the right. He was assisted by his son, James, who worked opposite. The open door led to Thompson's blacksmith's shop, where the wheel rims were forged, and it was in his joiner's shop nearby that the wood, which had earlier been seasoned on the premises, was processed for wheels. Fred Thompson ran a largely self-sufficient business, which was not uncommon for the period.

In the foreground of the painting rests a wheel hub, affixed with spars and awaiting the fitting of the hasp. Two men would perform this spectacular operation out-of-doors. They lifted the hub and spars into an exactly measured iron hoop, made white-hot on the forge. Immediately the metal was quenched with water, and this caused it to contract, sealing it around the loose-fitting wood of the wheel. Next the wheel was returned to the workshop and placed on a sawbench for painting.

It is the wheel at this stage that forms the focus of this composition. It makes a significant central feature which may be compared with that of the circular table in *An Inn Kitchen: 'Elevenses'* (375), and its vibrant red colour invites the viewer into the picture space.

Elwell would have realised that the days of

cartwheels, and their hand-production, were numbered. Just as in *The Last Cab* (292), he preserved a scene of an era which he recognised would soon be lost.

395. LAUNCHING TRAWLER, BEVERLEY SHIPYARD

Oil on canvas 49.50 x 59.75 cms
Signed Beverley Borough Council

Elwell captures the dramatic moment of the launching of a trawler. Its massive bow incises the sky with a dark curve.

While other vessels, still under construction at the shipyard[1], stand on the stocks, a crowd witnesses the launching ceremony at Cook, Welton & Gemmel Ltd., on the River Hull at Beverley. The unusual broadside launching was always made necessary by the confined space of the river. It caused a large surge of water, which on occasions drenched the onlookers on the bank.

It was the practice at the time for fishing trawlers constructed in Beverley to be delivered via the River Hull for fitting out at Princes Dock, Hull. The practice continued until 1963, when a demand for stern fishing trawlers (too large to be launched into, and to navigate the winding course

of, the river) brought about the demise of the company.

The broadside launching was a difficult manoeuvre, and it was known for vessels to capsize. The timing of the launch was critical, as it was only possible at the top of the fortnightly spring high tide. Yet the yearly tide tables, being unreliable, required skill in their interpretation.

The launch depicted in this painting occurred during wartime, when the production of vessels at the shipyard was greatly increased. Beverley-built trawlers were being taken over by the Admiralty, and it is possible that Beverley Council commissioned the painting to engender local pride in the town's contribution to the war effort.

A fellow artist in Beverley, Stephen Blyth, pointed out to Elwell that the figures in the painting were not complete; the latter retorted drily that there was no reason why they should be — he was only being paid £100!

Nevertheless, a scaled-up preparatory study (394), which he made of a ship on the stocks, showed the complex array of scaffolding, props and ladders that he was interested in portraying correctly.

1. Information from Zillah Weston

401. PREPARATIONS

Oil on canvas 71 x 91.50 cms
Signed Beverley Borough Council

Viewed from the opposite end of the Beverley Arms kitchen (when compared with *An Inn Kitchen: 'Elevenses'*, 375), this scene encompasses the range of ovens, and the shelves of blue and white china. Some of the maids were the same Elwell employees.

In the foreground herring-gutting is underway. To ensure a fresh supply of herrings while this painting was in progress, frequent deliveries were made to Fred's studio by the errand-boy of a Beverley fish shop.

402. THREE MAIDS

Oil on canvas 71 x 91.50 cms
Signed Beverley Borough Council

In his final variation on the theme of the Beverley Arms kitchen, first exhibited in 1946, he exploits the variety of tasks, the colourful detail and the sense of space. As usual an open door suggests a space beyond, and there is also a view through the large arched window to the courtyard of the hotel. The way Elwell has arranged the vegetables to project forwards from the table creates visual space behind.

Appropriately, this painting now hangs at the hotel whose kitchen it represents.

449. A COWSHED 2

Oil on canvas 61 x 73.75 cms
Unsigned Private collection

It is most likely that this was Elwell's last painting, which he was working on until just a few weeks before his death on 3 January 1958.

It is a re-working of *A Cowshed* (177), which he was first inspired to paint 20-30 years earlier and remained unfinished following his death.

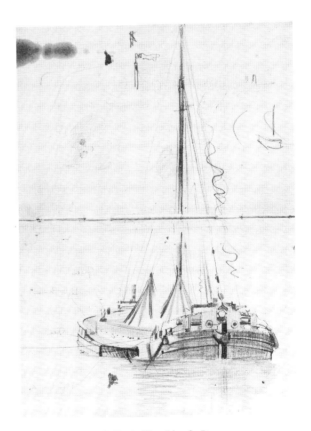

22. Paris Sketchbook, Barge

Portrait-Interiors: a Formal Audience

Those of Elwell's works which can be regarded as 'portrait-interiors' evolved from the strongest elements of his narrative, portrait, still life and interior paintings. In particular they developed from his 'conversation pieces', which, like *Tea Time* (122), described people's social and domestic interactions. Such subjects were very popular in Elwell's lifetime. The distinction between a painting like *Tea Time* and *The Birthday Party* (319) is that in the latter there is a far greater sense of balance and unity between the figures and the setting in which they are portrayed, with a sharper definition being achieved through a tighter handling of paint.

It was in the 1920s that Elwell began to present portraits of people in their own unique setting. By this stage his reputation had become well established, and, like Sir John Lavery (1856-1941), he found himself increasingly in demand to undertake this sort of commission.

These 'portrait-interiors' were painted in the meticulous style introduced with *The Last Purchase*, (156), for such fidelity was considered important, both by Elwell, with his eye for accuracy of detail, and by his patrons, to reflect their position in society. He placed his sitters effortlessly within the context of their lifestyle. Typically, paintings such as those made at Thorpe Hall (249) and Glamis (293), were conceived on a grand scale, and engendered a mood of elegance and well-ordered relaxation, as befitted their patrons.

He was later to find success with large and complex group interiors, such as *A Sheriff's Luncheon* (393), which recorded a specific event.

243. THE OLD LIBRARY, CASTLE ASHBY

101.50 x 127 cms
Location unknown

Elwell produced more than one painting at Castle Ashby[1], the 16th century seat of the Marquis and Marchioness of Northampton, overlooking the River Nene. In this particular painting he described in meticulous detail the sumptuous old library, filled with furniture and works of art, while he also incorporated the figure of the Marchioness into the setting. It established the relationship of the occupier with her surroundings, and provided a visual record of both.

Castle Ashby was laid out in the shape of the letter 'E' as a tribute to Queen Elizabeth I, and the gardens, planted with cedars and horse-chestnuts by Capability Brown, are considered among his finest work.

1. Information from *Burke's Peerage* and *The Times*, 13.8.1991.

249. SIR ALEXANDER AND LADY MACDONALD OF THE ISLES WITH THEIR FAMILY IN THE GALLERY AT THORPE

Oil on panel 100.25 x 125.75 cms Dated 1928
Signed Private collection

Fred and Mary Elwell were close friends of Sir Alexander and Lady Macdonald of the Isles[1], who lived at Thorpe Hall, a house of the Georgian period, in the East Riding. They spent a holiday together on Lake Como in 1922. Lady (Alice) Macdonald had a great respect for Fred's

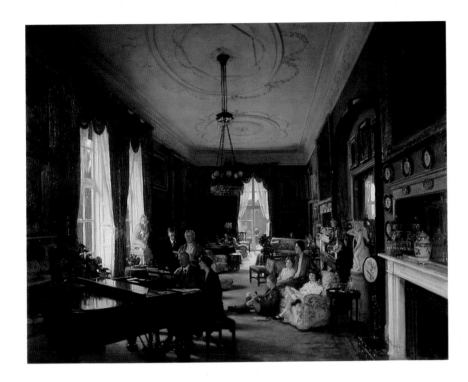

judgement on artistic matters, and he took a close
interest in the Macdonalds' ancient dynastic
history, owning books on the subject, including
Fortunes of a Family[2], written by Lady (Alice)
Macdonald. In 1927 Mary had produced a finely
detailed painting of Lady Alice in the Library at
Thorpe[3].

Elwell organised his 'portrait-interior' of the
family in the Long Gallery, where a musical
performance provided a common bond for the
portrait group. The idea was entirely appropriate.
Sir Alexander was himself a composer, and as
'the neighbouring squire' (291) was the
backbone of musical occasions[4]. He regularly
played the organ, which he had himself
constructed, at All Saints, Rudston[5]. In the
painting it is he who plays the grand piano,
accompanying his daughter, Celia, an
accomplished singer. Behind them stand Lady
Macdonald, and Godfrey, the heir to the title. The
audience, Rachel and her children, Somerled,
Jean and Daphne, is grouped around the sofa.

The Gallery itself is carefully defined, with
elaborate furnishings reproduced in meticulous
detail, and enlivened by the effect of light and
shade, and reflection. In the centre hangs a
Tiffany chandelier, which was originally
designed for oil lighting. It was, however,
converted to electric lighting by Sir Alexander as
early as 1886. Furniture
is arranged in groups to
facilitate conversation.

Sir Ian Macdonald of
Sleat, his great-
grandson, has explained that the accuracy of the
painting in showing the Gallery as it appeared in
1928 has proved to be most useful in its current
restoration. It has, for example, provided an exact
record of the deep pink colour of the walls, the
double drapes arranged on rods over the
windows, and the existence of the *Crouching
Venus* sculpture.

Elwell's success in unifying the room interior
with the portraits of eight members of the
Macdonald family did not go unnoticed. His
reputation as a painter, and particularly of
portrait-interiors, was much enhanced by this
work. At the Royal Academy, the painting was
hung 'on the line [at eye level] in the big room',
where it was 'extremely well received, both by
the press and by brother artists'. It quickly
brought 'commissions of a similar nature,
including one of the drawing-room at Glamis
Castle'[6] (293).

1. Information from Sir Ian Macdonald of Sleat, Bt.,
 F.R.I.C.S, M.R.S.H.
2. T. & A. Constable Ltd., Edinburgh, 1927.
3. *The Library at Thorpe Hall with Lady Macdonald sitting
 in an armchair*, 1927.
4. *The Times*, 30.4.1900.
5. Information from Alice, Lady Macdonald of the Isles, *A
 Sheaf of Memories*, A. Brown & Sons Ltd., 1933.
6. *The Artist*, Vol. VI, No. 6, Feb 1934.

293. THE EARL & COUNTESS OF STRATHMORE & KINGHORNE IN THEIR DRAWING ROOM AT GLAMIS

Oil on canvas 101.50 x 127 cms Dated 1931
Signed Strathmore Estates (Holdings) Ltd. (at Glamis Castle)

Claude, the 14th Earl, and Celia, Countess, of Strathmore[1], parents of Her Majesty Queen Elizabeth, The Queen Mother, are portrayed in their Drawing Room at Glamis Castle. The Earls of Strathmore[2] have been the lairds of the rich farmland north of Dundee since at least the 14th century, and the gaunt and turreted Glamis Castle, their family seat, is one of the oldest continuously inhabited buildings in Britain. The family's long and illustrious history is reflected in this interior-piece, with its barrel-vaulted ceiling, and historical portraits[3]. Elwell represents the splendid 60-feet-long interior with skill and accuracy, and yet with equal care he characterises the Earl and Countess in portrait form.

The commission marked the golden wedding anniversary[4] on 16 July 1931 of the Earl and Countess, who are depicted reading the congratulatory telegrams. The anniversary was an occasion when the Duchess of York (now Her Majesty Queen Elizabeth, The Queen Mother), at the chandelier-lit ball, led the dancing of an eightsome reel with the oldest tenant of the Strathmore estates. It was also celebrated by a garden party on the front lawns of the Castle, with 21 grandchildren and Sir Harry Lauder, the famous music hall artist, among the guests. Sir Harry asked the Princess Elizabeth which song she liked most, to which she replied, 'It's nice to get up in the morning but it's better to lie in your bed'!

The presentation of the painting was made on 6 October 1931 in the Drawing Room itself, by Colonel Steuart-Fothringham, as Convenor of the County of Angus, on behalf of the people of the County, of which the Earl was Lord Lieutenant.

1. Claude, 14th Earl of Strathmore, K.G., K.T., G.C.V.O., (1855-1944), who married Nina Cecilia Cavendish-Bentinck.
2. Information from Lesley Astaire, *Living in Scotland*, Thames and Hudson, 1987, p.20.
3. idem. A large painting of the 3rd Earl, his sons and hunting dogs. Below are portraits of Elizabeth I, Charles I and Lady Ar[a]bella Stuart. The stucco ceiling bears the monograms of John, 2nd Earl of Kinghorne, and his Countess, dated 1621.
4. Information from Lt. Col. P.J. Cardwell Moore, Glamis Castle Administrator..

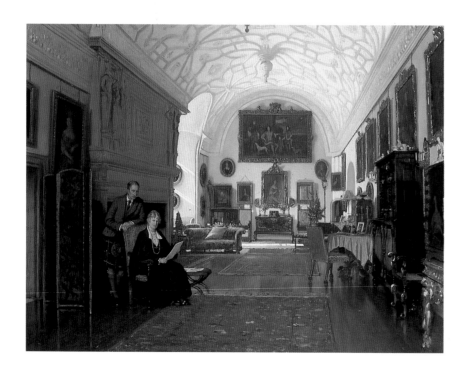

293. The Earl and Countess of Strathmore and Kinghorne in their Drawing Room at Glamis

319. THE BIRTHDAY PARTY

Oil on canvas 101.50 x 127 cms Dated 1934
Signed Beverley Borough Council

The rangy figure of the artist himself is in the foreground, contentedly drawing on his pipe. The scene, a party, is set in the dining room of Bar House, the Elwell's home.

Through his eyes, the viewer is invited to share the pleasure of what he observes: the room itself; his family and friends in conversation; the dinner which has reached the fruit course and the circulation of port; the copper bowl that decorates the dining table, and the full- blown roses, plucked from the garden, that Mary so adores. There are also many treasured objects resulting from years of collecting, and paintings by himself and Mary, by Munnings, Richard Jack and others, that recall a life steeped in art.

It is a contented view, and there is every reason for this: Elwell was 'master of the forgotten art of living'[1], and this painting is surely the visual evidence. For him, *The Birthday Party* can be regarded as the personal equivalent to the grand 'portrait-interiors' he was usually more accustomed to produce for his patrons.

By comparing this painting with preparatory studies on a painted screen (413), one of which took a wider view to include the entire fireplace, and, by observation of the room itself, it becomes clearer what Elwell had in mind. By reducing the scale of the room, eliminating a window on the far wall, and ordering his viewpoint, the scene of the group is made more intimate and the table central to the composition.

With Fred and Mary is Richard Whiteing (wearing a monocle), Resident Architect for Beverley Minster, whose home, St. Mary's Close, was the subject of *My Neighbour's House* (280). His fondness for drink was legendary in the town.

Kenneth Elwell, on the left, was Fred's nephew, who years earlier had featured in *Motherhood* (97) as the toddler in a bath. He was a painter whose career was guided by Fred. Kenneth painted scenes of Beverley and the surrounding countryside in a hard-edged style, and was also an exhibitor at the Royal Academy. His life and career were sadly curtailed in the Second World War, when he became a prisoner of the Japanese. He was travelling in a cargo vessel which was torpedoed and sunk by a U.S. submarine in the Pacific.

1. *Yorkshire Post & Leeds Mercury*, 4.1.1958.

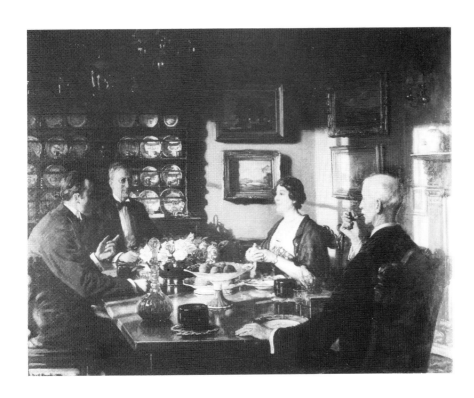

319. The Birthday Party

360. THE ROYAL ACADEMY SELECTION AND HANGING COMMITTEE, 1938

Oil on canvas 118 x 144.50 cms Dated 1938
Signed Royal Academy of Arts, London

When this painting was produced in 1938, Elwell had been recently elected as an Academician. He submitted this as his Diploma work, an example of his abilities which would be retained by the Royal Academy. The painting is curiously self-contained, having been perpetrated by a Member of the Academy, on the subject of the Academy, and for the purposes of the Academy.

The Diploma works of Elwell and his contemporaries were incorporated in an exhibition, 'The Edwardians and After', held at the Royal Academy in 1990. Portraiture predominated, and this painting by Elwell was regarded as setting 'an impeccable standard'[1].

It was painted in 1938 at a time when the values of the Royal Academy were under attack by the protagonists of modernism. This was the year in which Wyndham Lewis's portrait of T.S. Eliot[2] was rejected by the very same Selection and Hanging Committee portrayed by Elwell, and in which Augustus John resigned, accusing the Academy of stagnation[3]. Elwell's painting, by emphasizing the dignity and authority of its Members, would have been read by some as displaying their crusty indifference to change.

'These suited cigar-smokers are far from the conventional stereotype of artists as penniless dishevelled bohemians[4]', as they convene for their annual luncheon in the General Assembly Room of Burlington House. The richly classical 18th-century interior is quite naturally dark as Elwell has painted it. The main light source (from behind the painter) illuminates his fellow Academicians against the shade. He takes advantage by clearly defining their features in near-photographic portraiture. Also well-lit is the gleaming tableware upon white napery. Both the setting and figures are treated with equal attention.

Elwell was a co-member of the Committee, and was therefore fully justified in including himself. His own image, holding brush and palette, leans into the painting on the left, as if he had 'moved in front of a time delay camera'[4]. Around the table[5], from the left, are Sir Edwin Cooper, Sir William Russell Flint, Sydney Lee, Sir William Llewellyn (President), Sir Walter Lamb (Secretary), Oliver Hall, George Harcourt, Sir Walter Russell (Keeper), James Woodford, Stephen Gooden, Gilbert Ledward, S. John Lamorna Birch and Harold Knight. The porters are J. Coy and F. Hubbocks. Lamorna Birch, leaning forward in this group, was one of Elwell's closest friends.

360. The Royal Academy Selection and Hanging Committee, 1938

1. *Arts Review*, 5.10.1990.
2. Sidney C. Hutchison, *The History of the Royal Academy 1768-1986*, Robert Royce Ltd, 1986, p.163.
3. M. Holroyd, *Augustus John*, Vol. II, 1975, p.107.
4. David Briers in Catalogue for 'Fine Art: A Selection of Paintings, Sculptures & Drawings by Royal Academicians, 1770-1980', Glynn Vivian Art Gallery, Swansea, 1985.
5. List of Academicians present, Catalogue for 'The Edwardians and After', Royal Academy of Arts, London, 1988.

393. A SHERIFF'S LUNCHEON

Oil on canvas 127 x 167.75 cms Dated 1945
Signed The Guildhall Collection, Hull

A historic event is recorded: the visit of the Prime Minister, Winston Churchill, to the Reception Room at the Guildhall of Kingston upon Hull. There had been considerable bomb damage in the City during the Second World War. The height of the bombing had occurred on 8 and 9 May 1940, but throughout the whole period of the War, enemy air raids destroyed as much as 75 per cent of the City's housing.

Churchill arrived in Hull to inspect the severe damage on 7 November 1941. The day coincided with a commemorative luncheon to which he was invited by the Sheriff of Hull, the builder Robert Tarran, and it is this assembly which Elwell records.

The occasion celebrated the 500th anniversary of the grant of a Royal Charter by King Henry VI to the City of Kingston upon Hull, enabling the appointment of its first Sheriff, John Spencer, in 1440. In addition, the Charter also permitted its Aldermen to wear red robes, as in the City of London. The year 1941 was also the 400th anniversary of the grant by Henry VIII, of the first Charter of Incorporation to Trinity House of Kingston upon Hull[1].

Elwell captures the point at which the Sheriff is presenting his guest of honour to the assembled company, including Lord Alexander, First Sea Lord, Dr. William Temple, Archbishop of York, and Lord Middleton. The artist has also included himself and his wife, seated near the bottom right corner.

Particularly poignant, in view of Churchill's wartime mission, is the scaffolding, visible through the central archway. A recent bomb blast had seriously damaged half of the Banqueting Room (situated beyond the archway) and blown out the end wall. As the scaffolding indicates, the room was still under repair at the time of the luncheon.

As the largest group portrait[2] undertaken by Elwell, this painting would have presented quite a challenge to him. He was aged 75 when he completed it in 1945, with the aid of a photograph to capture the crowded scene. The painting is symmetrically arranged to place particular emphasis upon the formality of the occasion, while in its detail it testifies to wartime austerity. Notable is the absence of the Civic silver and lavish fare.

The work probably brought Elwell into direct contact with Churchill, as indicated by a letter[3] from Churchill at 10 Downing Street which refers to the welcome receipt of a gift (contents unknown) from the artist.

1. In 1541 Henry VIII granted a Charter bestowing the status of a Corporation upon 'The Fraternity or Gild of the Holy Trinity of Kingston upon Hull'. In 1581 Queen Elizabeth I granted a new Charter to the Guild, which was then to be titled 'The Gild or Brotherhood of Masters and Pilots, Seamen of the Trinity House in Kingston upon Hull'. A. Storey, *Trinity House of Kingston upon Hull*, Trinity House of Kingston upon Hull, p.15-16.
2. A key to individual figures normally hangs beside the painting at the Guildhall. In c. 1964, when the key was produced, 46 figures could be identified by name.
3. Undated letter (in a private collection) from Winston Churchill to Elwell.

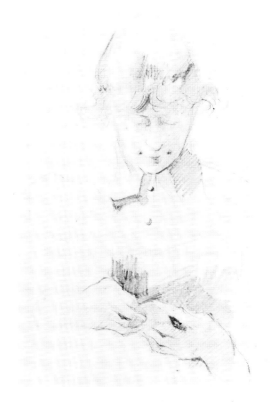

22. Paris Sketchbook, Woman Reading

119

413. Screen 2
Elwell followed the unusual custom of using Japanese folding screens as bases for experimental compositions. Visible, above, are his early conceptions of Kitchen Scene *(254),* Long Gallery, Burton-Constable *(286),* I Dreamt St. Peter Sat For His Portrait *(406) and* Inventory and Valuation for Probate *(411)*

The Paintings of Frederick W. Elwell, R.A.

Page numbers indicate those paintings for which there are text entries

		Page
1.	Still Life with Fish (or Still Life, Codfish, or Codfish & Herrings), 1897	10
2.	Classical Study	16
3.	The Aged Coal-Porter	
4.	James Holmes	
4.1.	Old Lady, 1890	
5.	Portrait of George Monkman, Mace Bearer of Beverley, 1890	16
6.	The Butler Takes a Glass of Port (or All Things Come to the Man Who Waits), 1890	43
7.	The Trumpet Player, 1890	66
8.	Portrait of a Man in 'Ruff Collar' Dress	
9.	Head of a Young Girl, 1890	
10.	The Cello Player (or Interval for Refreshment or The Snuff Taker), 1891	66
11.	Basket of Country Flowers	
12.	Portrait of Charles Hobson, 1891	17
13.	Self-Portrait Study	17
14.	January Packet, 1891	75
15.	Small Study of James Elwell	17
16.	Orchard	76
16.1.	Aike Beck	
17.	Beverley Beck by the Lock, 1893	77
18.	St. Mary's Church. North-East Corner, 1893	
19.	St Mary's Church from a Garden	
20.	Sketch of St. Mary's	
21.	Léonie's Toilet (or Dolls or The Toilet), 1894	18
22.	Paris Sketchbook	67
23.	Pierrot et Danseuses	67
24.	Disgraced, 1895	
25.	The Day After the Fête, 1895	68
25.1.	Le Retour des Braconniers	
26.	Still Life with Mushrooms, 1895	12
27.	Mrs. M.J. Frost, 1895	
28.	Female Nude, 1895	19
29.	Marigolds, 1896	
30.	Caddy Boy	
31.	Cavalry Cartoon	44
32.	Partridges, 1897	
33.	Portrait of Florence Elwell	20
34.	Old Man with a Pipe, 1898	20
35.	Girl with a Kitten 1	21
36.	Girl with a Kitten 2	
37.	Girl with a Kitten 3	
38.	Artist in His Studio	91
39.	Portrait of G.H. Knight, 1898	
40.	Beverley Beck 1, 1898	77
41.	Still Life with a Brace of Pheasants, 1899	12

		Page
42.	Portrait of Edith Boyes	
43.	Portrait of Joseph Henry Horsley, Esq., J.P., 1899	
44.	F.G. Hobson, 1900	21
45.	James E. Elwell, 1901	21
46.	Driffield Trout Stream 1, 1901	79
47.	Driffield Trout Stream 2	
48.	Bathers, 1901	69
49.	Boy with a Hoop	22
50.	Pot Boy, 1903	98
51.	The Last Beverley Pipemaker	99
52.	Reflections	
53.	His Daughter's Legacy	
54.	Mary Dawson Holmes, 1904	22
55.	Leven Canal, 1904	79
56.	Lady with Black Cap	23
57.	Beverley Beck 2	
58.	The Lock-Pit, Beverley Beck	
59.	Beverley Beck 3	
60.	Beverley from the Golf Club	
61.	The Cut Finger	
62.	River Hull near Wilfholme	79
63.	River Hull	
65.	Study of Trees	
67.	Small Painting of Two Boats	
68.	The Gypsy Encampment	
69.	River and Trees, Wansford	
71.	The River Hull at Brigham, 1905	79
72.	Farmhouse, Wansford, 1905	
73.	Farmyard Scene	
74.	Cornfields	
75.	Pallas Athena Owl, 1905	79
76.	Anlaby House 1	
77.	Anlaby House 2	
78.	Ragwort at Cayton Bay, 1906	
79.	Speeton Cliffs, 1906	
80.	Trout Stream, Wansford	
81.	Portrait of W. Bro. Ald. Mm. Holder, J.P., M.R.C.S., P.M., P.Z., P.P.G., 1906	
82.	John E. Champney, 1906	23
83.	William Spencer 1	
84.	Christopher Pickering, J.P., 1906	
85.	James Mills, 1906	
86.	Mrs. J. Downs	23
87.	Portrait of a Young Girl	24
89.	Mrs. Arthur Chorley	
90.	Portrait of Annie Elwell	24
91.	Portrait of James E. Elwell	24
92.	Staithes, 1907	80
92.1.	Looking up the Driffield Canal, by the Trout, Wansford	80
92.2.	River Hull near Brigham 1, 1908 ?	80
92.3.	River Hull near Brigham 2	
93.	Portrait of Major-General Sir Charles Holled Smith, 1908	

		Page
94.	Portrait of M.M. Westerby, 1908	
95	Geraniums 1	
96.	An Old Palace in Venice, 1909	81
97.	Motherhood	44
98.	Study for Picture 'For These and All His Mercies'	45
99.	'For These and All His Mercies' (or Grace Before Meals or Cottage Scene), 1909	45
100.	Florence a Pastel	
101.	The Dressmaker	99
101.1.	A Breezy Day at Sandsend, Whitby	
101.2.	Mischief, 1911	
101.3.	Portrait of Mrs. Smith	
102.	The Wedding Dress, 1911	46
103.	Mrs. James Mills, 1911	
104.	Vigo, 1911	
105.	An Arbour with Mountain View, 1911	
106.	The Housekeeper's Room (or Morning Orders), 1911	47
107.	William Spencer 2, 1912	
108.	On The Musk Esk, 1912	
109.	The Homecoming, 1912	47
110.	The First Born, 1913	48
111.	Slumber , 1913	50
112.	Mustard Field	81
113.	Calves in a Field	81
114.	Visby	
115.	The Artist's Studio	
116.	Study for the Lawyer	
117.	Visit to the Lawyer's, 1913	50
118.	An Old Favourite	
119.	Alderman Thomas Shemelds Taylor, J.P., 1913	25
119.1.	Wilfred George Bartlett, 1913	
120.	The Hon. Mrs Cholmondeley	
121.	Dr. Lee, 1914	
122.	Tea Time (or The Two Visitors)	51
123.	Sandsend, 1914	
124.	Coastal Scene	
125.	The Little Visitor	
126.	A Mother & Child 1, 1915	
127.	Refugees in My Studio 1, 1915	
128.	An Old Stable 1	
129.	An Old Stable 2	
130.	The Cart Horse Stable	
131.	Going to Work	
132.	The Grindstone	
133.	The Rowing Boat	
134.	Mrs. W.R. Todd	25
135.	The Garden, Bar House, 1914	82
136.	Garden Scene, Bar House	
137.	Garden Scene, Late Afternoon	

		Page
138.	In My Garden	
139.	The Garden at Bar House, Beverley	
140.	Lily Pond, Bar House	
141.	Evensong, Beverley Minster 1 (or Memorial Service to Lord Kitchener), 1917	92
142.	Portrait of a Small Boy, 1917	25
143.	Barbara	
144.	A Jam Factory	100
145.	Study for Maids with Pigeons	
146.	Maids with Pigeons (or Hilda and Mary), 1918	101
147.	The New Frock, 1919	51
148.	The War Worker	
149.	Stream through a Village, 1919	
150.	The 'Beverley Arms' Kitchen (or An Old Inn Kitchen), 1919	101
151.	Demobilized	
152.	A Lobster Salad	
153.	Four Friends	52
154.	Portrait of Col. Richard Hodgson, 1919	27
154.1.	River Scene, 1920	
155.	A Woodcarver's Shop, 1920	102
156.	The Last Purchase (or The New Purchase), 1921	52
157.	His Last Purchase	
158.	Alderman Harry Wray, 1921	27
159.	The Mace Bearer, 1921	
159.1.	A Mother and Daughter	
160.	Armstrong's Garage, 1921	103
161.	Four Oils on One Board, 1921	
162.	August Morning, Mulgrave Wood, near Whitby	
163.	Towpath near Beverley	
164.	The Lake Como from Lenno	
164.1.	Menággio from Lenno, Lake of Como	
165.	Lenno and Lake Como from the Monastery of Aqua Fredda, 1921	
166.	Lenno and its Bay, 1921	
167.	Lake Como, 1921	
167.1.	Hotel Garden, Lake of Como	
168.	A Stormy Day on Lake Como	
169.	Continental Lake with Figures on a Jetty	82
170.	Italian Scene with Lake, 1921	82
171.	Thorpe Hall in the East Riding of Yorkshire, 1921	
172.	An Old Inn Kitchen (or Maids in the Kitchen or An Old Kitchen), 1922	104
173.	In the Hall of the Beverley Arms	
174.	Ramsey, Isle of Man	
175.	Ramsey Harbour, Isle of Man	82
176.	The Garden Party	82
177.	A Cowshed 1, 1922	105
178.	Portrait of Frederick Needler, 1922	
179.	Girls in the Needlers Factory Dining Room	
180.	Sketch of Sanger's Circus, an Afternoon Performance (or The Big Top, Sanger's Circus)	
181.	Sanger's Circus, an Afternoon Performance, 1923	69
182.	Performers' Entrance	70
183.	Caravans at Rye, 1923	71
184.	Polly (or Pony)	
185.	Corner of a Horse Tent, Sanger's Circus, Rye	71
186.	Sanger's Ring Horses	71
187.	Horse Tent, Sanger's Circus (or Circus Horses)	71
188.	Welsh Ponies, Sanger's Circus	
189.	The Farrier's Tent (or The Circus Forge)	72
190.	Caravans at Billericay	
191.	View of the Thames	
192.	A Courtyard in Albi, France, 1924	
193.	Albi Cathedral, Tarn, Southern France	82
194.	Albi, October Morning	
195.	Albi Cathedral	
196.	The Cathedral & Palace, Albi	
197.	Italian Scene	83
198.	Pont St. Georges, Cahors	
199.	La Place Gambetta, Cahors	
200.	An Old Street, Cahors, 1925	83
201.	The River, near Cahors	
202.	A Wet Day, Cahors	
203.	Cahors, Pumpkins	
204.	Caravans at Cahors	
205.	The Quay, Cahors	
206.	Market Place & Cathedral, Cahors	
207.	A Café at Cahors	
208.	The Tower of the Pope Jean, Cahors	
209.	The Beverley Band Practises in My Studio	72
209.1.	Les Baux, across the Valley	
209.2.	The Castle of Les Baux, Morning	
209.3.	A Grey Day at Les Baux	
209.4.	Castle of Les Baux, Provence, 1925	84
210.	The Cathedral, Avignon, 1926	
211.	The Pope's Palace, Avignon	
212.	The Cathedral Doorway, Avignon	
213.	View from Les Rochers de Justice	
214.	The Footbridge, Vaison-la-Romaine	
215.	Avignon from Les Rochers de Justice	84
216.	The Palace of the Popes, Avignon: Grey Morning	
217.	Pont St. Bénézet, Avignon: Afterglow	
218.	Avignon from Villeneuve	
219.	Vaison-la-Romaine, Provence	
220.	Afterglow, the Bridge at Avignon	
221.	La Porte du Rhône, Avignon	
222.	The Palace of the Popes, Avignon: Afternoon, 1926	85
223.	The Tower of Philip le Bel. Villeneuve	
224.	The Place Crillon	
225.	In Camera	54
226.	The Front Pew	54
227.	Screen 1	
228.	'To Be Sold by Auction'	92
229.	A Badminton Court, 1926	73
230.	Self Portrait 1	27
235.	Olives & Cypresses, Provence	
236.	The Valley of Ouveze, Vaucluse	
237.	The Market Cross, Beverley 1, 1927	85
238.	The Market Cross, Beverley 2	
239.	Beverley Minster	85
240.	Path to Beverley 1	86
241.	Path to Beverley 2	87
241.1.	Beverley Beck. A Summer Scene	
242.	The Terrace, Castle Ashby	
243.	The Old Library, Castle Ashby	114
244.	The L.N.E.R. Musical Society at Queen's Hall, 1927	
245.	A Palais de Dance	73
246.	Portrait of Charles H. Gore, 1927	28
247.	Portrait of Henry Micks, 1928	28
248.	Mrs R. Hodgson	29
249.	Sir Alexander & Lady Macdonald of the Isles with Their Family in the Gallery at Thorpe, 1928	114
250.	'Widdall's', 1928	105
251.	A Polisher's Shop	107
252.	The Fiddle-Maker	
253.	Portrait of Capt. Sir Henry Samman	
254.	An Inn Kitchen (or Kitchen Scene), 1929	107
255.	South Bay, Scarborough, 1929	
256.	Scarborough from the Spa (or South Bay, Scarborough)	
257.	Scarborough Harbour	87
258.	Scarborough Bay	
259.	Salzburg, Early Morning, 1929	
260.	The Fortress, Salzburg	
261.	The Roof-Tops, Salzburg	
262.	An Austrian Village	
263.	The Lake, Velden, Carinthia	
264.	A Village in Carinthia	
265.	Mount Sion 1	

		Page
265.1.	Mount Sion 2	
266.	An Alpine Landscape, 1929	87
267.	From the Balcony of the Park Hotel, Cortina d'Ampeggo, 1929	
268.	Morning. Riva, Lake of Garda	
269.	Riva, Lake of Garda	
270.	From the Hotel Gardens, Riva, Lake of Garda	
271.	Sun Baths, Riva, Lake of Garda	
272.	Mountain Valley Scene, Cortina d'Ampeggo, 1929	
273.	Adamello Mountains, North Italy	87
274.	The Coliseum from the Palatine Hill, Rome	
275.	Palace of Septimus Severus, Rome	
279.	Self-Portrait 2	29
280.	My Neighbour's House, 1929	93
281.	Portraits of Canon & Mrs Fisher, 1929	
282.	Study for the Curiosity Shop ? (unfinished)	
283.	A Curiosity Shop 1, 1929	94
284.	The Bailiff Man	55
285.	Burton Constable, South Front, 1929	
286.	The Long Gallery, Burton Constable	94
287.	The Rt. Hon. Thomas Robinson Ferens, P.C., LL.D. 1, 1930	29
287.1	The Rt. Hon. Thomas Robinson Ferens, P.C., LL.D. 2	30
288.	Col. J.B. Stracey-Clitherow, 1930	30
289.	Bric-a-brac, 1931	95
290.	Interior, Bar House, Beverley	
291.	'The Squire' (or Family Prayers), 1931	55
292.	The Last Cab (or My Neighbour Returns), 1931	56
293.	The Earl & Countess of Strathmore & Kinghorne in their Drawing Room at Glamis, 1931	116
294.	Study of Drawing Room, Glamis Castle	
295.	His Majesty King George V, Preparatory Study	
296.	His Majesty King George V, 1932	32
297.	Study for The Window Seat	
298.	The Window Seat, 1932	57
298.1.	A Mother and Child 2	
299.	A Bedroom Interior	
300.	Study for the Staircase	
301.	The Staircase	
302.	Mrs Stephen Ellis Todd at 94, 1932	33
303.	A Man with a Pint, 1932	34
304.	Another Man with a Pint	34
304.1.	Study for Reading the Will	
305.	Reading the Will, 1933	
306.	The Library, Eaton Hall	
307.	Major Sir Robert Spencer-Nairn, Bt.	
308.	Mrs. Hunt Hedley	
309.	North Bar Within	87
310.	A View of North Bar Within, with St Mary's Church	87
310.1.	Saturday Market	
311.	North Bar Street, Beverley, 1933	
312.	North Bar	88
313.	Self-Portrait 3, 1933	34
314.	Self-Portrait 4	
315.	T. Hudson, Esq., Vice-President, British Trawlers' Federation, 1933	
316.	The Hall, Caythorpe Court	
317.	Lt-Col. C.T. Samman, J.P., R.A., M.C., Master of the Worshipful Society of Apothecaries, 1928-31. Presentation Portrait, 1934	
318.	The Fish Stall, 1934	58
319.	The Birthday Party, 1934	117
320.	Pekinese, 1934	
321.	Corner of My Studio, 1934	
322.	The Arts Club, Dover Street	95
323.	A Boy with a Pig	36
324.	The Landlord	36
325.	Seated Nude in Studio (or The Model), 1935	36
326.	Lord & Lady Blackford on their Golden Wedding at Compton Court, Somerset	
327.	Still Life: A Mixed Bag	
328.	A.E. Morgan, Esq., M.A., Principal & Vice-Chancellor of Mcgill University Montreal, formerly Principal of the University College, Hull, 1935	
329.	Portrait of Edward Ackroyd	
330.	South-West of the Minster, from a Distance	
331.	Beverley Minster from Hall Garth	88
332.	The Clock Tower at Avallon	
333.	Cathedral Doorway, Avallon	
334.	View from beside the Clocktower, Avallon	
335.	The Clock Tower, Avallon, Burgundy	
336.	Cathedral at Avallon, 1936	89
337.	Reginald Ringrose, Esq.	
338.	E.B. Emden, Esq., M.A., Principal of St. Edmund Hall, Oxford. Presentation Portrait	
339.	James Downs, Esq., O.B.E, J.P., 1936	
340.	The Lying-in-State, Westminster Hall	96
341.	The Harbour, 1937	
342.	Scarborough South Bay & Beach	
344.	Interior of a Barn	107
345.	The Barn	
346.	Pigs in a Barn, 1937	
347.	The Evening Meal, Pigs, 1937	109
348.	The Pig-Sty	
348.1.	Near Corte, Corsica	
348.2.	Gulf of Porto, Corsica	
348.3.	Piana, Corsica	
349.	Girl Polishing Pans (or Pan-Cleaning Day), 1937	109
350.	Girl Plucking a Goose	109
351.	Edgar Paulin	
352.	Portrait of Walter Goodin, 1937	37
353.	The Garter Service, St. George's Chapel, Windsor, 14th June 1937	96
354.	The County Court, Beverley, 1937	59
355.	Study for the Police Court	59
356.	The Police Court, Beverley, 1938	59
357.	H. Wheelock, Esq.	
358.	Mrs. Wheelock	
359.	Sir Prince Prince-Smith, Bt.	
360.	The Royal Academy Selection & Hanging Committee, 1938	118
361.	Woodland Scene, 1938	
362.	The Meet	
363.	The Matterhorn	
364.	View near Zermatt	
365.	Matterhorn 2, 1939	
366.	Zermatt: Afternoon	89
367.	Col. Raleigh Chichester-Constable, D.S.O., M.C., J.P.	
368.	Patience	
369.	Capt. Adrian Bethell, Master of Holderness East Hounds	
370.	Lady Prince-Smith	
371.	Edward Wates, Esq.	
372.	Girl with a Cigarette	
373.	Model-Ship Builder (or Spence's Studio)	110
374.	Study for 'Elevenses'	
375.	An Inn Kitchen: 'Elevenses', 1940	110
376.	'My Old Friend, Mrs Leake'	38
377.	Refugees in My Studio 2, 1940	60
378.	An Old Yorkshire Friend	
379.	A Wheelwright's Shop, 1941	111
380.	Portrait Group, Cairnbulg Castle, Aberdeenshire, 1942	
381.	The Keep, Cairnbulg Castle, Aberdeenshire	
382.	Interior: The Keep, Cairnbulg Castle, Aberdeenshire	
382.1.	Evensong, Beverley Minster 2 (or Interior of Minster), 1942	

	Page
382.2. View of Beverley Minster from Keldgate Manor Garden, 1942	
383. In a Bar, 1943	39
384. Cottages on Buttermere	
385. Brick Bridge	74
386. St Fillan's, Perthshire	89
389. Portrait of a Girl	40
390. A Munitions Factory	
391. A Musical Interlude	
392. A Family Scene	61
393. A Sheriff's Luncheon, 1945	119
394. Study of a Ship in Stocks	
395. Launching Trawler, Beverley Shipyard	112
396. Drawing Room, Masham (or The Green Room)	97
397. Man Reading in Bed, 1945	
398. Still Life: A Cold Ham & Things (or A Sideboard I Remember, or Still Life of a Ham, Stilton, Celery, Pie, Bottle and Plates), 1945	13
399. Still Life: Frugal Fare	
400. Portrait of Wing-Commander John Viney, D.S.O., D.F.C., A.F.C., 1945	
401. Preparations	113
402. Three Maids	113
403. A Hay Loft in Wartime	61
404. Beverley Minster: Late Afternoon	
405. Arts Club Smoking Room	
406. I Dreamt St Peter Sat for His Portrait (or An Allegory of Art & Artists)	62
407. Swedish Coast	89
408. The Fishmongers	
409. Percy Dalton, Esq., 1947	40
410. Study for Picture, Valuation for Probate	63
411. Inventory & Valuation for Probate (or Arden's Vaults), 1947	63
412. Ghar Ullin Apple Sammy Markaway	40
413. Screen 2	
414. J.R. Chichester-Constable, Esq.	
415. Alexander Alec-Smith, Esq., Merchant, Kingston upon Hull	
416. Geraniums 2	
417. Arnold Cleminson, Esq., 1948	41
418. A Little Garden Fête	
419. The Flower Room	
420. A Winter Posy	
421. Snapdragons	
422. Roses & Larkspurs	
423. Harvest Festival Gifts	13
424. Arminel, 1950	
424.1. Portrait of George Odey, Esq., M.P., 1950	

	Page
425. George Odey, Esq., M.P. for Beverley	
426. Mixed Flowers	
427. Zinnias	
428. Michaelmas Daisies	
429. Portrait of Miss Elizabeth Chapman	
429.1. Brig. J.N. Cheney, O.B.E., Deputy Lieutenant of the East Riding	
430. Posthumous Portrait of His Majesty King George VI Colonel-in-Chief the East Yorkshire Regiment 1922-1952, 1953	42
431. Posthumous Portrait of My Grandfather, Greenland Whaler, 1956	
433. Pansies	
434. A Bowl of Roses	14
435. The Lumber Room	64
436. The Yellow Room	
437. Winter Sunshine	
438. Geraniums 3	
439. Spring Flowers	
440. Polyanthus	
441. Daisies	
442. Basket of Roses, 1955	14
443. Still Life with Fish 2	14
444. An Old Barn Essex	
445. Old Leeman	
446. Mrs Rosemary Adams, F.R.C.S.	
447. Still Life: The Pickwick Club	
448. A Curiosity Shop 2	
449. A Cowshed 2	113

It has not been possible to assess the likely dates of execution of the following paintings:

500. Lake Scene Yorkshire
501. Sketch of Farmyard
502. Portrait of Janet
503. Nude in a Cave
504. Interior with Welsh Dresser
505. Elderly Victorian Lady and Young Girl
506. The Chef
507. Series of Small Studies on Canvas
508. Salisbury Cathedral
509. Self-Portrait 5